CLASS
PICTURES

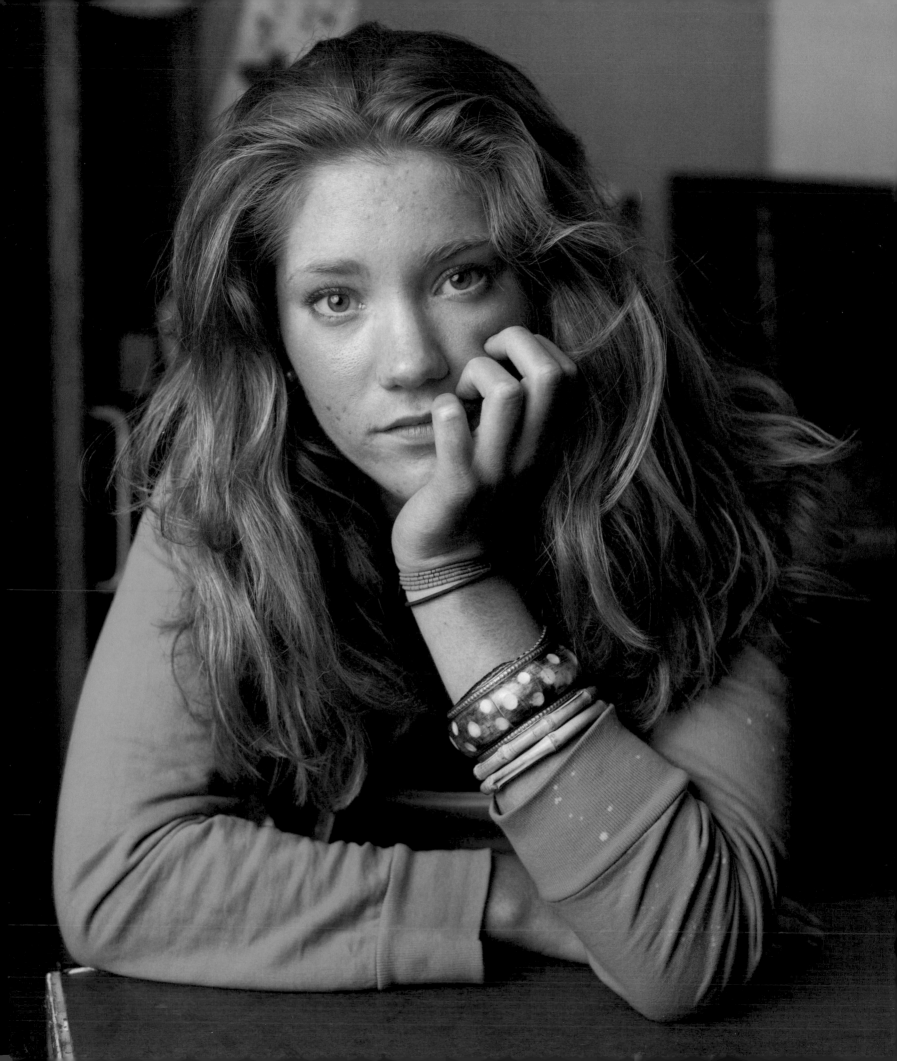

CLASS PICTURES

PHOTOGRAPHS BY
DAWOUD BEY

ESSAYS BY
JOCK REYNOLDS
AND
TARO NETTLETON

INTERVIEW BY
CARRIE MAE WEEMS

aperture

This book is dedicated to my son, Ramon Alvarez-Smikle, who inspired this work

I would also like to acknowledge the contributions of the following individuals: Walker Blackwell/Black Point Editions, Nancy Barr, Julie Bernson, Dan Collison and Elizabeth Meister, Eileen Finnegan, Donn Harris, Shirley Hightower, Sandra Jackson-Dumont, Emily Keeler, David Meehan, Ceci Mendez, N. Y. Nathiri, Ronny Quevedo, Yvette Amstelveen Rock, Stephanie Smith, Jacqueline Terrassa, and Bob Thall.

THIS PROJECT WAS MADE POSSIBLE, IN PART, WITH GENEROUS SUPPORT FROM AGNES GUND AND DANIEL SHAPIRO.

FRONT COVER: Kevin, 2005. See pages 108–9.
FRONTISPIECE: Emy, 2005. See pages 86–87.

EDITOR: Nancy Grubb
DESIGNER: Patricia Fabricant
PRODUCTION: Matthew Pimm

THE STAFF FOR THIS BOOK AT APERTURE FOUNDATION INCLUDES:
Ellen S. Harris, *Chief Executive Officer;* Michael Culoso, *Director of Finance and Administration;* Lesley A. Martin, *Executive Editor, Books;* Susan Ciccotti, *Production Editor;* Sarah Henry, *Production Manager;* Andrea Smith, *Director of Communications;* Kristian Orozco, *Director of Sales and Foreign Rights;* Diana Edkins, *Director of Exhibitions and Limited-Edition Photographs;* Catherine Archias, Laura Cooke, and Julie Pilato, *Work Scholars*

First edition
Printed in Hong Kong
10 9 8 7 6 5 4 3 2 1

Library of Congress Cataloging-in-Publication Data

Bey, Dawoud, 1953–
 Class pictures : photographs / by Dawoud Bey ; essays by Jock Reynolds and Taro Nettleton ; interview by Carrie Mae Weems. -- 1st ed.
 p. cm.
 Includes bibliographical references.
 ISBN 978-1-59711-043-3 (hardcover : alk. paper)
1. Students--United States--Exhibitions. 2. High school students--United States--Pictorial works. 3. Bey, Dawoud, 1953– I. Reynolds, Jock. II. Nettleton, Taro. III. Weems, Carrie Mae, 1953– IV. Title.

TR681.S78B39 2007
779'.2--dc22
 2007009062

Aperture Foundation books are available in North America through:
D.A.P./Distributed Art Publishers
155 Sixth Avenue, 2nd Floor
New York, N.Y. 10013
Phone: (212) 627-1999
Fax: (212) 627-9484

Aperture Foundation books are distributed outside North America by:
Thames & Hudson
181A High Holborn
London WC1V 7QX
United Kingdom
Phone: + 44 20 7845 5000
Fax: + 44 20 7845 5055
Email: sales@thameshudson.co.uk

aperturefoundation
547 West 27th Street
New York, N.Y. 10001
www.aperture.org

The purpose of Aperture Foundation, a nonprofit organization, is to advance photography in all its forms and to foster the exchange of ideas among audiences worldwide.

CONTENTS

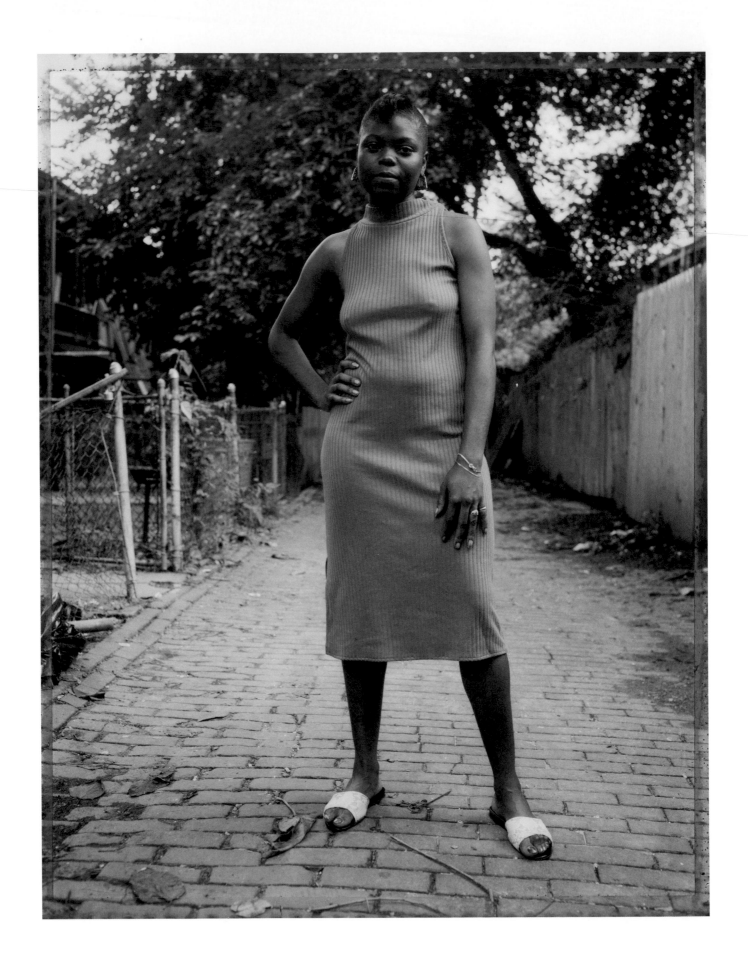

SELF-EVIDENT

JOCK REYNOLDS

Nineteen eighty-nine was a memorable and disturbing year in many respects, particularly if you happened to be living in the nation's capital. I was there at the time, directing the Washington Project for the Arts (WPA) and collaborating with many fine colleagues to exhibit the work of living artists. While the U.S. Congress was quietly allowing the American savings and loan industry to pick the American taxpayers' pockets for hundreds of millions of dollars, some congressmen—notably Senator Jesse Helms and Representatives Richard Armey and Torn Delay—proved more than willing to help the press take its eye off a badly spinning ball. They did so by focusing intense political attention on the National Endowment for the Arts (NEA). Readers will no doubt remember how a hitherto well-respected federal agency was excoriated, and its peer-review grants-making process vilified, for awarding a grand total of $45,000 to partially fund a pair of exhibitions by photographers Andres Serrano and Robert Mapplethorpe. In the midst of the cultural firestorm that Helms, Armey, Delay, and others provoked by characterizing one of these artists as a blasphemer, the other a pornographer, and the NEA as a bastion of contempt for family and moral values, the WPA stepped in to provide a local venue for the Mapplethorpe retrospective after it had been canceled by the Corcoran Gallery of Art. And in this process, I learned a lot—very fast—about how images and words can be linked to create wildly varied stereotypes and meanings.

It was during that same tumultuous year of 1989 that I first came in contact with the moving and powerful work of photographer Dawoud Bey, an artist with whom I have since collaborated on many projects. Richard Powell, then director of programs for the WPA and right in the midst of organizing the important exhibition *The Blues Aesthetic: Black Art and Modernism,* called me into his office to view some stirring street portraits that Bey had made in Harlem and Brooklyn, along with others created more recently in the African-American neighborhoods of Washington, D.C. I particularly remember beholding *A Young Woman between Carrolburg Place and Half Street, Washington, D.C.,* 1989 (opposite), and *A Young Man after a Tent Revival Meeting, Brooklyn, New York,* 1989 (page 8), and immediately sensing how different these images of adolescents were from those I was seeing almost daily in local crime stories. Unwilling to let all-too-familiar stereotypes of black youth and neighborhoods stand, for years Bey had been creating an alternative and

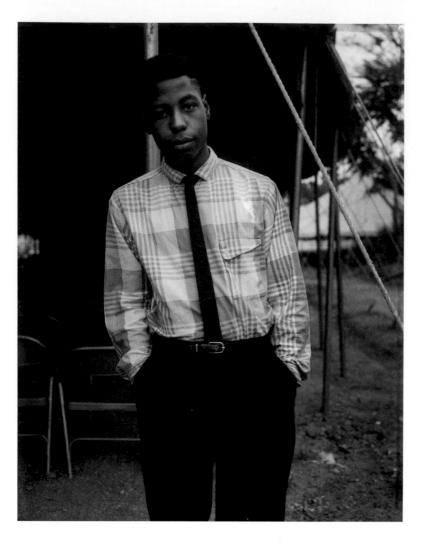

affirming vision. The citizens he portrayed stood forth in their familiar environs with a calm sense of purpose and individual identity, in stark contrast to the sullen mug shots of black youth being promulgated throughout the mainstream media.

The artist's own racial identity, personal experience, and intense empathy with others had clearly enabled him to share this very different view of the many strangers he met and photographed. Spending ample time in local neighborhoods with his 4-by-5-inch view camera, he simply observed where and how people lived, then talked with them to gain their willingness to pose. By using positive/negative Polaroid Type 55 film, Bey could almost instantly assess the visual results of his picture making and simultaneously give a black-and-white contact print to his subjects. And thus the encounter between artist and subject, as a dual act of personal communication and sharing, was completed right on the spot.

Looking at *A Young Woman between Carrolburg Place and Half Street* again today, I see a formidably self-assured individual standing right in the middle of the cobblestone alley leading to her home. Both beautiful and serene, she also seems ready to give you a good piece of her mind, if you were to misbehave in her neighborhood. *A Young Man after a Tent Revival Meeting* is another highly empathetic portrait. His open gaze toward the camera evidences a gentle sense of welcome and trust. This is a reflective adolescent worth knowing.

It was not until 1992 that I had the opportunity to work directly with Dawoud Bey. By then I was directing the Addison Gallery of American Art at Phillips Academy, Andover, Massachusetts, and expanding its Edward E. Elson artist-in-residence program to commission new bodies of work from living artists, while also seeking to create active learning experiences for independent and public high school students and teachers. Two things prompted me to invite Bey to Andover. First, I had seen and liked a number of the new large-format color portraits he was then making of his artistic peers and immediate family, using a 24-by-20-inch studio camera that the Polaroid Corporation had

provided for his use in Manhattan. More important, I continued to reflect on how Bey was engaging the conundrum of racial identity within his work. I wondered how he might respond artistically to a situation that confronted him with other enduring American institutional stereotypes—those inherent to a venerable New England prep school and a pioneering American art museum.

By 1992 Phillips Academy had changed in many ways from the all-boys school of my youth. Most noticeably, it was now coeducational, with a student body evenly balanced by gender, almost a quarter of which was self-described as being "of color." Andover's Addison Gallery, one of the first American teaching museums, was also regularly engaged with students and teachers from local public schools, including nearby Lawrence High School. It was with this multifaceted context in mind that I arranged for Bey to have access to one of Polaroid's large studio cameras if he would spend a couple of months as artist in residence. Intrigued by the offer to engage students from both Andover and Lawrence in an intensive photographic portraiture project, one that the Addison pledged to exhibit in whatever form it took, Bey accepted the invitation. Soon he was meeting with students over meals, on school pathways, in classrooms, throughout the gallery, and on field trips to the Polaroid camera studio at the Massachusetts College of Art, Boston, where he began posing and recording his young subjects. I remember how rich Bey's conversations were with students, teachers, and others during his residency. He spoke eloquently about how an artist might choose to create his or her own identity in the world, not only as a maker of visual images but also as an educator, social activist, and role model for young people.

It was always fascinating to watch Bey interact with the students. He gave them minimal pre-session instructions, asking only that they dress and present themselves as they pleased. Sometimes his subjects wanted to be photographed individually and other times in tandem—as a couple, twins, or just friends. He sensed the importance of these desires, granted them, and sometimes suggested other possibilities as his subjects became comfortable with him while he adjusted backdrop paper, lighting, a simple chair or two, and the camera, talking all the while. At some particular moment, when he sensed a pose was just right, Bey would record the image with a timely squeeze of his remote shutter bulb. And then, as soon as his large Polaroid portrait developed—in a few short minutes and right before the students' eyes—that picture would be discussed and another might be made with an adjustment suggested by either Bey or his subject(s). I especially remember a young Latino couple from Lawrence High School who posed together during one of these sessions. Impeccably coiffed and dressed, they were eager to display their devotion to one another before the big camera. Bey's first picture of the pair was a beauty, but he seemed to sense that there was something more to be had. Almost casually, he suggested to the girl that she wipe away her lipstick for the next exposure. A few minutes later the next picture showed the couple looking

strikingly younger, more tender, and more vulnerable (opposite). Nothing more had to be said. Everyone in the studio was pleased and knew which was the truer portrait.

As Bey worked with the large Polaroid studio camera, he also began experimenting with concepts of time and of pictorial composition that amplified both the visual complexity and the emotional content of his work. He did this by recording sequential images of the same subjects, cropping and overlapping them within the ground glass of the camera, then juxtaposing the developed images as framed pairs and trios. In other triptychs the artist made during his residency, a sense of sequenced action and time, reminiscent of Eadweard Muybridge's nineteenth-century motion studies, came to the fore. Bey would move the large Polaroid studio camera and make multiple exposures of the group of students who were posing for him. At the end of such sessions, one could only guess at how much time had elapsed between Bey's multiple exposures, for he chose them not to arrest human motion in specific increments, as Muybridge had done, but to subjectively reveal human identity and emotion over time.

When it came time to exhibit the diverse portraits at the Addison Gallery, Bey made another important conceptual decision. By titling each portrait simply with the subject's first name, and by not adding any school affiliation to the wall labels, the artist invited those viewing his work to contemplate the students on a first-name and face-first basis. The gallery audience was thus invited to put aside any suppositions it might otherwise make regarding the students' academic aptitude, economic class, or family background, and look deeply and carefully at the humanity of each person. After all, it was virtually impossible to tell by appearance alone what kinds of families these youngsters came from and which school they were attending. One might have easily (but incorrectly) guessed that Hilary and Taro (see page 18) were local boys hailing from Lawrence and that the Latino couple were Andover students from well-to-do families in Miami or Los Angeles. Stereotypes were unsustainable in the presence of Bey's complex portraits.

Bey's next artistic and educational ventures took him out to Chicago. Working in Columbia College's photo studio, he began creating larger and more ambitious portraits. He would pose one, two, three, four, or sometimes even five subjects for multiple-exposure sessions that produced a host of images, which he then edited, framed, and exhibited in various combinations of two, three, four, six, or eight Polaroid panels. The visual and emotional complexity of these portraits grew in power not just from their scale but also from the variety of ways that Bey continued to experiment with time, light, and color. Having earlier been inspired by the black-and-white portraits of photographers such as Walker Evans, Dorothea Lange, Russell Lee, Ben Shahn, and Roy DeCarava, Bey was now becoming fully attuned to hues of skin color. He actively paid attention to them not just as carriers of racial identity but for their aesthetic beauty, and he employed a broader array of colored backdrop papers and more carefully considered lighting to imbue his human

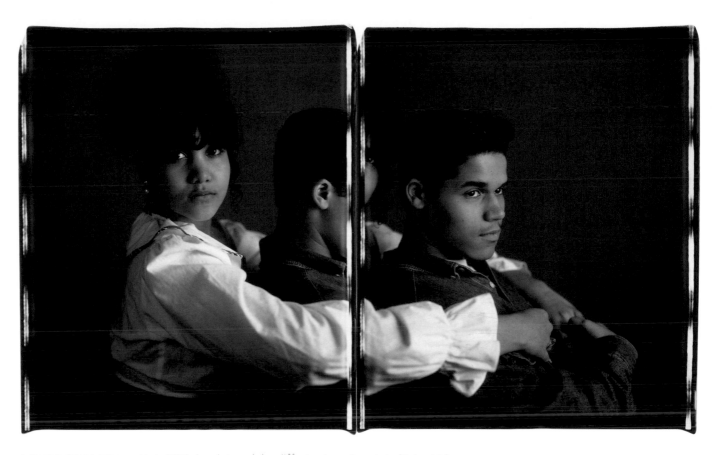

A Couple from Lawrence High, 1992. Two internal dye diffusion transfer prints (Polaroids), 30⅛ x 22 in. (76.5 x 55.9 cm), each. Private collection

subjects with greater emotional nuance and visual presence. He also took time to look at work by Old Master painters (Rembrandt, Frans Hals, and so on) and nineteenth-century American artists (Thomas Eakins, Henry O. Tanner, and others), paying attention to the ways they had posed their sitters against austere backgrounds to help the viewer focus on that particular individual at that particular time. Pieces such as *Brian and Paul*, 1993 (page 12), clearly demonstrate the new directions that Bey's work was taking.

Bey was already well regarded as an accomplished artist and teacher by 1991, when he enrolled in the Yale University School of Art's photography program (he received an MFA degree in 1993). His deep engagement with students in Andover, Lawrence, and Chicago must have been strongly influenced by his own decision to seek additional knowledge within a formal educational program. Perhaps this accounts in some way for the special empathy Bey clearly evidences when he moves so comfortably among his young subjects as both a peer learner and a mature mentor. He has never lost this dual perspective.

A mid-career retrospective can be either a harrowing experience or a great boon to an artist. In 1995 Bey was invited by Kellie Jones, then an adjunct curator at the Walker Art Center in Minneapolis, to present twenty years of his portraits. He was also given the

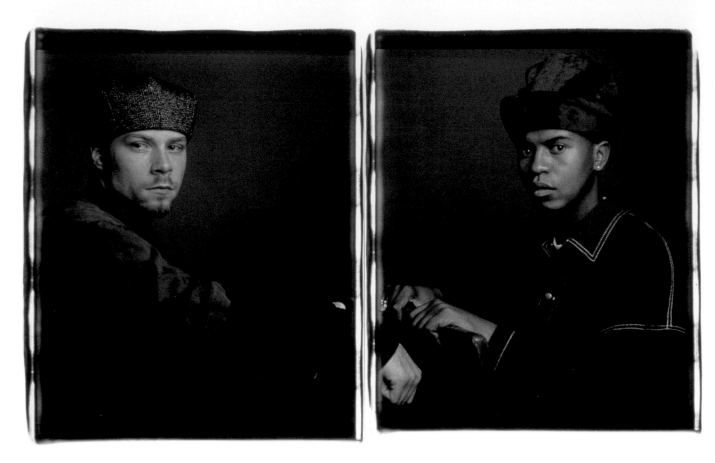

Brian and Paul, 1993. Two internal dye diffusion transfer prints (Polaroids), 30⅛ x 22 in. (76.5 x 55.9 cm), each. Walker Art Center, Minneapolis; Justin Smith Purchase Fund

opportunity to produce new work through a residency project that once again took the artist and one of Polaroid's large studio cameras on the road. In Minneapolis he worked with sixteen high school students for two weeks, during which he not only created a number of new portraits but also got his subjects involved in making their own photographic self-portraits. This proved to be another conceptual step forward, for Bey was eager to learn even more about the young people he was portraying—who they were and how visually expressive they might themselves be—and also to make it abundantly clear that his creative work was not just about himself and his own strong desire to make pictures.

Chicago was soon to figure again in Bey's life, when in 1998 he left his assistant professorship at Rutgers University in New Jersey to become a full professor of photography at Columbia College. He has taught there ever since, but he also travels regularly to other educational and cultural institutions. Like most truly interesting artists, Bey has a restless creative nature that prevents him from becoming complacent. I first noticed that he was starting to question just how much more information and insight he could wrest from the continued use of the large Polaroid camera when I invited him back to his alma mater not long after I moved to New Haven to direct the Yale University Art Gallery in 1998. Bey had

frequently been working very close up to the faces and hands of his teenage subjects when using the big camera, employing its highly descriptive lens and film to record intricate visual details. Nonetheless, during his working stay in New Haven he spoke openly about feeling the need to return to a simpler and more portable camera, one that would allow him, in some yet undetermined way, to revisit his roots as a street photographer. He seemed almost ready to become active once more as an image maker in the world beyond a formal studio, and he was clearly longing to observe and record young people in more varied circumstances; where they studied, worked, lived, and played. He was also hungry to draw out something more about them as individuals.

Bey perhaps sensed that one of the reasons his portraits of young people appear so open and revealing is that the conversations he always has with them establish bonds of trust and respect before he ever records a subject on film. He was well aware, too, of pioneering publishing projects such as James Agee and Walker Evans's *Let Us Now Praise Famous Men* and Langston Hughes and Roy DeCarava's *Sweet Flypaper of Life*. One presented impoverished sharecroppers in Alabama to America at large; the other did the same with everyday citizens of Harlem. Both beautifully juxtaposed dignified portraits with eloquent descriptions of these people, their environs, and their daily lives. With this and more in mind, Bey began striking out in some new directions.

By 2002 Bey had readied a new body of color photographs for public viewing, which he debuted at the Gorney Bravin + Lee gallery in New York. His central subject continued to be young people, many of them African-American teenagers, but Bey had met and photographed these adolescents in more anonymous urban circumstances, outside his more usual contexts of schools and museums. One posed for him with arms braced over bicycle handlebars. Others stood or sat in the city parks and various neighborhood locations where he encountered them and gained their consent to be recorded by his tripod-mounted 4-by-5-inch film camera. His new portraits were also printed larger than life-size, each on a single sheet of 50-by-40-inch color paper. The show took a strong critical hit from Ken Johnson of the *New York Times*, who questioned whether Bey hadn't inadvertently created images that affirmed enduring stereotypes of minority youth, no matter how big and beautiful his photographs were, nor how worthy his intentions. This harsh review gave Bey something to ponder as he readied to engage his next major creative endeavor.

The Chicago Project was launched as an intensive twelve-week artist's residency that the University of Chicago's David and Alfred Smart Museum of Art commissioned through its curatorial and education departments. For starters, all of the twelve high school students involved in the project were asked to complement the photographic portrait Bey made of them with one of their own making or choosing. They also each agreed to record audio interviews with Bey's collaborators, Dan Collison and Elizabeth Meister, as well as to write short personal descriptions of themselves—whatever they most wanted to make

Installation, *The Chicago Project,* David and Alfred Smart Museum of Art at the University of Chicago, 2003

known about themselves when the project was finally shared with an audience.

The student portraits thus ended up taking two forms when exhibited in the Smart Museum of Art—one visual, the other verbal. The audio portraits were transmitted directly downward from twelve suspended parabolic speakers onto a dozen custom-designed gallery benches, each of which had been placed in front of one of the portraits that Bey had created and a complementary image that the students had either made or chosen to put on view there. Visitors could thus consider Bey's and the students' images and words together in ways that drew out much more information about what these young people were feeling and thinking. And even though some aspect of how they were represented as individuals was entrusted to Bey, Collison, and Meister, the timbre and inflection of each recorded student voice, written statement, and self-made (or self-selected) photographic portrait remained unique.

After spending an afternoon carefully looking through and listening to *The Chicago Project,* I came to better understand why Bey's creative process has become more complex over time. His strong desire to integrate the artistic practice of a portrait photographer with that of teacher and mentor has led him into a larger realm of collaborative creative inquiry and educational practice. His still evolving way of working is perhaps more familiar to scientists, who today increasingly function in large teams of senior and junior researchers rather than as lone experimenters. That said, Bey's approach to artistic practice and education is one that many schools and teaching museums throughout America are beginning to explore more fully, in quasi-laboratory conditions. The results are often heartening, and underlying these experiments is a deep interest in making art and knowledge more accessible and meaning-ful to young people—especially during adolescence, when they are so often embroiled in a turbulent process of emergence and maturation.

This book, *Class Pictures,* features a collection of sixty individual student portraits that Bey has created in recent years, from 2003 to 2006 (pages 24–143). He made them in many schools and communities throughout the United States, working in collaboration with young people who met and spoke with him before agreeing to become his subjects. In turn, he asked these students to write a personal statement before he photographed them, reveal-ing whatever personal information they wished to share about themselves and to accom-pany their photographic image out into the world. In a very real sense, these visual/verbal portraits have been coauthored by Bey and his subjects. The artist has carefully con-

templated and then recorded each person who sat before his camera, with the full visual acuity and emotional sensitivity he brings to his work after decades of creative practice. Bey's subjects have similarly brought forth something of their own expertise, their unique knowledge of themselves and the world as they have experienced it to date. Their collected statements in this volume remind me of Studs Terkel's landmark book of interviews entitled *Working* (1974), which was subtitled *People Talk about What They Do All Day and How They Feel about What They Do.* In *Class Pictures* we are being offered a collective portrait of American adolescents today, one that resounds with complexities. And the students involved in this creative work have all undertaken their collaboration with Bey as a serious endeavor. Not one of them is smirking for the camera or wisecracking in his or her remarks. They have been regarded respectfully and seriously by Bey and have responded to him in kind. Given the impact of these results, I do wonder why we don't ask our young people more often to tell us what they are really thinking and feeling, and how they would like to be seen and heard.

What is it that these students are willing to reveal about themselves through both images and words? Almost anything and everything, the expected and the unexpected. Consider these "class pictures" in any order you choose. As you do, observe the stringent and systematic ways that Bey has chosen to frame each of his subjects within classroom spaces that are never recognizable as belonging to any specific school. These backgrounds are all in soft focus and contain various combinations of blackboards, posters, desks, bookcases, and other fixtures common to learning environments. The students often bring some of these elements into the sharply focused foregrounds. Some sit astride chairs, others at desks and tables, and still others stand. None of them employ external props. They simply present themselves as they are, wearing what they choose, facial expressions arrayed to say, "This is me." The poses they strike are similarly austere, but remarkable in playing changes on the myriad ways that arms and hands can be folded and clasped, heads can be held high or tilted.

Take a look at Kevin (page 109), perched sideways on a school chair in the corner of his classroom, where two slate blackboards converge. He is wearing a personally mono-grammed baseball cap, brand-name sweatshirt, and designer jeans. He leans directly into the camera, his handsome features beautifully lit and his eyes locked on the lens. In describing a youth in which "there was no more time for childhood," he reveals the death of his father, whose passing strikes him as both blessing and curse. The fact that he had already lost his father even earlier, to prison, makes the calm visage and poignant state-ment he offers to Bey all the more remarkable.

Charles (page 42), a close-cropped redhead, also leans forward. He sits with arms crossed on the back of an empty desk-chair, with a jumble of others behind him in the room. His clothing is quiet and understated; he has come to have his portrait taken wear-ing a simple brown sweater and tan shorts. Their visual modesty makes his intense blue

eyes, pursed lips, and attentive expression more noticeable as he ponders the emphasis on "competition" and "success" at his prep school. He wonders why "there are no prizes for letting other people win." What a deeply admirable thought to anyone who is actively questioning what genuine success in life might mean.

Shalanta (page 55) has determined a clearer path to her future, saying, "Success is where I am headed." She comes the closest of all of Bey's subjects to giving up a smile for the camera, but stops just short of doing so. Her hands are clasped together, fingers adorned with rings and wildly appliquéd nails that call to mind the talons of a falcon. She's happy to confirm a reputation among her peers as being "crazy but intelligent." That said, her tousled braided hair and girlish paisley dress look mighty prim and proper. Although still perched a bit awkwardly between girlhood and womanhood, Shalanta has already set her sights high.

Shaheeda (page 85) sits before the camera on the floor of her classroom, her knees tucked up under folded arms, with a sad and sullen expression bordering on resignation. She's already had her first child and acknowledges how difficult it is to care for him. The young mother is finding it hard to get enough sleep, retain her boyfriend, and stay in school. Realizing that her freedom is slipping away, she raises a metaphor of hope for herself. "I wish I could fly. If I could fly, I would fly to school and never be late. I would fly in the sky with the birds." The large hoop earrings she's wearing call to mind the brass rings on a merry-go-round she may never catch.

Terrance (page 65), garbed in a Phat Farm sweatshirt and a bit of bling, projects an armored and defiant personality. Shouldering up to a blackboard in his classroom with both hands stuffed in his pockets, he's almost scowling. One certainly wouldn't know this is a "momma's boy" if Terrance didn't tell you so himself. His love for his mother is deeply felt, and one can readily sympathize with his homesickness at a boarding school far from home. How touching that this young man can reveal his emotional vulnerability so openly to Bey and thus to all those who will encounter *Class Pictures*. The full measure of trust implied in this relationship between artist and subject is something to be cherished.

Simone (page 49) sits at a table with her small pale hands curled into fists. She levels an intense look at Bey's camera and willingly tells the world what's been bothering her. Having chosen to stay close to home, she has always been in "the minority at my school so it doesn't bother me, unless it becomes an issue with other people, then it bothers me." As a white student attending an almost all-black high school in Chicago, she's had the reverse experience of African-American Terrance. You detect Simone's determined but tentative sense of belonging in the expression she projects, one I've seen countless times in human situations charged by race and social stereotypes.

And so, these and the many other portraits in *Class Pictures* compel our full attention with images, thoughts, and issues. If you remember your own adolescence with any sense

of honesty and accuracy, you'll likely see something of yourself in some of Bey's subjects. You'll also likely recognize yourself in some of the students' statements, which may recall personal experiences and emotions from years ago—or perhaps from the present, if you are now raising children of your own.

At a time when political power, consumerism, celebrity, and notoriety seem more than ever to determine which people come to public attention through the mass media, Dawoud Bey continues a quest to affirm the essential individuality within our country's increasingly diverse population, especially its young people. He is resolutely determined to make them more self-evident to those who engage his work as artist, educator, and citizen. And the words "self-evident" are key to understanding Bey's creative enterprise, for they mean as much to him as they did to the daring colonists who signed our Declaration of Independence. He is deeply committed, just as our founders were, to the full realization of basic human equality and greater access for all to the "unalienable Rights" of "Life, Liberty and the pursuit of Happiness."

Bey asserts that our country's greatest challenge, in this era of a rapidly changing global economy, is how well we as a people can hold together and grow around the basic principles that have been central to our democracy from its beginnings. Much is known about how imperfect our Union still is and how often its cohesion and purpose have been tested. And isn't it also abundantly "self-evident" now that we need to do a much better job collectively of providing educational opportunities and mentoring for all youths residing in America and throughout the world? Dawoud Bey's *Class Pictures*, created collaboratively by students and an artist working together within some of the "best" and the "poorest" schools in America, is fraught with toughness and tenderness, clarity and confusion, ambition and resignation, hope and despair, as well as much more. You won't be able to determine from the pictures and statements where these adolescents hail from, but if you regard them as an indivisible whole—our youth—then perhaps our collective responsibility to them and their peers will become clearer and more urgent.

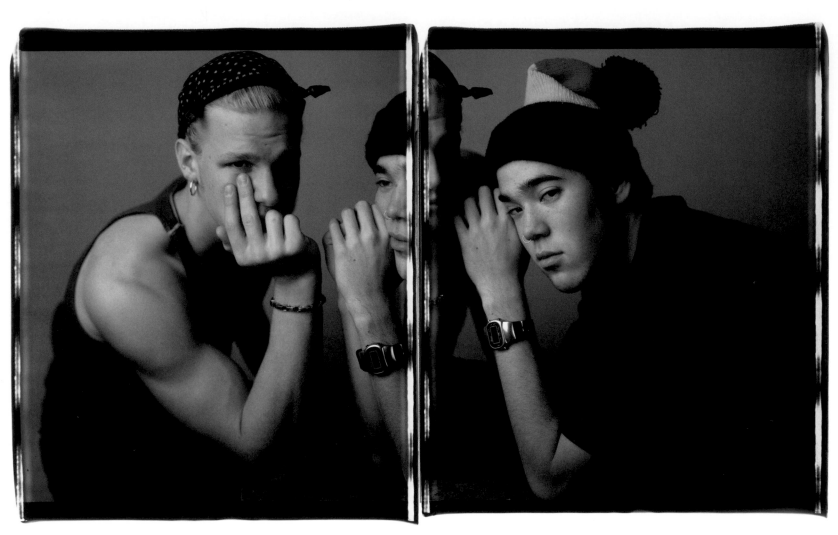

Hilary and Taro, 1992. Two internal dye diffusion transfer prints (Polaroids), 30⅛ x 22 in. (76.5 x 55.9 cm), each. Whitney Museum of American Art, New York; Purchase, with funds from the Photography Committee

OUTSIDE INSIDE: ON DAWOUD BEY'S CLASS PICTURES

TARO NETTLETON

*Frankly, have you ever heard of anything stupider than to say to people,
as they teach in film schools, not to look at the camera?*

—CHRIS MARKER, *SANS SOLEIL*

Dawoud Bey once exclaimed, in an insightful interview with Jock Reynolds, "You know that in the black community style is king!"[1] We might say the same of teenagers. Teenagers are often marked by their excessive attention to the details of their appearance. From their intricately sculpted hair—supported by gels, or shaped up with a razor—to the pants tucked under shoelaces to keep them from covering up too much of their shiny patent leather sneakers, their attention to detail never ceases to amaze. And yet style is about much more than mere appearance. It is a way of being and presenting, of signifying oneself.

When I look today at *Hilary and Taro* (opposite), the photograph that Bey made of me while I was a student at Phillips Academy in Andover, I am confronted by the likeness of a past self who is a stranger to me. (This strangeness is apparently even more obvious to others than to myself. Showing a postcard of this image to my girlfriend recently, I jokingly asked, "Which one do you think is me?" Genuinely uncertain, she answered, "Neither?") The portrait feels strange because I am trying to extract private memory from an image that is now public. I try to piece together clues left by my sartorial style. I am wearing a hat I had asked my Japanese grandmother to knit for me in red, yellow, and green; a dark gray oversize T-shirt; a digital wristwatch I found in Tokyo; and a silver ring in my nose, which my friend Andrew pierced for me around that time. All of these—with the exception of the nose ring, and to some extent the hat, because they are products of significant relationships that I still have today—are banal or commonplace. That is what style is: contexts in which you place yourself to show others where you're coming from.

By banal, I don't mean that style is insignificant. But it does entail subjecting ourselves to a particular style, even if we make it our own. It's easy to make a list of styles. They do it in dozens of street-snap fashion magazines coming out every month in Tokyo,

where the idea of a "supermarket of style" is most visible (and where I spent the first half of my life). The idea of not being faithful to one style was once provocative, but what young person could have a single, unadulterated point of cultural reference in today's world? More pertinent, I think the sartorial plurality shared by many high school students at this point echoes the in-betweenness that teenagers experience both physically and psychically.

What is more difficult than deciphering the referents of dress in *Hilary and Taro* is remembering my psychological state at the moment that Bey made this picture. In looking at it now, I (think I) look tougher than I remember feeling. My head is turned at a 45-degree angle. I am looking squarely at the lens, but my chin is tucked slightly toward my sternum, so that my eyes are angled slightly up. My pose is somewhere between contemplative and confrontational. My arm and my hand are about half the size of those of Hilary, sitting next to me. As if to emphasize this disparity, my forearm is doubled, repeated in the two juxtaposed Polaroid panels that constitute the diptych. For me, this is the *punctum* of the image. It pinpoints the feeling of awkwardness I felt when faced with Hilary's seemingly effortless ability to traverse between the subcultural and athletic worlds. The latter seemed completely unavailable to me, and perhaps my reflective expression in the photograph was a way to hide my emotions.

In a rather negative brief review of Bey's work, one *New York Times* critic characterizes Bey's photos as capturing "variously good-looking young people . . . gaz[ing] back at us with pensive expressions and soulful eyes."[2] Expressing a thinly veiled condescension toward teenagers, the critic writes that the pictures register "little more than photogenic looks and adolescent attitudes (wary toughness, uncertain vulnerability)." Style clearly has much less resonance for him than it does for Bey.

When the reviewer concludes by asserting that Bey's images "do more to affirm stereotypes than to subvert them," it seems as if he is projecting his own idea of what teenagers are like onto Bey's portraits. His criticism of the photographs reflects a popular assumption about teenagers: that they are self-obsessed creatures preening over their hair and clothes without much going on upstairs. A cartoon in the September 4, 2006, issue of the *New Yorker* shows a teenager with a diagram of his brain's contents: "My Space," "You Tube," "PS3," "Scarlett Johansson," "Snoop Dogg," "Counter-Strike," "Family Guy," "Video iPod," "Manga," and "Jessica Alba" take up most of the brain, leaving very little room for "algebra."

I know that my mother and stepfather thought similarly of me around the time *Hilary and Taro* was made, although to them my brain seemed to be entirely occupied by one thing. On more than one occasion, my mother asked me very seriously to quit skateboarding; I think she was afraid that, left to my own devices, I would do nothing else with my life. Those conversations are some of my most memorable experiences of adolescence, unforgettable because they marked such an utter failure to be grasped by a person I am so close to.

Bey's photographs, and the accompanying texts written by their subjects, reveal an important secret about teenagers: they have complex interior worlds. This complexity, noted by Stuart Hall in regard to Bey's photographs in 2001,[3] is even more apparent in Class Pictures, his series juxtaposing photographs of high school students with texts they've written (see pages 24–143). Bey asks his sitters to reveal something about themselves that people would not otherwise know. The resulting confessions repeatedly testify to the fact that life is deadly serious for his subjects. They fall madly in love, sometimes for the first time or seemingly for the last. Friends and relatives die, or are murdered. Fathers abandon their families. These teenagers display remarkable strength and poise in the face of such life-shattering experiences.

When adults perceive teenagers to be superficial, it is often because visual appearance fails to communicate subjective experience. The violence with which stereotypical images betray their subjects is a familiar issue to many of the teenagers depicted in Class Pictures. As one of the subjects, DeMarco (page 113), says: "I like when people look at a picture of me and be like, 'Oh he looks like he'll do something bad like this.' . . . 'Cause I like to prove people wrong so I can make me look better in the end. 'Cause as they get to know me, then they'll see." Clearly, DeMarco is acutely aware of the disjunction that can occur between "a picture of me" and the "me" that becomes visible only through experience and knowledge. Unlike many images, Bey's quiet photographs successfully close this gap by speaking of, rather than for, their subjects.

Like DeMarco, Omar (page 100) is conscious of how he is perceived: "I know that I shouldn't but sometimes I wonder how other people look at me. What do they see first? . . . I think that people see my skin color first. They probably see me as a brown guy." Such limited perceptions are reinforced by the fact that teenagers' feelings, thoughts, and inner turmoil are often not made available to adults.

All of the subjects in Class Pictures pose with their hands touching some other part of their bodies.[4] This act of self-touching suggests a closed circuit or an interior space neatly wrapped in an envelope of the body. The relative tightness of the photographic composition also evokes a feeling of solitude, which is underscored by the subjects' texts. This closedness of the poses is often juxtaposed with a face that looks out squarely at the viewer. As a result, the viewer is confronted with and made aware of both the subject's and the viewer's vulnerabilities. As the philosopher Emmanuel Lévinas has written, the face is at once most vulnerable, "inviting us to an act of violence," and "what forbids us to kill."[5] It is this sense of vulnerability and of responsibility for the Other that Bey captures in both image and text, and that distinguishes his Class Pictures from the sort of class pictures found in a yearbook.

Those yearbook pictures ordinarily provide an occasion for a person to present herself and to announce allegiances to friends, bands, authors, experiences, memories, and so on.

In Bey's series, the comments by Amy (page 35), which conclude with a list of her interests, come closest to those seen in a yearbook. "I would," she writes, "like to meet Robert Rodriguez, the Dalai Lama, or the Alkaline Trio." Such class pictures are *public pictures,* which, according to Erving Goffman, "are those designed to catch a wider audience." *Private pictures*, on the other hand, are "designed for display within the intimate social circle of persons featured in them."[6] By opening up the photographs to their subjects' texts, Bey incorporates a confessional facet, thereby positioning his Class Pictures somewhere between public and private pictures. He turns his images, which are exhibited publicly, into an intimate and private occasion in which we, as viewers, are confronted with the photograph's openness and its subject's unflinching vulnerability, bringing us into relation with the depicted subject. This relationship necessarily takes on an ethical dimension and commands us to respond accordingly.[7]

The simultaneous fragility and resilience seen in the subjects' faces and their confessional writings are, in part, the result of Bey's working process. In the past, when I sat for him, he would slow down the session to allow his subject to play an active role in the image-making process. Now, with the use of the subject's texts, the process becomes collaborative in a different way. Their poses may suggest closure, but the subjects are nevertheless candid, both in image and in text. This candor attests to the intensity of the intersubjective experience involved in creating the images and to Bey's avoidance of moral judgment, which makes the pictures such successful collaborations.

Bey's work is the result of an effort to get away from the act of taking pictures, with all its implications of theft. With *Class Pictures,* it may be more appropriate to speak of his making or receiving a picture. Even though the subjects get to have their say, they, like all of us, fail to express themselves fully or finally, in writing or in pose. The construction of the self is an ongoing process, and these portraits inevitably remain mere fragments. Their fragmentary nature is precisely what makes them so credible. Bey quietly presents his photographic subjects with empathy and without reducing their complexity—something rarely achieved with images of teenagers, who are so often both looked at and overlooked.

NOTES

1. Jock Reynolds, "An Interview with Dawoud Bey," in *Dawoud Bey: Portraits, 1975–1995* (Minneapolis: Walker Art Center; New York: Distributed Art Publishers, 1995), p. 106.

2. Ken Johnson, "Art in Review: Dawoud Bey," *New York Times*, May 10, 2002, www.nytimes.com.

3. Stuart Hall and Mark Sealy, *Different: A Historical Context* (New York: Phaidon Press, 2001), p. 61.

4. According to Erving Goffman, self-touching can "convey a sense of one's body being a delicate and precious thing." *Gender Advertisements* (Cambridge, Mass.: Harvard University Press, 1979), p. 31.

5. Emmanuel Lévinas, *Ethics and Infinity* (Pittsburgh: Duquesne University Press, 1985), p. 86. I am indebted to Douglas Crimp and his essay, "Face Value," in *About Face: Andy Warhol Portraits* (Hartford, Conn.: Wadsworth Atheneum, 1999), for drawing my attention to this work.

6. Goffman, *Gender Advertisements*, p. 10.

7. Lévinas, *Ethics and Infinity*, p. 97: "The tie with the Other is knotted only as responsibility. . . . The face orders and ordains me."

PLATES AND STATEMENTS

RASEC

Whether one might perceive it as a gift or a curse, I find it difficult to say who I am. The reason being is that who I am at this very moment can be very different from who I am in another situation. I am a procrastinator, and my fear of being ignorant can at times lead to an uncontrollable urge to learn and experience new things. Quite simply (as if anything is), I'm a dreamer. I love music, art, dance, humans. Human emotion itself is a monster no one can understand, yet it intrigues me immensely. I feed off of creativity and originality. These energies are my motivators.

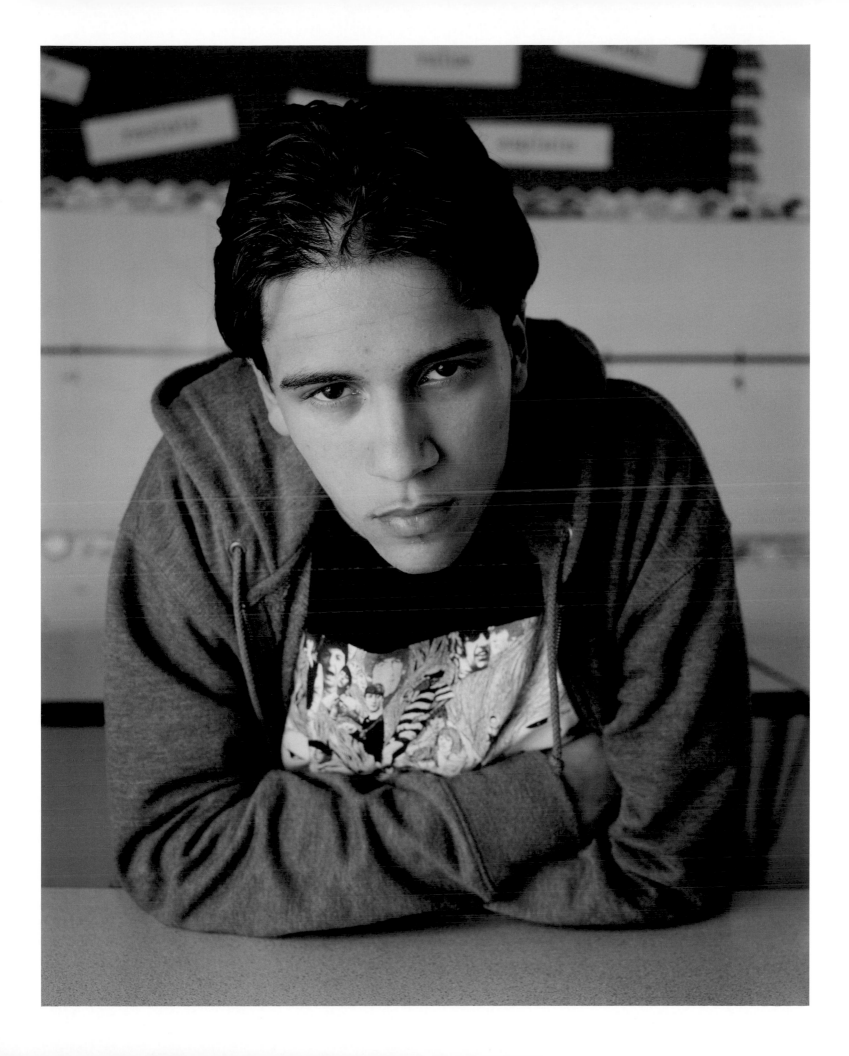

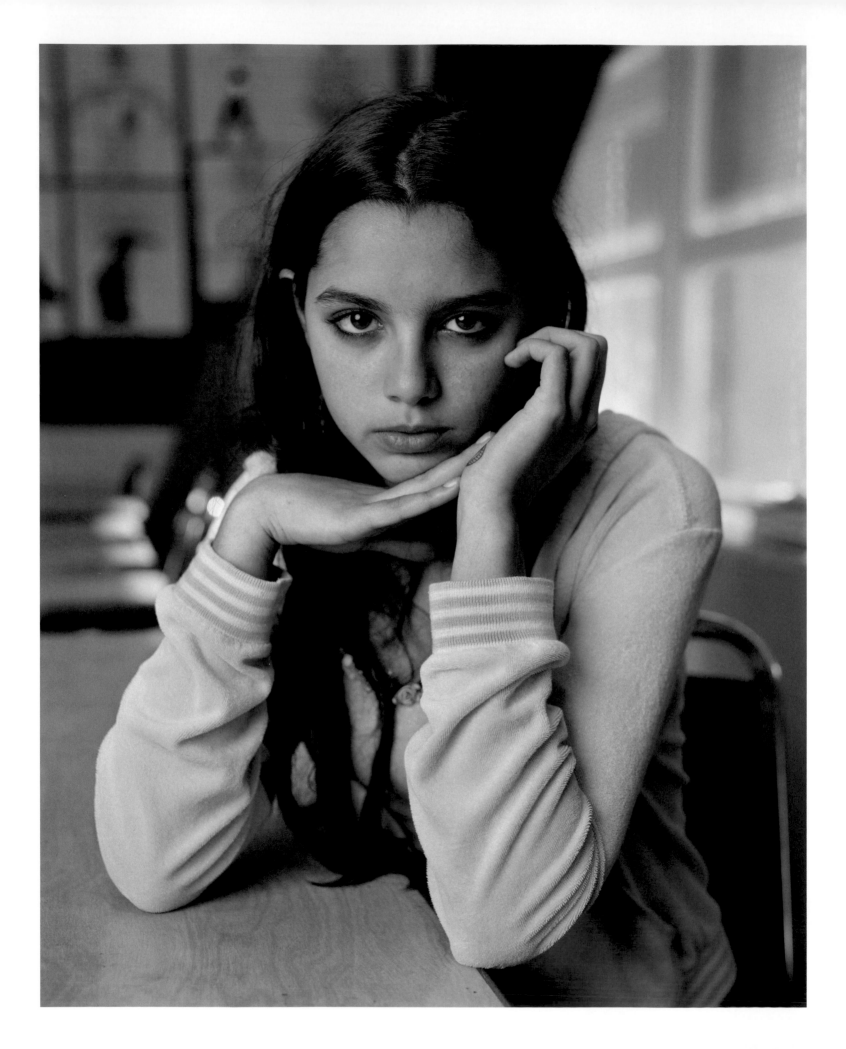

USHA

I can speak four languages, I am an actress, and when I was about thirty seconds old I reached up and took my dad's glasses off of his face. When I was eight years old, I visited my cousin's school in India. They didn't have a roof, so during the monsoons they got rained on. When I went home, I raised enough money to build them a roof and buy some school supplies.

THERESA

A lot of people ask me, ask me how old I am, and they will sometimes, they will say, "Ten." And I'm like, I'm not ten, I'm fifteen! And it doesn't hurt or anything, but I feel that God is giving it to me for a reason. Maybe he, he doesn't want me to look my exact age. Maybe he wants me to be unique and different from other people.

Well, I try to think of, like, a happy thing. Like sometimes I watch the news— I try to watch the news every day. And then I watch *60 Minutes* with my father, and so I hear about different things around the world, and I also listen to Andy Rooney. Yeah, he seems sort of funny. 'Cause, I remember one thing he was talking about: opening medicine. He was saying that trying to open a medicine bottle, he said that it's child proof, but it's adult proof, too, because it's hard to open the bottle. And the reason that I'm saying this is because it's hard for a female to open up on what they'll be, or what they are. And for me, for what I am, it's sort of hard because I face discrimination. Males see you as weaker than they are. And they say, You can't do this, you can't do that, and I know I *overcome* that because I believe in myself. And nobody can put me down.

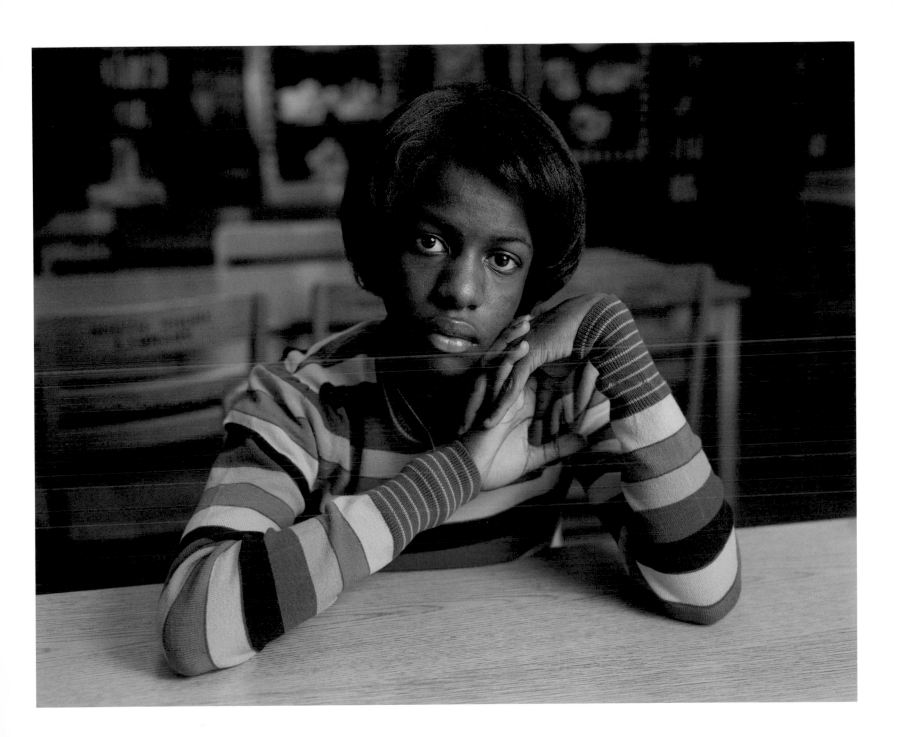

JAMES

Aside from me being one of the only white kids in my school, I'm also different from regular kids. I never was the normal one in my family or school. I am going on from high school to study music. But I don't play the piano or guitar. I play the tuba and the baritone horn. Not the most commonly played instruments. When I play, though, I love it. There isn't a more freeing feeling to me. So that's me.

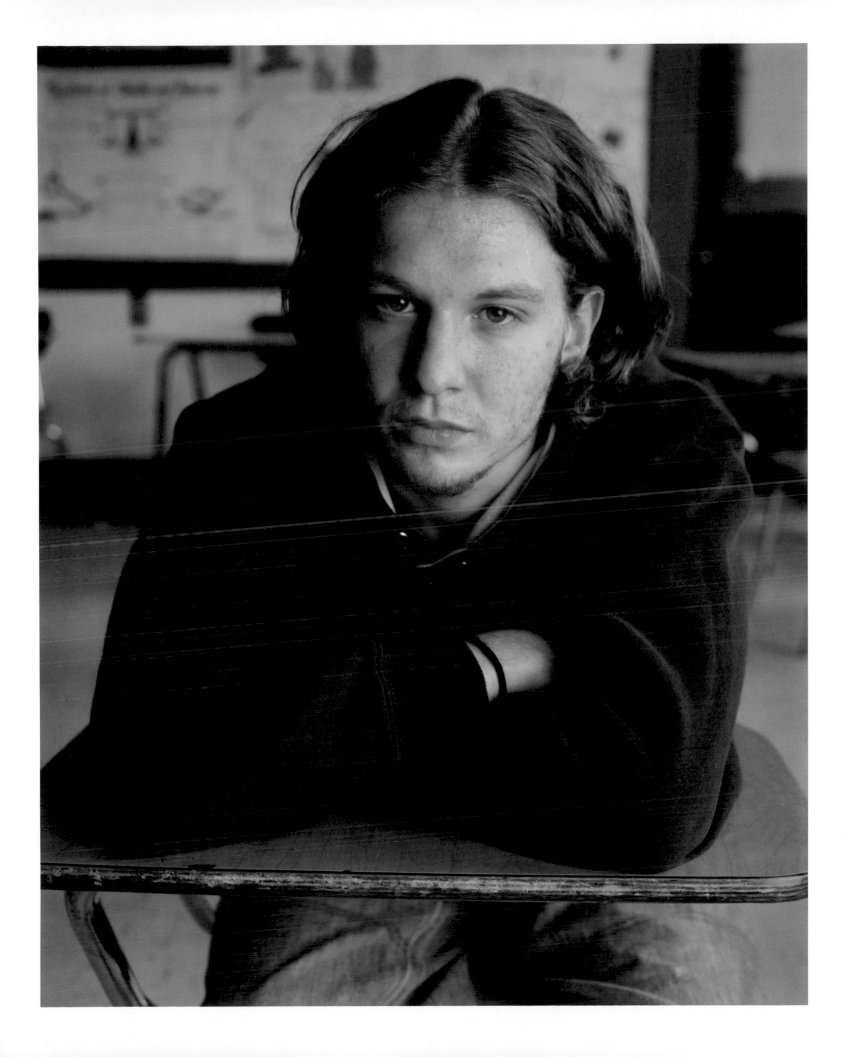

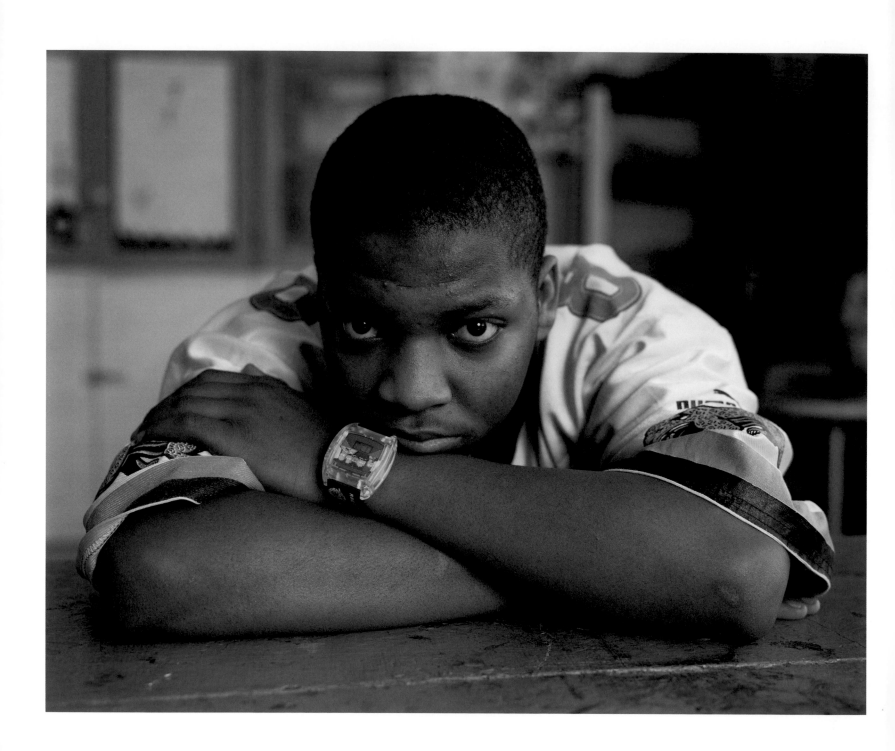

CHRIS

I think I come off as a bad person, 'cause when I get around people I don't know, I kind of ball up into a shell and don't really voice myself when I should, 'cause I'm so affected by what people think of me that I don't wanna, like, give them the stereotype of a young person my age. Stereotype would be: Don't know nothin', probably ain't goin' to be nothin'.

Can I tell a story? One day, right, me and my cousins, we was riding in the car. We had pulled over to go over to this girl's house, and we was sitting on the car and the police pulled up on us and they told us to get on the car or whatever, right, so we got on the car and everything. So further and further along they started asking us questions, and it's really making me *mad* because they're asking you questions but they're trying to see, like, if you're goin' to say something dumb. But you're not really saying nothin' dumb, but they're depicting you to *be* dumb but you don't feel that you *are* dumb. So that's frustrating because if somebody thinks you're dumb, and you know you're *not* dumb, you're gonna want to tell them, but the police, if you try to, you know what I'm saying, get out of line with them, they hit you or somethin'. So really I kept my mouth shut.

AMY

I don't like it when people make assumptions about me because of the way I look. It's even worse when people make assumptions about my parents because of the way I look. My family is pretty conservative. All the other parents want to know, "What kind of mother lets her daughter dye her hair pink?!" I'm a good kid. I don't drink or do drugs, I don't hurt other people, I like to recycle. I want to start a radio show, free Tibet, and study Buddhism. Why should my having pink hair bother people? We should all be free to do whatever makes us content, as long as we don't disrupt the well-being of others. I would like to meet Robert Rodriguez, the Dalai Lama, or the Alkaline Trio.

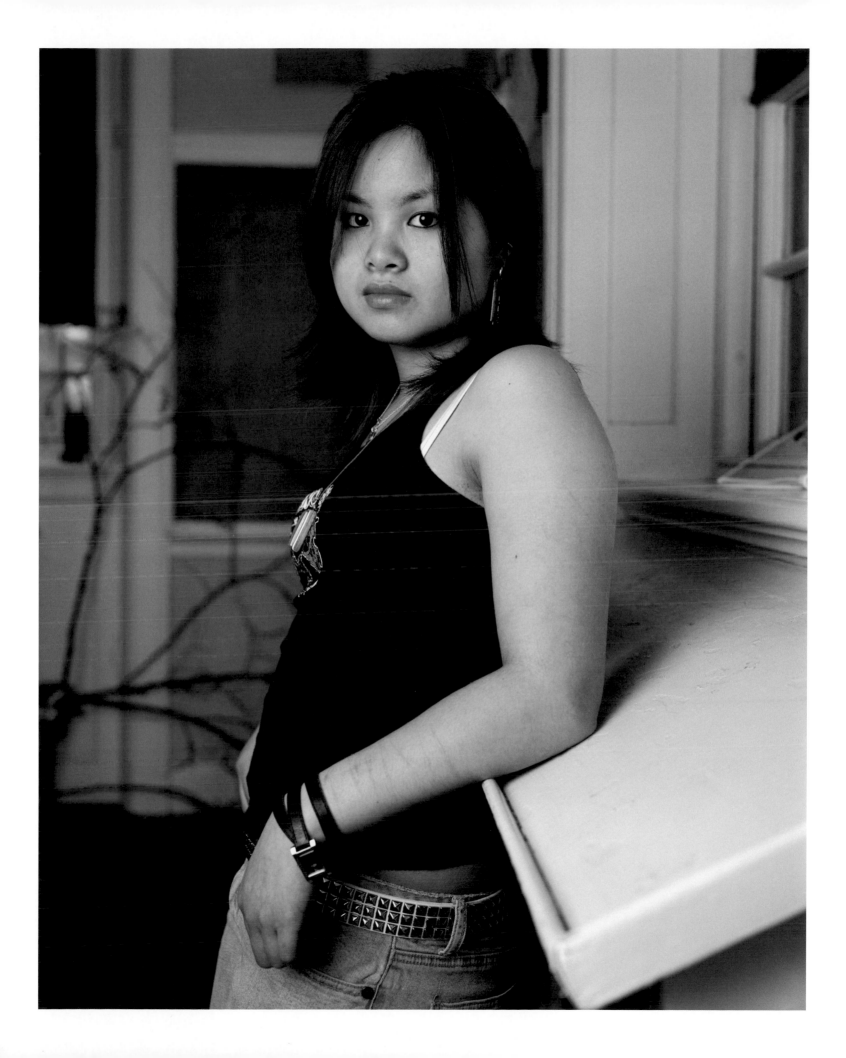

DIMITRIUS

When I was little, my mother showed me how to play baseball, because it helped me stay off the streets. When I got to Chadsey, I knew I had to play a sport in high school, so I picked football. Football was not a cool sport to me, but I stuck with it. This is my last year of high school, and when I broke my leg, I thought it was going to be my last time playing football, forever. But now my leg feels a little better. The doctor said I can play football in college. I will be ready next year.

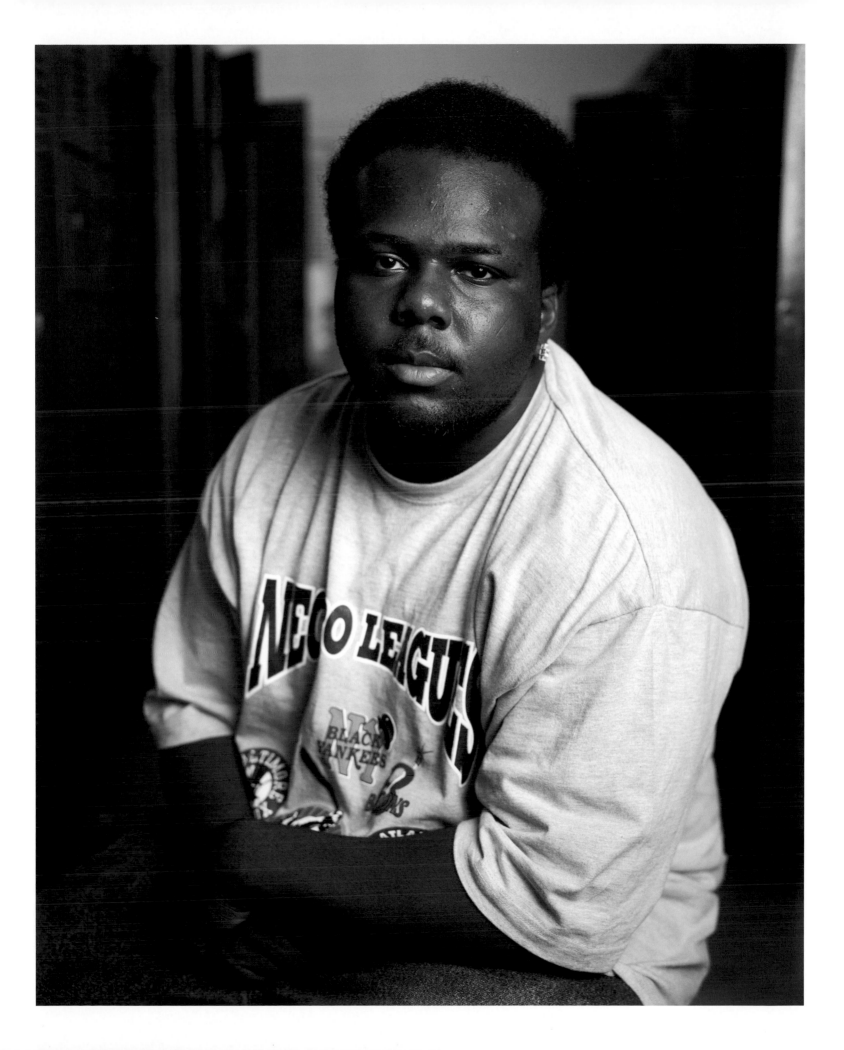

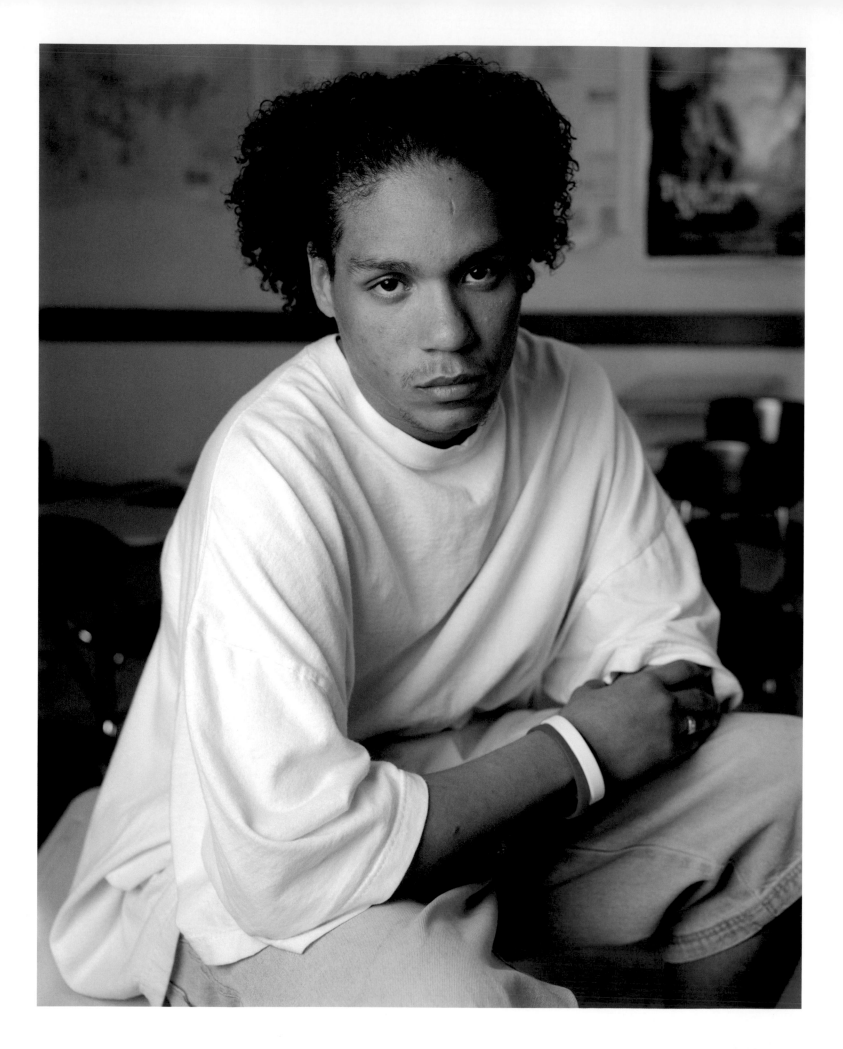

GERALDO

I am the person people look for when they want to have fun and cheer up. I am always a happy person, always with a smile on my face, but always hiding the truth. The truth is, I am not always happy, but me smiling and having fun is a way to disguise or cover up how I am really feeling 'cause I have problems like everybody else, but I just hide them or put them away. So that's how I go around every day, just lying, not just to myself but to everyone else.

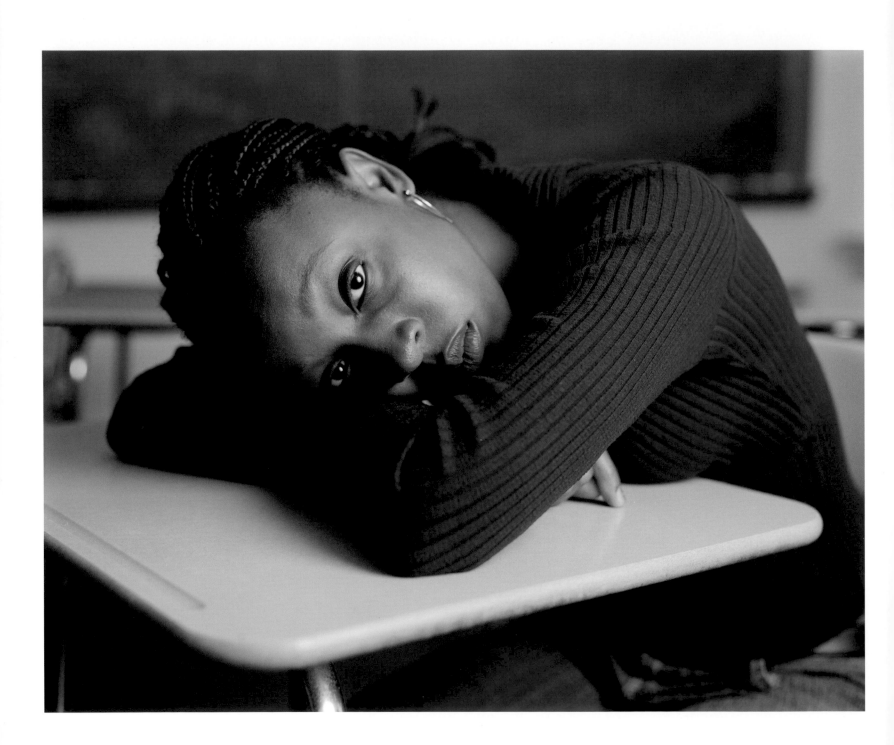

MGBECHI

Looking at me, it is obvious that I am a young African-American woman. Some
may see pride behind the firm position of my lips, others may see that I am a
person who is always looking, looking deep into another's face, another's actions,
always analyzing, thinking, interpreting. Some may even say I'm twelve, fourteen.
But nothing, nothing in the world would make me happier than to have someone
say to me, at first glance, "You must be from Nigeria, an Igbo gal, an Ngwa gal."
I would wish that a person could tell that from the very first glance, could see
in my initial "nice to meet you" smile that in my heart of hearts, in my wildest
fancies, I am a dancer. This is my identity, it is who I am, what I wish to be, what
I love to do. And so, when I become the neurologist, psychologist, philosopher,
novelist of my dreams, I know I will always see the things deep inside me that
make every success shine brighter, I will see the fountain of beauty that streams
behind my every smile, my source of strength, my motivation, my happiness.
I thank my parents, my family, my true homeland, for shaping who I am today;
I love to dance, I am an Ngwa gal, I am Mgbechi.

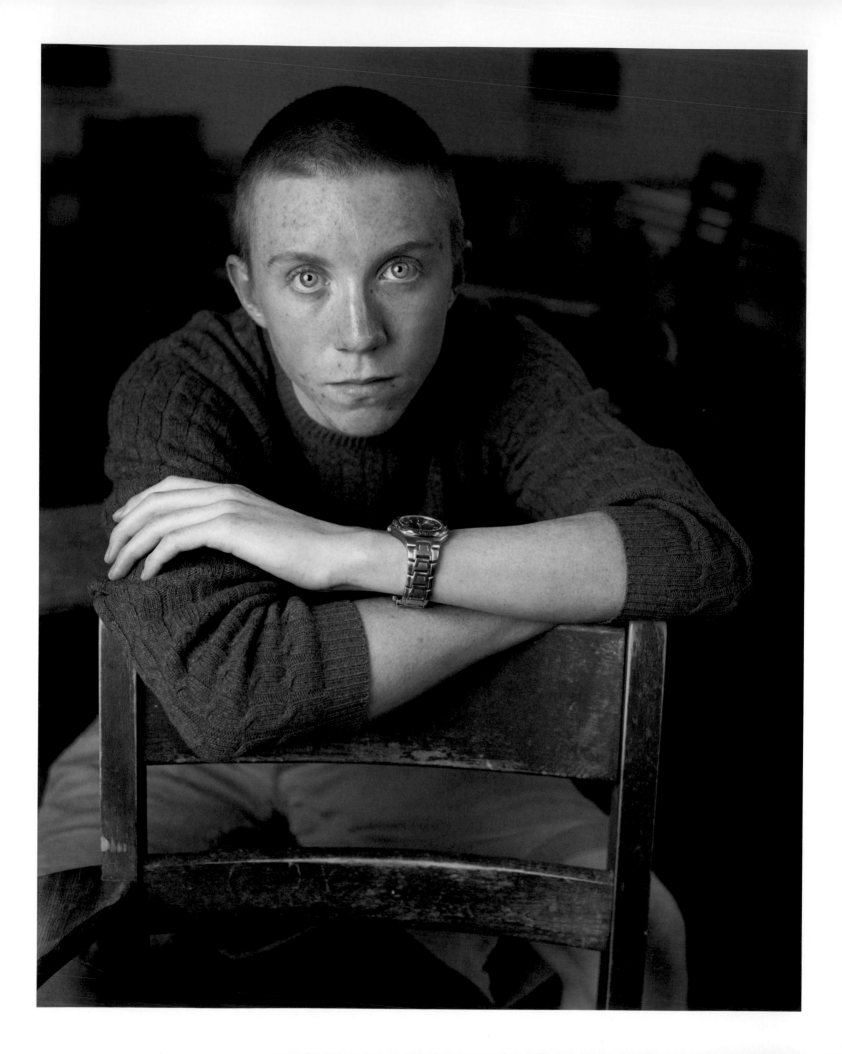

CHARLES

There are a lot of things I don't do or say. I think I have an especially acute sense of self-awareness and ability to control my behavior. I think about everything I do. I weigh the consequences and the necessity, and lots of times I just decide to keep things to myself. I try to be conscientious. One time in the seventh grade a kid hit me, but I didn't fight back. I could have easily, but I tried to do the right thing by leaving. Some kids probably thought I was a wuss. I guess you can't have everyone like you. I kind of see that as a defining moment, I guess. I'm generally kind, and I don't like being pushy or competitive, but I think that doesn't get you far, especially at a school like Andover. You succeed by doing better than the people around you, by making sure they don't. There are no prizes for letting other people win, but maybe success just isn't worth it.

SAHENDY

I came from the Dominican Republic when I was going to eighth grade in the year 2001. That was the first time I even visited the United States. I always wanted to go to New York City, and when I came to the country I first bended steps in New York City. I was eager to learn English because I wanted to communicate with family members that were born here and I knew that was my first step to be successful in this new country. I went to the Bruce School, where I met my best friend, Michael. I had my arguments with many people because I was the new girl in the block. I always knew I came here to better myself and to be someone and be a better citizen for my community. I started to develop lots of passion for writing and reading, frequently told my friends to read out loud for me. I decided that the word *immigrant* would apply for me or a person that came from another country eager to fight for my dreams. I had moments where a family of four was living in a studio for two. My attitude and good treatment helped me to gain a lot of friends. I have a strong personality, but I'm very confident and most of the time I get what I want. I'm still trying to succeed in this life, but I constantly ask my friends, "If I am doing it, why can't you?"

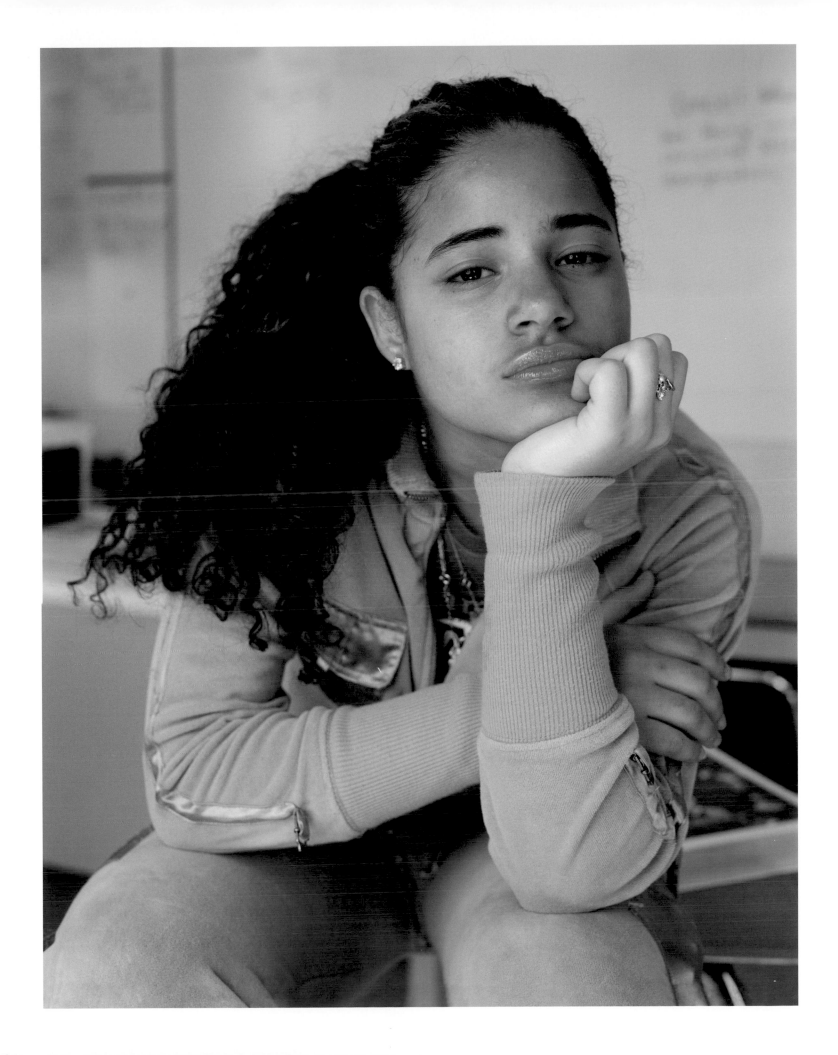

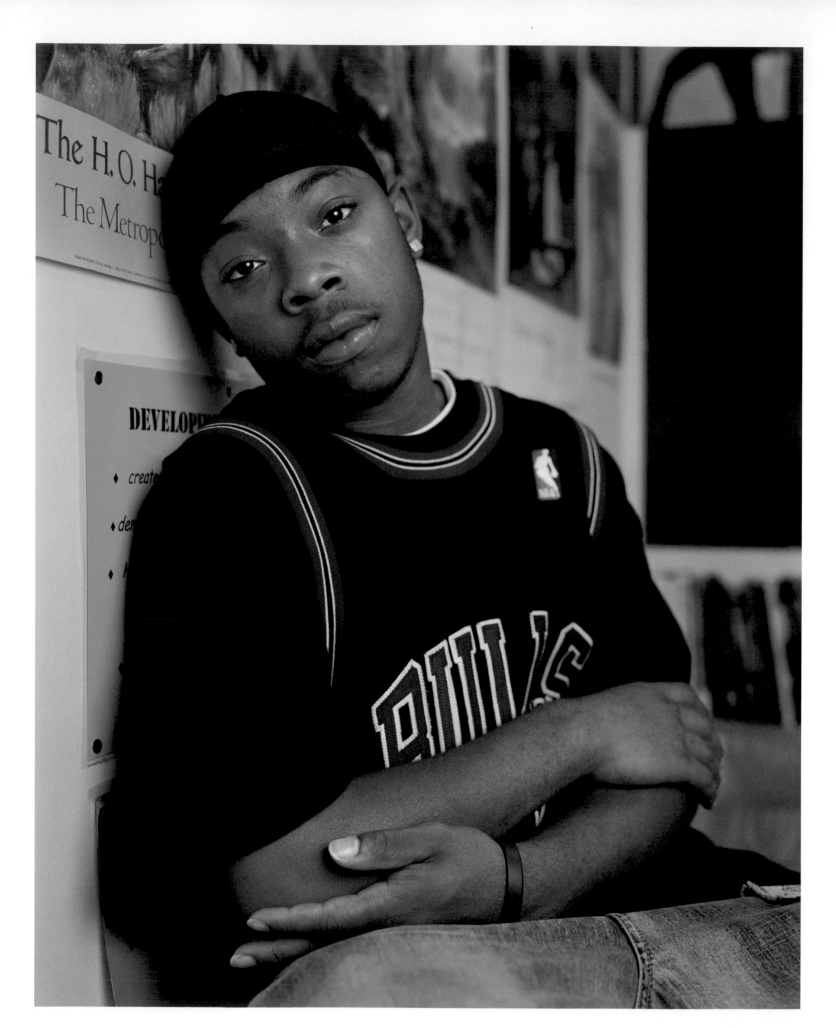

ANTOINE

When I was seven years old my father went to jail, and that left me just with a mother, so she had to play both roles as a mother and father. That only made her stronger. That was kind of a challenge for me, because I had to decide whether or not I wanted to go further than my father. That drove me to become successful. That's when I got into comedy, and I would watch *Saturday Night Live.* I started watching a lot of movies, and that made me want to get into theater. That's what I want to do now.

SIMONE

I've always been, like, the minority at my school so it doesn't bother me, unless it becomes an issue with other people, then it bothers me. I guess some people assume that I'm different when I'm not necessarily, because usually I'm the only white person in the class and I guess they think that I don't wanna talk to them or something, but . . . I'm sort of quiet in class. They assume that maybe I have something against *them*, but they really don't have any reason to think that. I don't know, they ask me if I would ever, like, be friends with black people and I'm like, I *have* black friends. You just don't *know* who I'm friends with and . . . People have asked me if I would ever date black people and stuff like that. I said that, yeah, I would and I *have* dated black people and I *have* plenty of black friends. Not only am I, like, one out of very few white people with blacks, but I'm also not exactly too wealthy.

So, like, I don't know, that's affected me a lot when it comes to, like, being able to do things, like, there was one thing I wanted to do. It was a paleontology thing over the summer. It was with the University of Chicago. I don't know where they went, but they went, they went away for like a month, and it sounded really cool. And it was for minorities *only*, yet, I felt that I was a minority. So I was upset. I said I was going to apply anyways, but . . . I didn't.

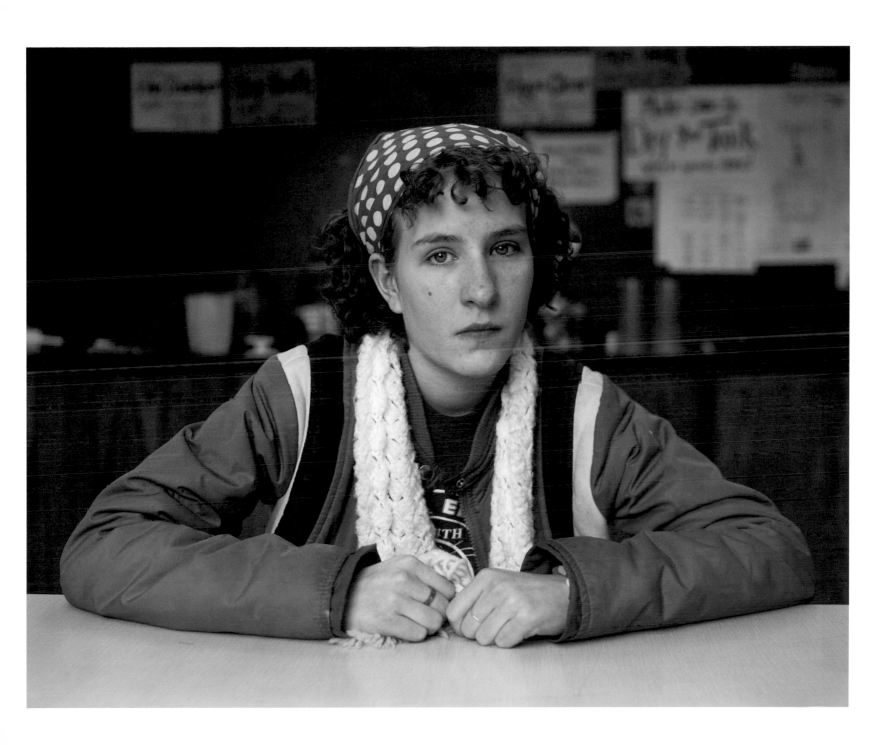

CATHERINE

I'm full of stories. Not that I'm a liar, but it's just that when I meet people for the first time I like them to get to know me. One way to get to know me is by my stories. The way I just present myself to people, I always have people laugh at me, and it's because I'm sort of a goofball. My best friends Angie and Gloria are the ones who can really tell you, because with both of them, I'm this spontaneous girl, but also someone that you can talk serious with. Even through hard times, we always find a way to laugh.

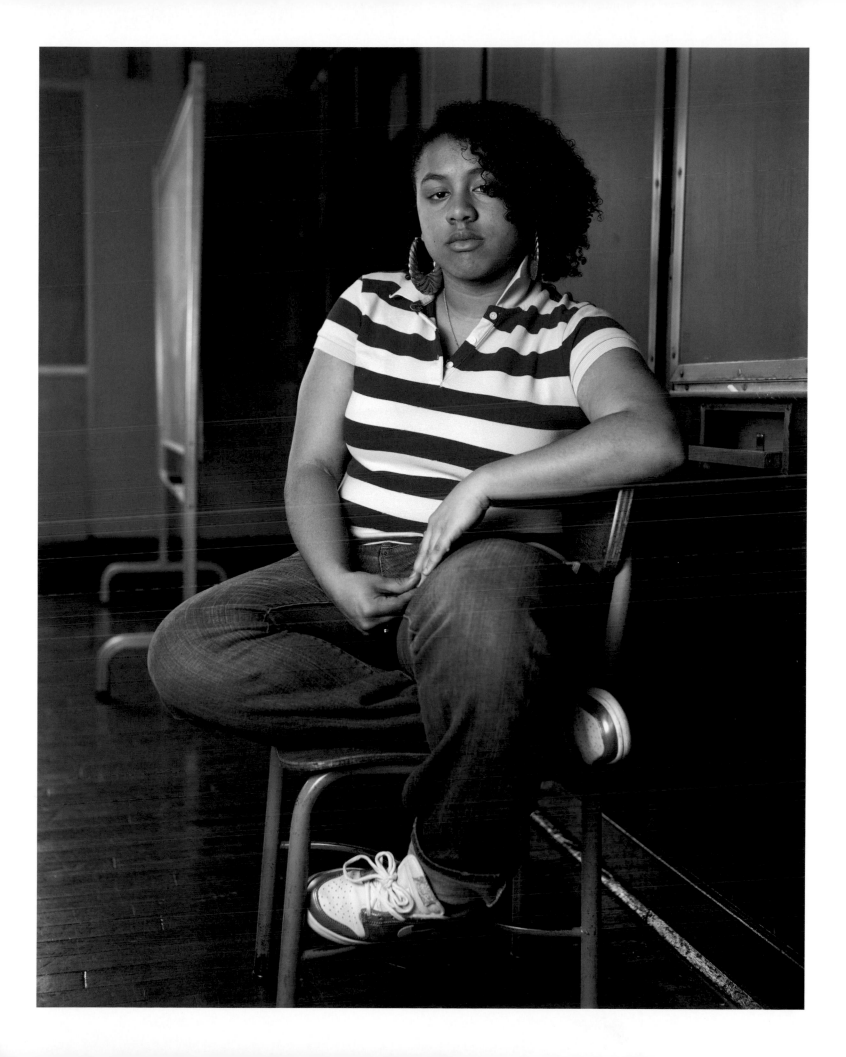

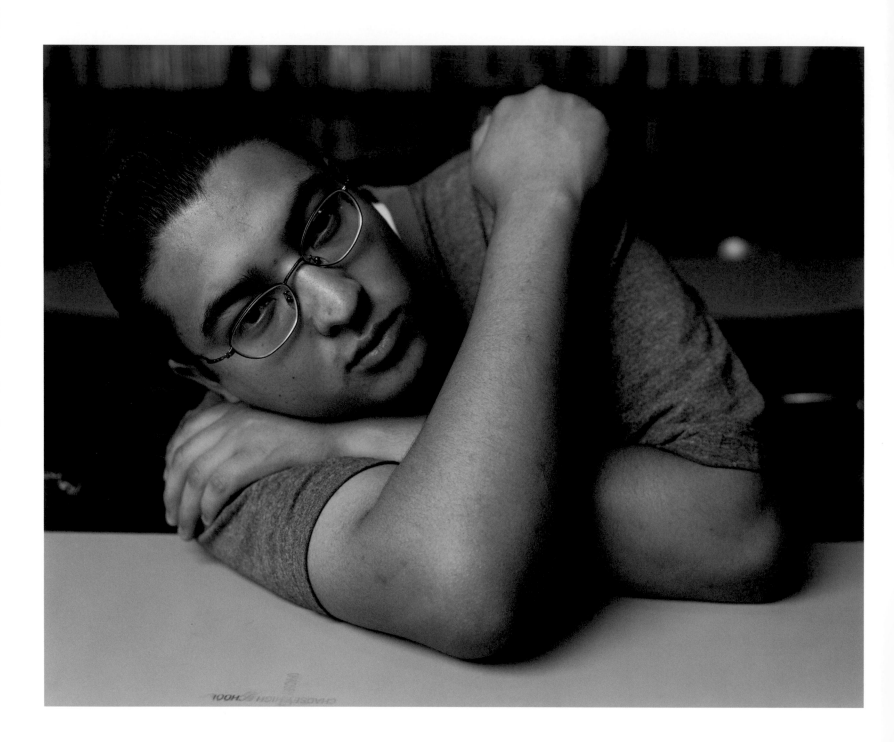

AURELIANO

Until I was about six years old, I lived in Mexico. I lived in a small town where everyone knows you, and where you can walk around without being scared of people. I played with my friends mostly all day. We played soccer. We also climbed trees. During the rainy season, we played in the creeks and rivers. In the creek, we made dams out of mud, leaves, and rocks. I did not know how to swim so I didn't get in the river. I still don't know how to swim, and I'm eighteen years old. I just played on the banks of the river. I sat there playing with mud. I didn't care that I did not know how to swim, and I still don't care. I had fun on the banks of the river.

SHALANTA

People around me have to be positive, and like to be around me. All of my friends would describe me as crazy but intelligent. Most people are intimidated by my look, but later get to see that I am a loving, fun-going person. I love children, and would someday like some of my own. When I grow up, I want to be a pediatrician, and later own my own day care. To get there I have to keep a focused mind and stay on the path that I am on now. It won't be hard, because success is where I am headed.

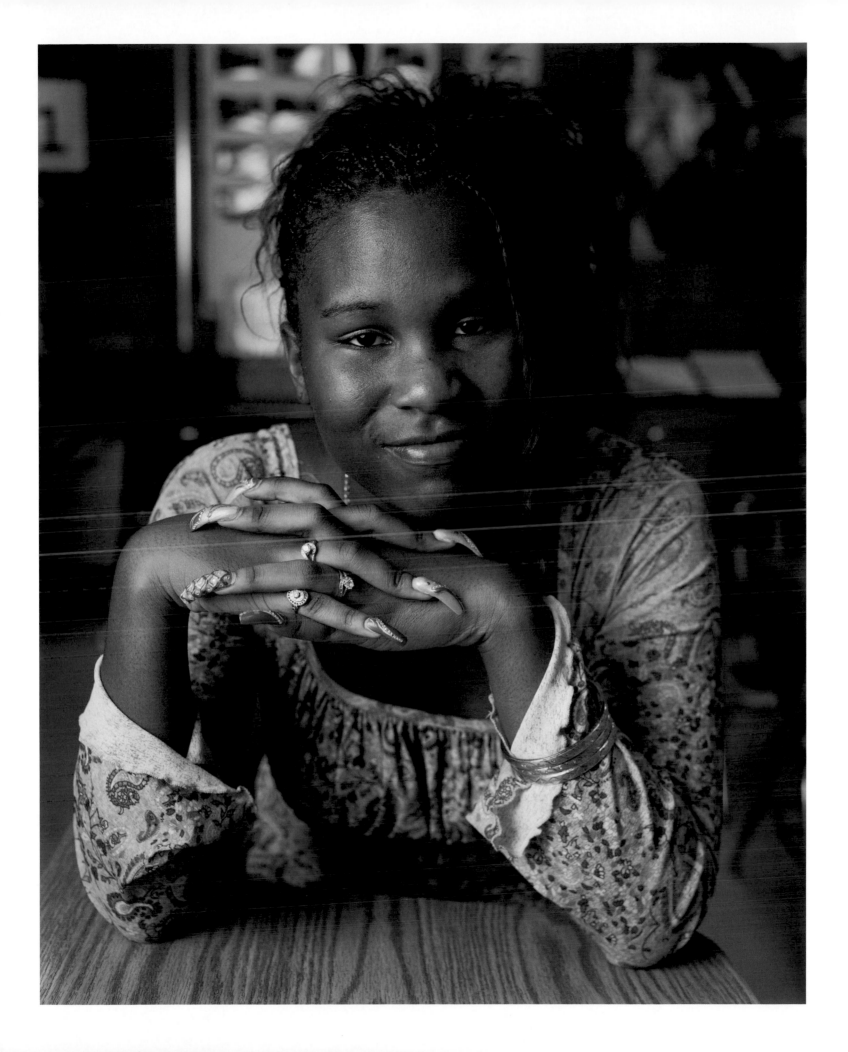

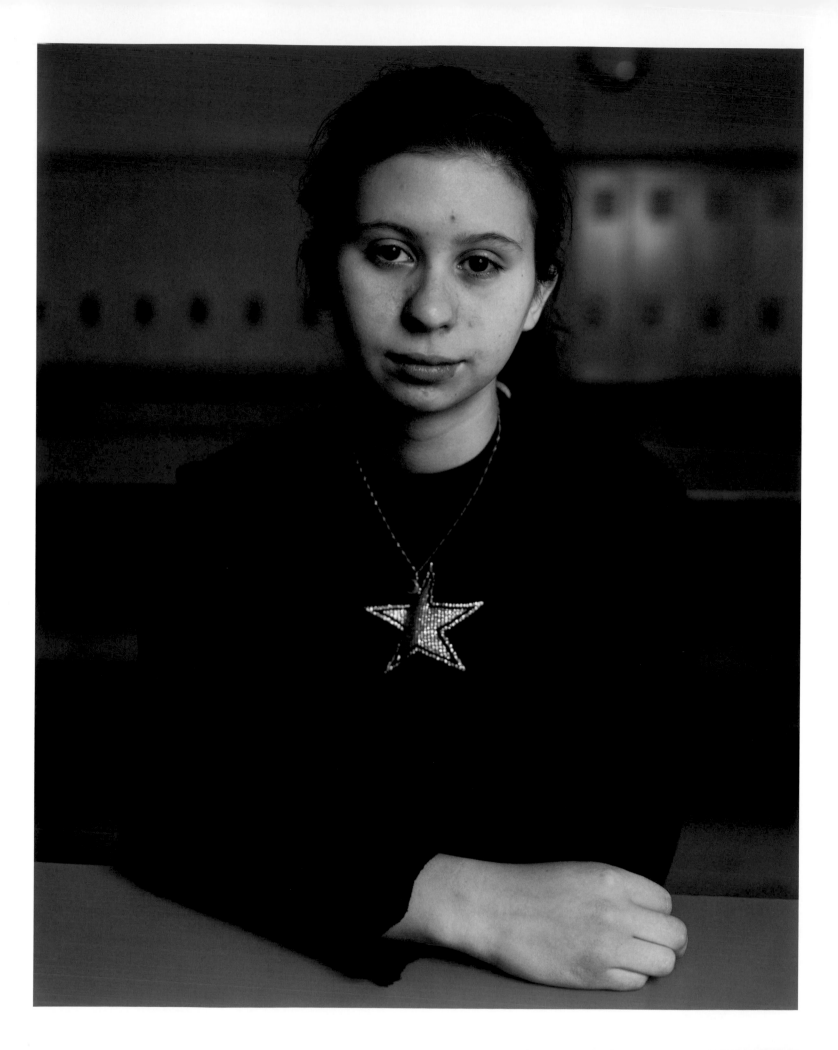

SARAH

My dad's Iranian, and so, my dad didn't want to have me tell that I was Iranian in my college essay just because I think he might have felt that someone might read it and, you know, be biased against Iranians or something like that, I guess. He's a little sensitive about it sometimes, so, just because I'm his little girl and he doesn't want me to be hurt by anything. I didn't know whether or not to put it in 'cause, you know, when he first told me *not* to tell, it was sort of like, of course I'm going to tell! It's part of who I am! And then it's sort of, well, you know, *maybe*, I shouldn't. And then, I just ended up saying that he was foreign-born, "my father is foreign-born," or something like that. Like I'm not going to hide it from the world; it was just this college essay. I mean I wasn't *happy* about it at first, but then when I saw it from his point of view, I was like, okay.

ZIARRA

When a person sees me for the first time, they will notice that I am very creative fashion-wise and personality-wise. I seem girly (which I am), but little do people know I also do "guy" things like skateboard and aggressive in-line. Even though I'm a talkative person, I do take time to listen to others. I am known to give great advice and I always look at the bigger picture and think critically toward every situation. Because of that I think psychology would be a great field for me in the future. When people first see me they think I'm very quiet and sometimes a little intimidating because I look serious (because I think a lot), but once I get to know people, I can be a lot of fun. My bubbly attitude wins people over.

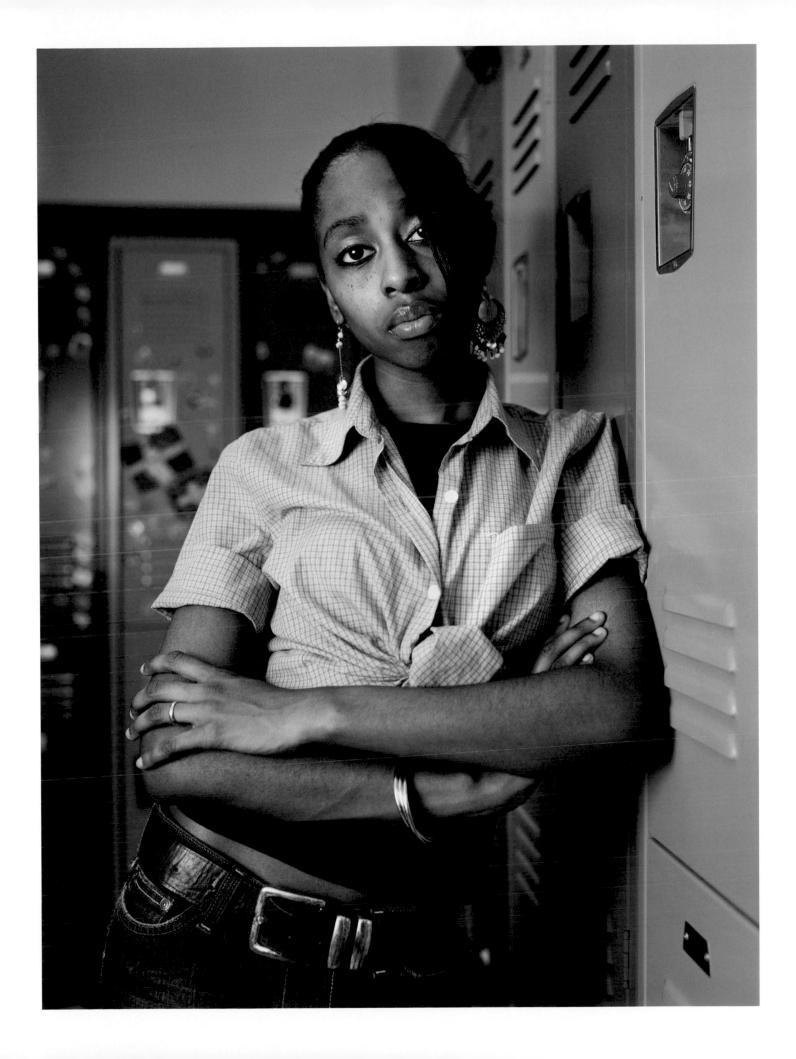

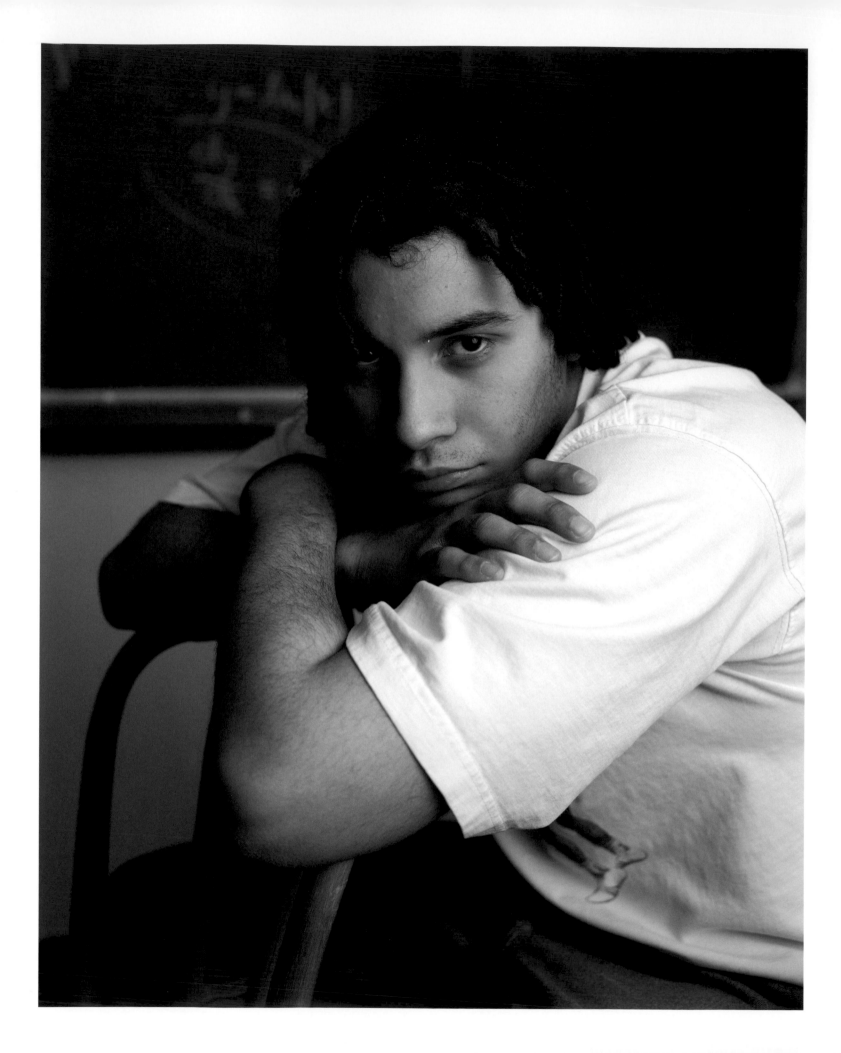

ALEJANDRO

I am an only child. This fact about me has probably had more to do with who I am as a person than any other. As an only child, especially of divorced parents, I never really had a sense of immediate family, although I've always cherished the love of my many friends before, but I've never had a best friend, and I think emotional connections between two people are better than having several acquaintances, and I can't assert from experience but I've heard dozens of times that there is no bond stronger than that between siblings. I'm jealous of anyone with a brother or sister.

NOHELY

I wonder . . . I wonder. This is what my brain is telling me. Sometimes I think
I talk too much. Then I realize I'm just talking to myself. You're smart . . .
My mom never tells me that, but my teachers and her friends do. Once I fell,
I think I landed on my face. My mom has my face, or I have hers. Though I like
to think I had it first, she always reminds me that she is older. I know, though,
that I had it first because my grandfather had it before any of us and he gave it
to me. I wonder if they leave the thin brown skin on the M&Ms. I love chocolate.
Sometimes I wish it loved me so that it would pay me to buy it and eat it. I like
the special black and white M&Ms. My nails are black. James took a picture of
them once when they were chipped. I love to paint. I love to draw and write and
paint. Sometimes people confuse me.

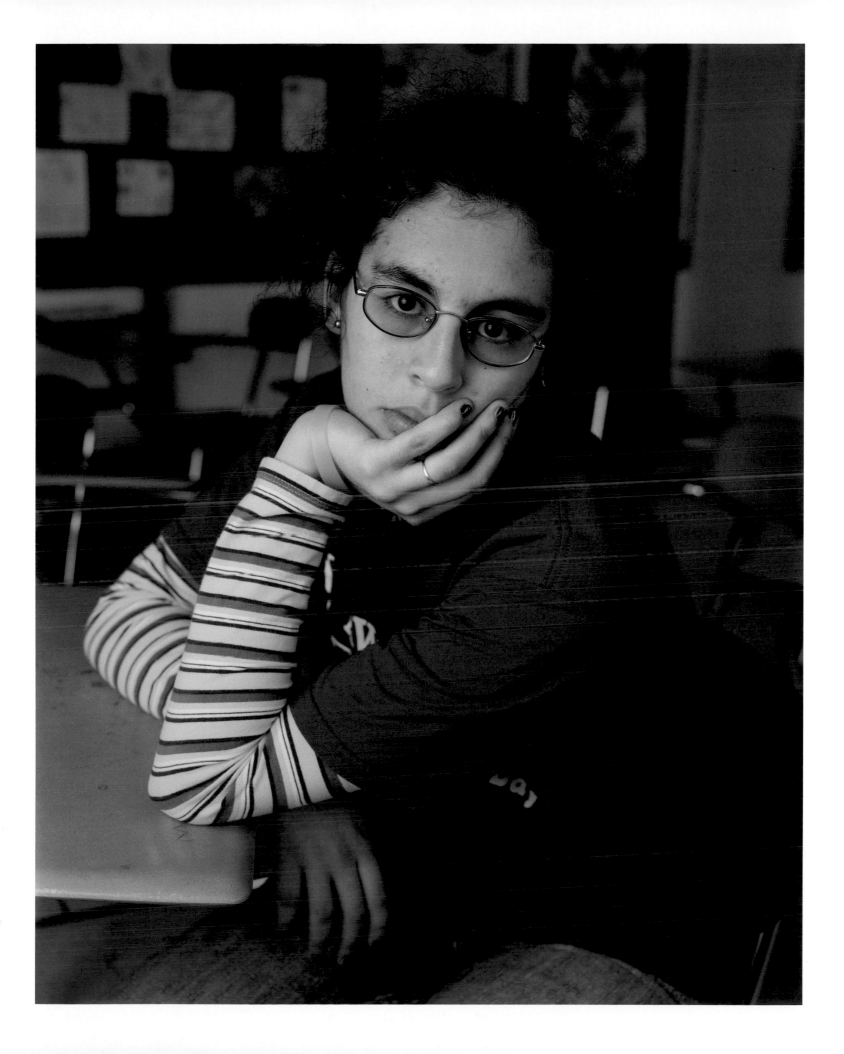

TERRANCE

One thing people do not know about me is that I am a "momma's boy." My mom is my best friend, a person I know I can trust till the day's end. When people get to know me they always perceive me as "the strong silent" type, as one of my friends put it. But I love my family and friends more than anything else imaginable. We are really close with each other; that's why it was such a big deal for me to go away to boarding school. I was homesick for the longest time. But now that I am going to college back in the South, I will be closer to my family and friends. I believe having a support group as knowledgeable as mine (family and friends), my transition from being a young boy to a man was so much easier, especially being a black male. So I know when people first meet me, or even the people that say they know, don't think of this when they see me.

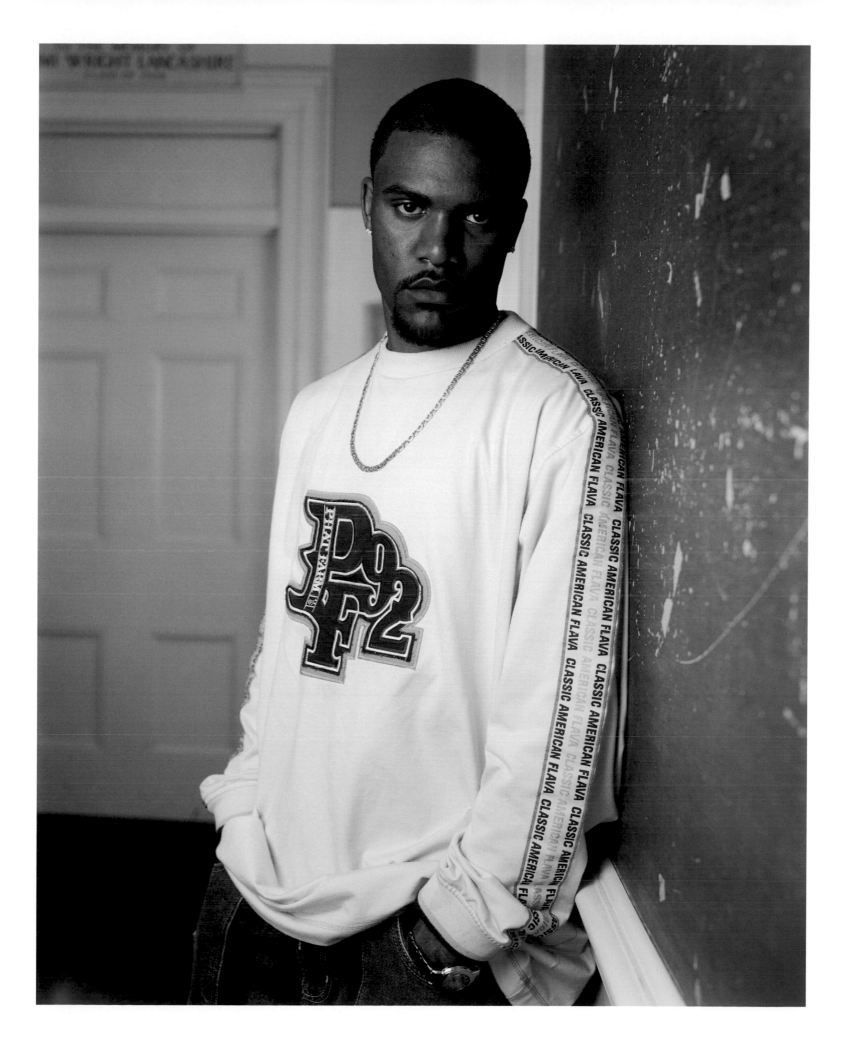

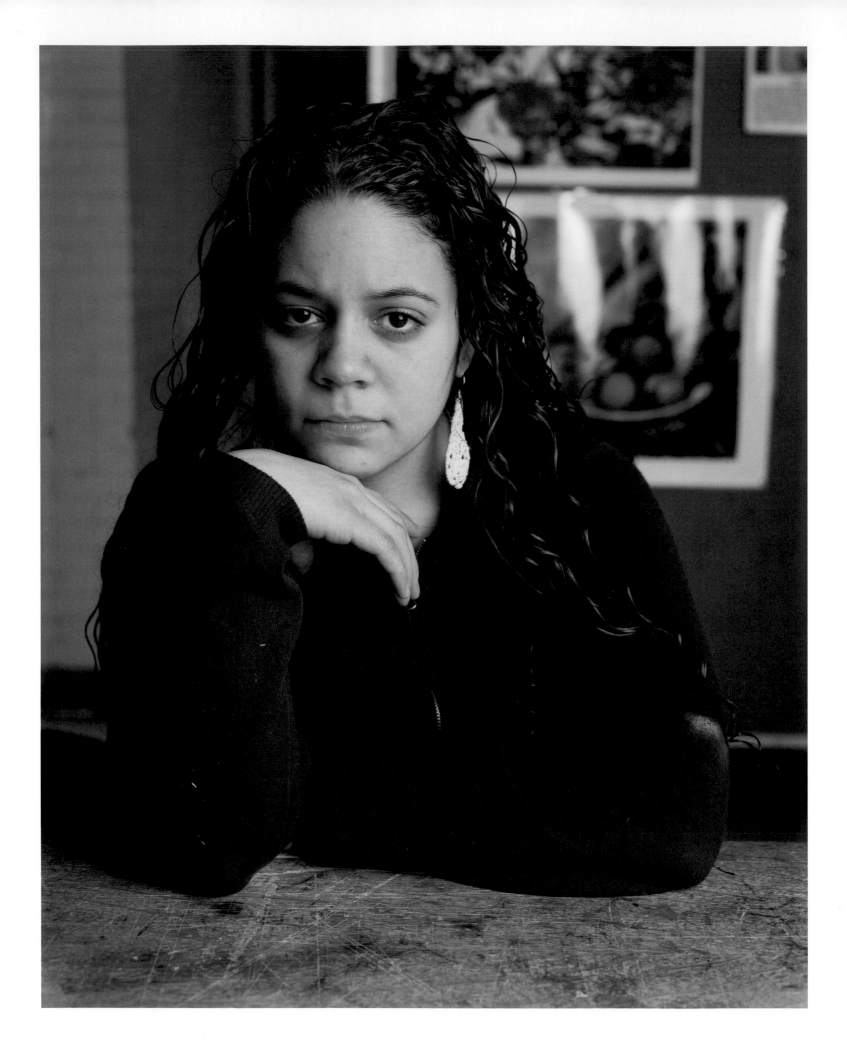

KENDRA

I once heard someone say, "Our darkest moments are the turning points in our lives." This was my reality when my grandmother died of liver cancer in 1997. I was nine years old and admired everything about my artistic, wise, and beautiful "Abuela." At age fifty-one, the mighty woman of my childhood defenselessly fell victim to a disease she didn't know she had. My world turned black like the midnight hour. When her body was cremated, somewhere between the depths of the furnace and reality, a piece of my soul was consumed, incinerated to ashes and buried, forever lost.

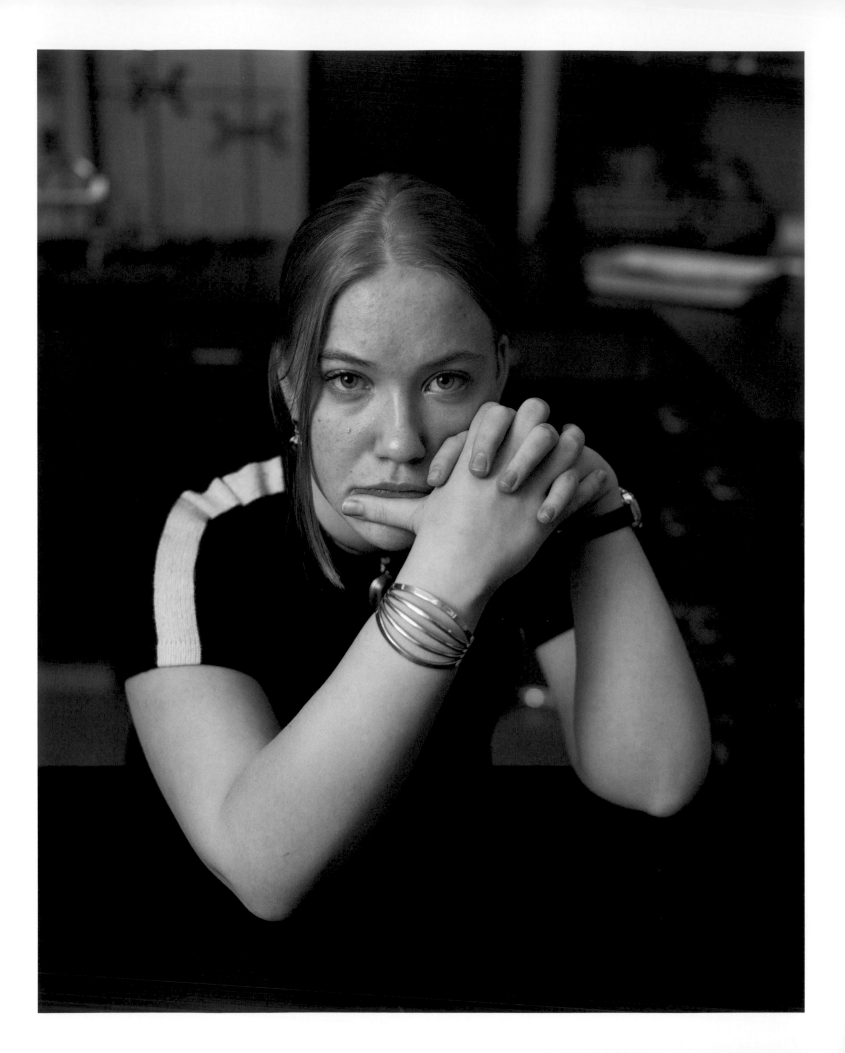

JULIA

There was a period of time where I was like, really, really depressed and that was
in eighth grade, and during that time I'd been missing steadily one day a week
of school because I just couldn't get out of bed. Like, I remember, Mondays and
Wednesdays were the worst. Mondays because it was the beginning of the week
and you had the whole week in front of you, and Wednesdays because it was still
going, it hadn't ended yet. But, so, by the time I got to spring break and we had
nothing to do, I had no real reason to get out of bed. And . . . my mom was really
scared, 'cause my sister had finally gone into the hospital for bulimia. And . . . she
was more worried about me than she was worried about my sister just 'cause I
seemed so deranged. I couldn't think in big words. I couldn't really think; my mind
was just dead. That was right after I hadn't told anybody for three months that
my sister was throwing up, and I kind of imploded. I mean, that was kind of like
our relationship—Laura would tell me something and then I couldn't tell anybody
else. I used to feel like I was her, like her human diary, and it was a nice feeling,
I felt really important to her. And I think I *was* in many ways, I just don't think
she really appreciated me that much.

BARRET

I was born in Africa. Sixteen days after I was born, me and my family moved to America, living in Queens in New York. It was nice, but the weather here didn't get along with me. My body would get a rash, and my family had to take me to the doctor. They tried all kinds of medication, but nothing really worked. It was hard for my mom and father because I would cry almost the whole night. In 1991, my parents decided to move back to Africa because of how the weather didn't go with me and other problems. So we moved to Africa. Life was good, and as I grew up things kept getting better. So then, when I was older, we moved back here, and the weather goes with me, kind of. I wish I never had health problems.

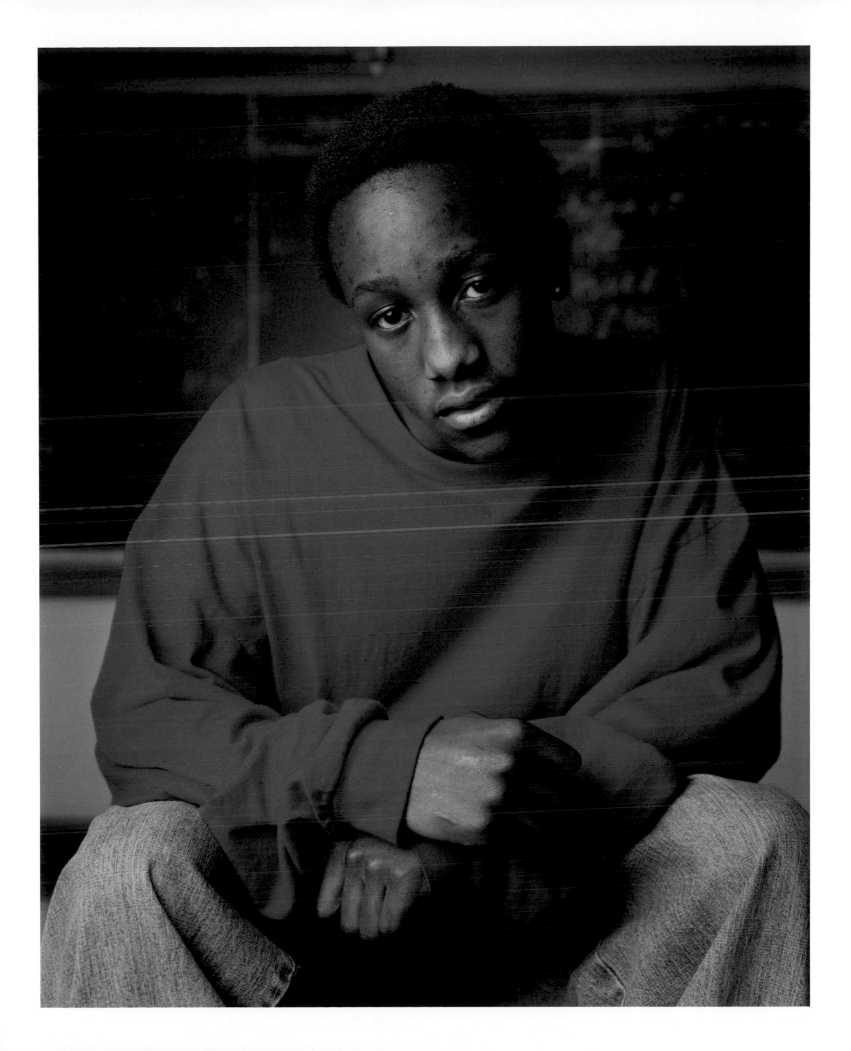

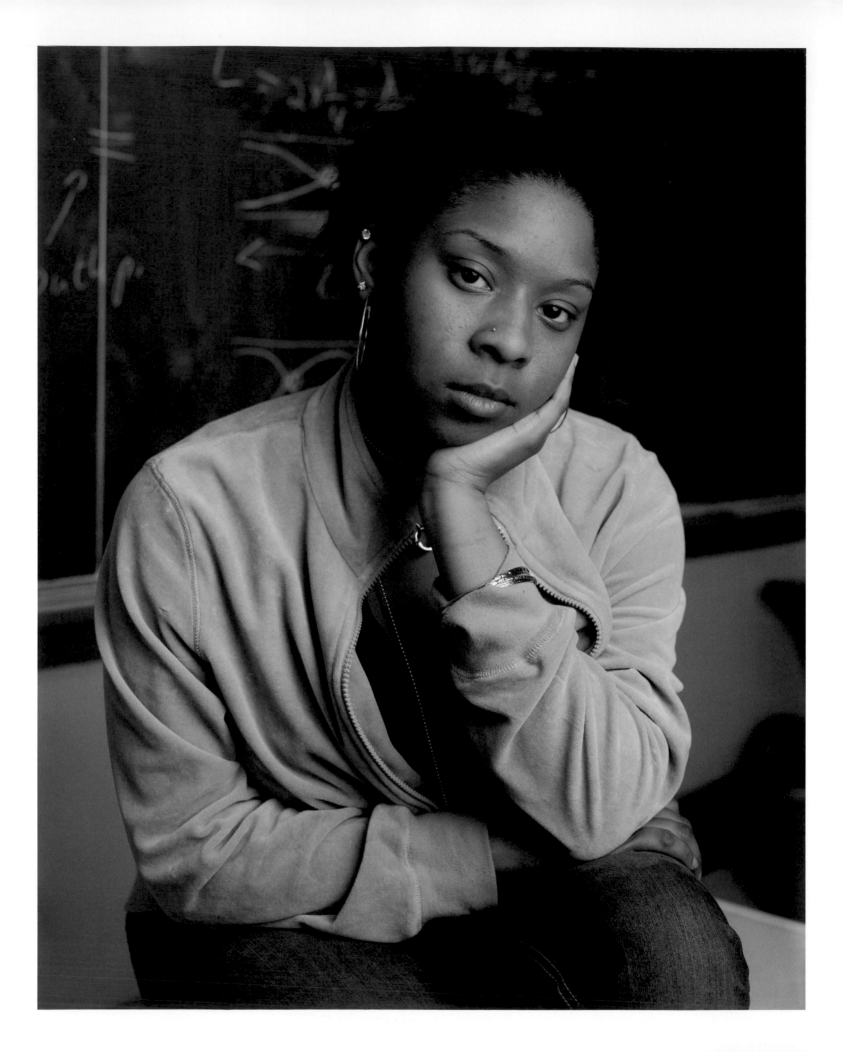

MARIA

I'm not mad or angry, this is just my face. I'm very friendly and don't have an attitude unless you give me a reason to have one. I'm not liked by many people, but the few who do know, those are what you call friends. I don't have any enemies and I don't hate anyone, this is just my face. It is not hard to make friends around, or to trust anyone, but the ones you do make friends with, you stick with. This isn't a bad school but a bad city, and people don't throw respect around, so you basically have to do this for yourself. I have dreams for this city, who knows if they might come true. I had dreams of being a somebody, but as of right now, I'm going where life is taking me. To me, there is no point in planning your life or where you'll be after college. People have dreams and those dreams can be shattered at any point in time, even if you're a straight-A student. I don't know where I'll be a few years from now, but I hope music and photography have a big part in my life.

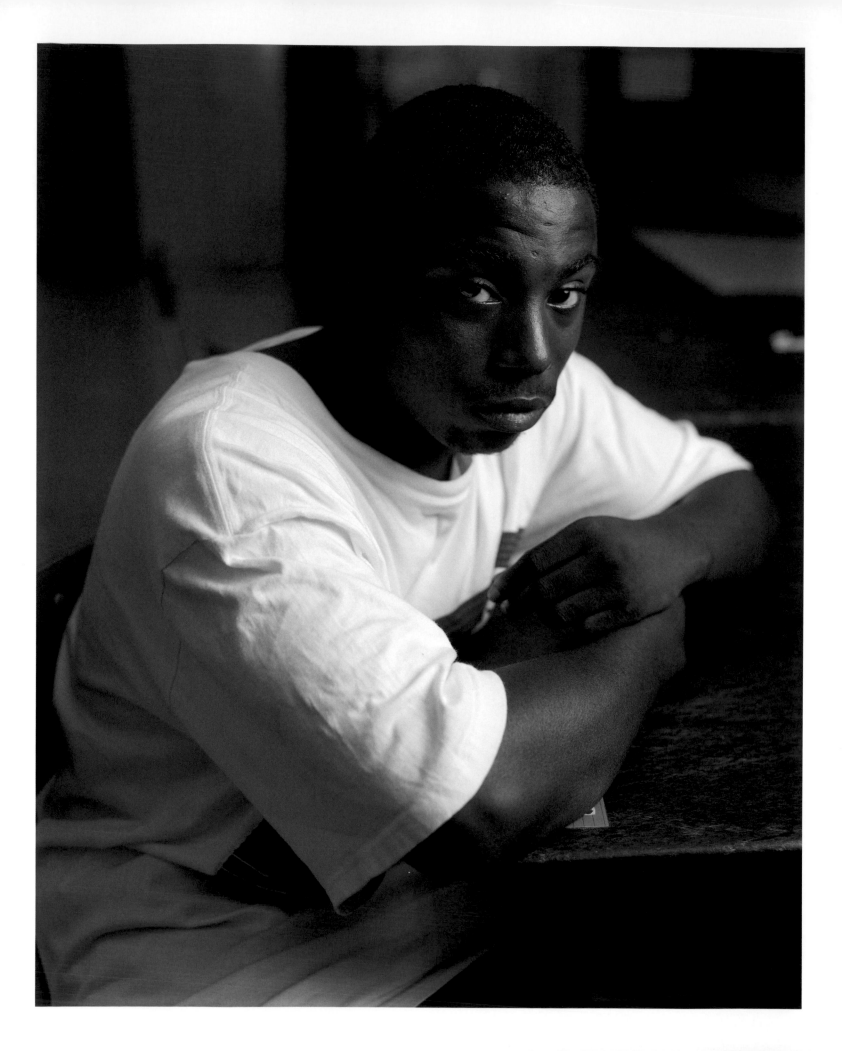

YAHMÁNEY

When I was in school I was acting like a fool. Half the time I was suspended.
Then when I finally realized that I needed to change was when I got to the
seventh grade. I noticed that if you act good, people treat you differently.
When I was acting bad, people just treated you like a minority. They treated
me like I just was nothing. I thought to myself, "Maybe if I change, people will
actually start treating me differently, treating me like I got sense." Then, after,
when I got into eighth grade, I received my first 3.0 grade point average, then
I knew if I could do that, I could do anything. Then when I came to high school,
I started off rocky. In the ninth grade I started off kinda bad because I couldn't
pass some of my classes. But I still passed though, and I ended that year off
with a 3.0. Up to my eleventh-grade year, and the middle of my tenth-grade year,
I had a 4.0, and I knew if I could do all this, I could do anything.

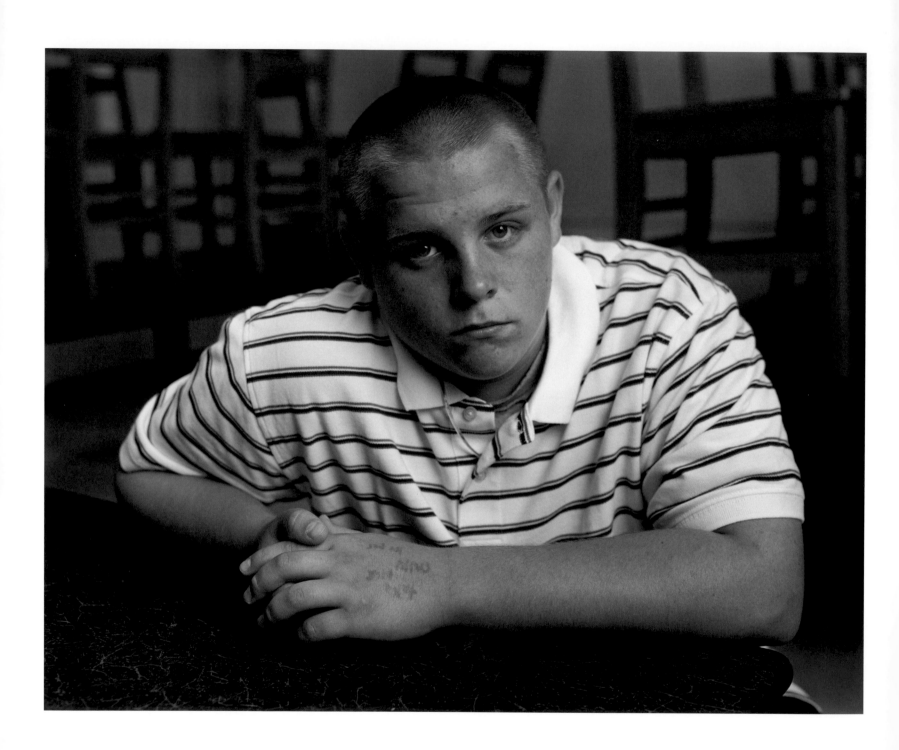

AUSTIN

What up? My name is Austin. I'm fifteen, and my birthday is in March. I like to play sports, but my favorite sport is basketball, and I play for a team. My favorite class in school is Science. I like to go out on Friday nights and chill. I usually go to the movies and to the bowling alley and other stuff.

CAROLYN

My dad had been sick for a very long time. He was diagnosed with Lou Gehrig's disease when I was in, maybe, eighth grade, so I was about thirteen, and, over a period of about three years, he just disintegrated into basically nothing. He couldn't walk or talk or move or swallow for that matter, and then when I was sixteen, my sophomore year of high school, he died.

You just don't know what to do. Because you're just sort of stuck there, like, "I can't do anything about what's happening right now," and it's very painful. Because you sort of forget that there's life beyond that and, especially, that there was life before that because there was a period of time where it was, like, the disease and, like, the whole thing is engulfed and your memories are engulfed with all that sadness. And you try to get beyond that, but it's so hard. You have to move on with life, as hard as it is, and once you reach a sort of period where you can, and you can be happy again, it is very rewarding to be able to do that and to be able to pull yourself up again, and to be stronger maybe, to be able to do that.

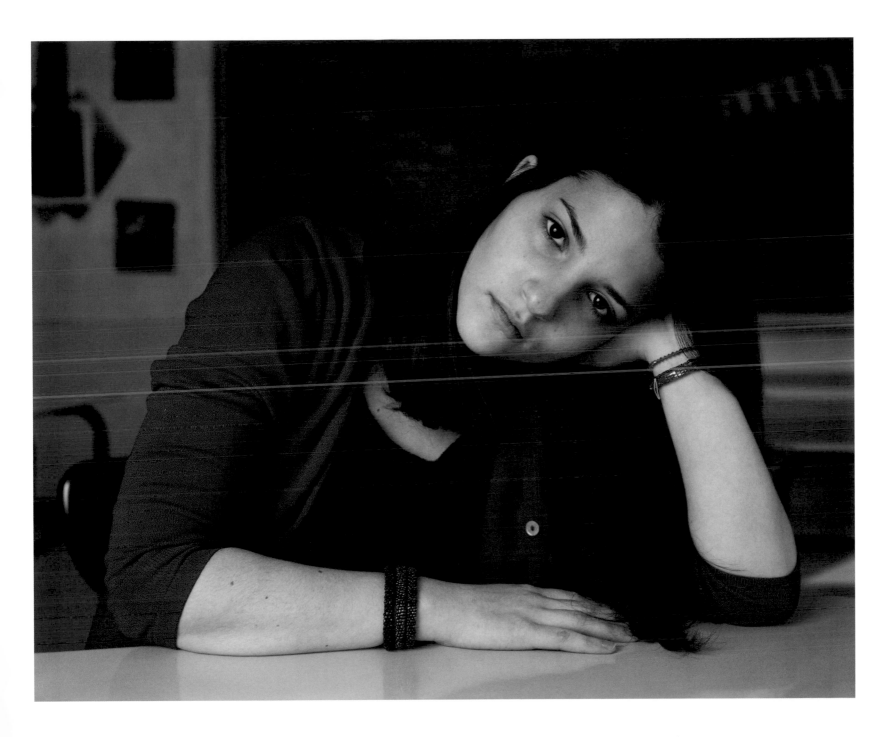

QUENTIN

I would say I am cool all-around, like, my personality. I'm very thoughtful.
My attitude is always laid-back. My social life is a little dull. That's because
I'm shy. I live with a single parent, and I'm the youngest of four kids.
I love my momma because she's never let me down once. We might not be
rich, but we aren't poor either.

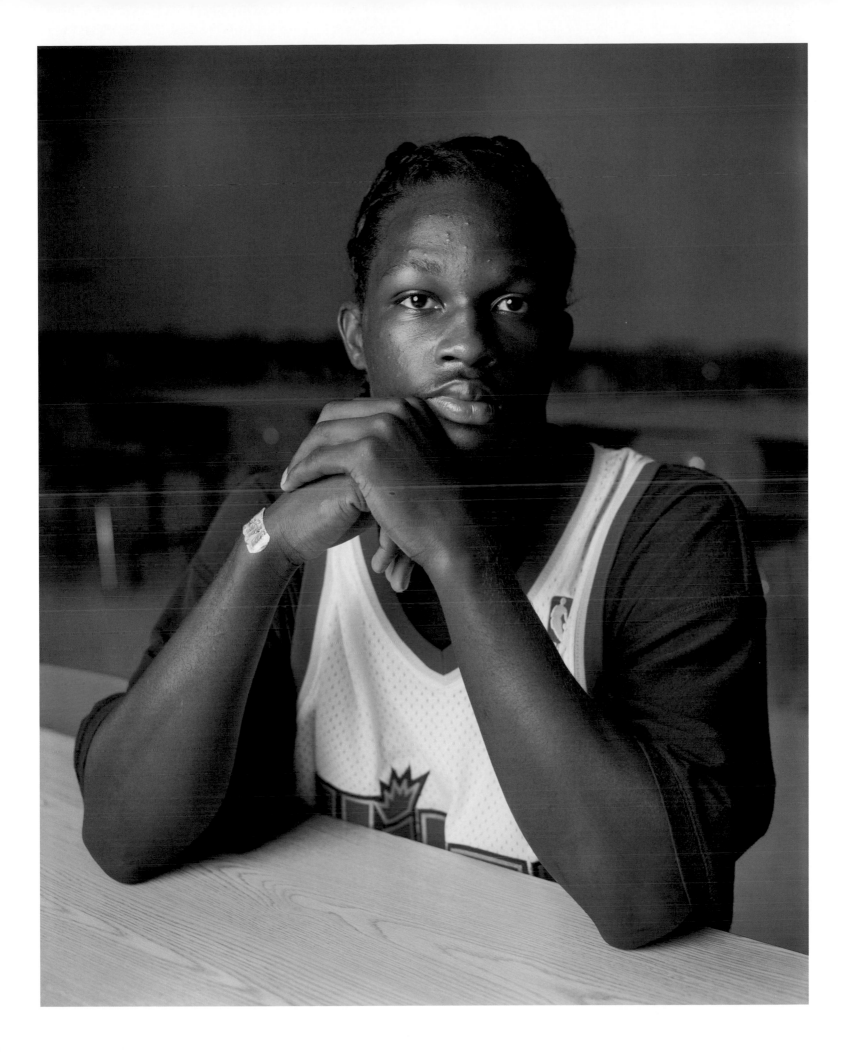

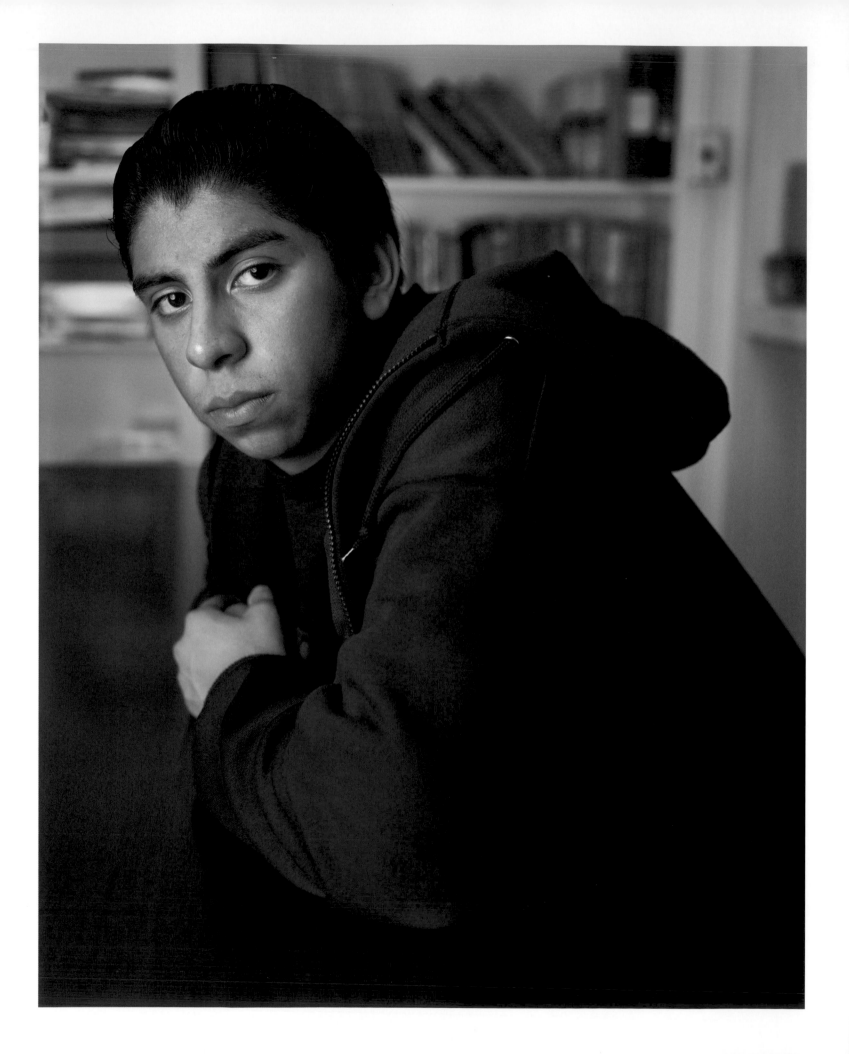

MARCO

My name's Marco, and I am Latino. I come from El Salvador, but have lived in
the Bay Area since I was little. I love to play soccer, and want to turn professional.
I hope to do something with my life someday and bring my family up.

SHAHEEDA

When I want to get away I can't. I can never get away because there's always this annoying crying voice every time I leave out the room. Sometimes when I want to get away from Chupa, I take him upstairs to his grandfather and I go play the Xbox. I play *Soul Caliber II* the most. It doesn't last for long because he sends Chupa right back to me. Sometimes I get away with my boyfriend Deon. We go to the movies or the mall to buy stuff or just to take a ride. I wish I had a babysitter twenty-four hours a day so I could just sleep and me and my boyfriend could go on a trip somewhere nice. I wish I could fly. If I could fly, I would fly to school and never be late. I would fly in the sky with the birds.

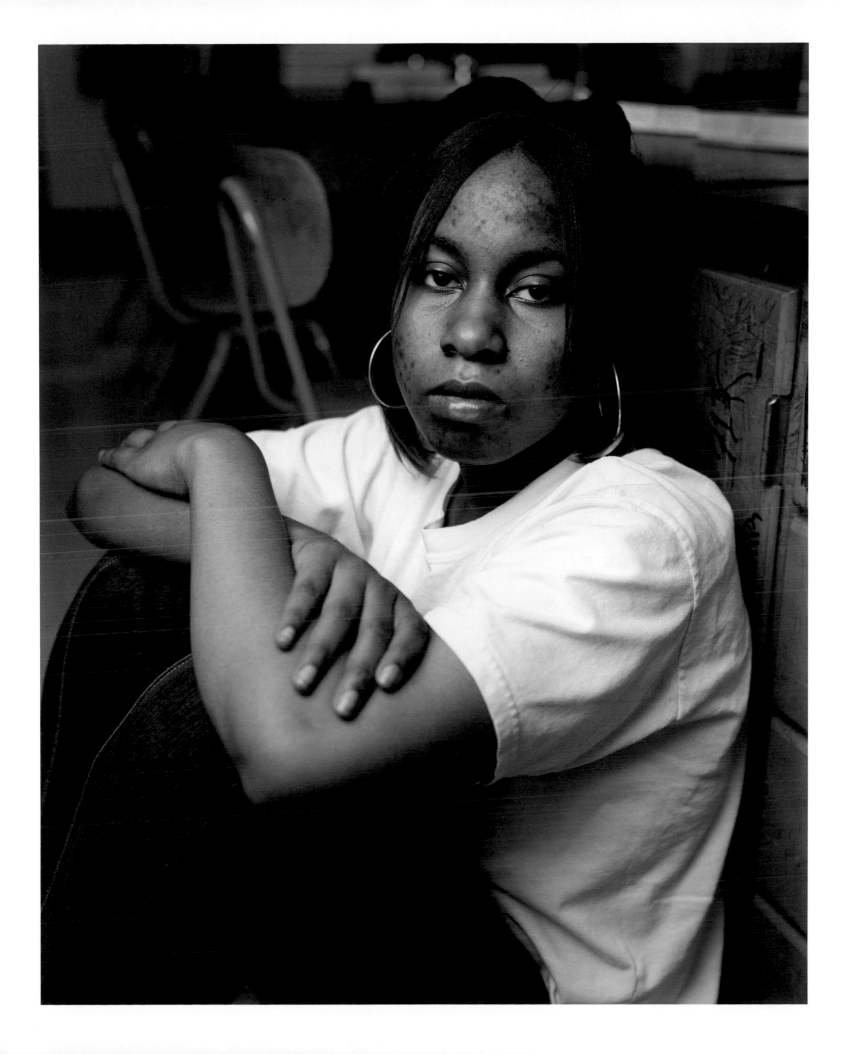

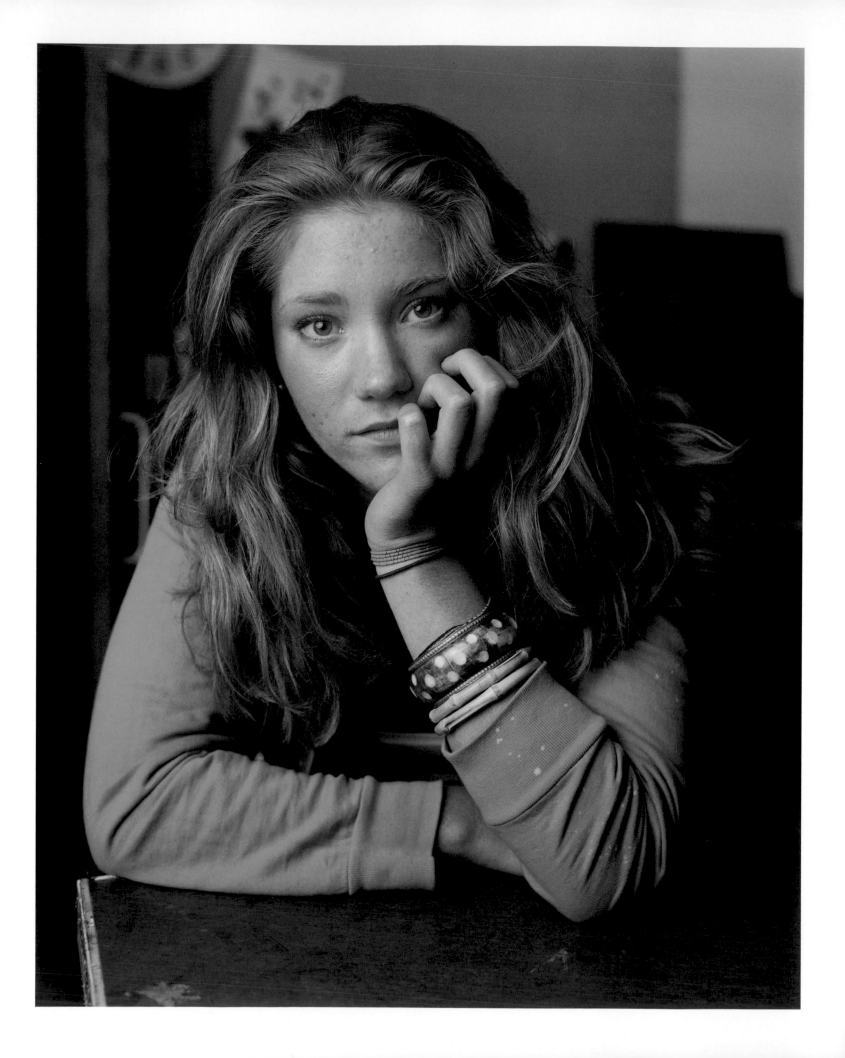

EMY

My mother's side of the family lives in Sweden. We usually spend summers there, on a small, very rural island in the Stockholm Archipelago. There are no roads, no cars, no flushing toilets. It's truly beautiful there though, I love it. I spend most of my time in the water, either fishing for dinner with my grandfather, sailing with my cousins, or shampooing my hair off the jagged, gray cliffs. The water is perfect there—it is cool, very cold actually, deep blue, and not too salty. That is why I appreciate spending summers on the island with my family. I have learned the ways of the water, and how to interact with nature peacefully and effectively.

I desperately want to make a difference, and save our planet before it's too late. I'm afraid that our society doesn't quite understand the significance of nature, that most people don't quite realize just how powerful it is. The destruction needs to stop, and I believe that it is my responsibility as an active, aware, and able young person to contribute to the environmentalist movement and fight for a change! I know my efforts would make my grandfather proud.

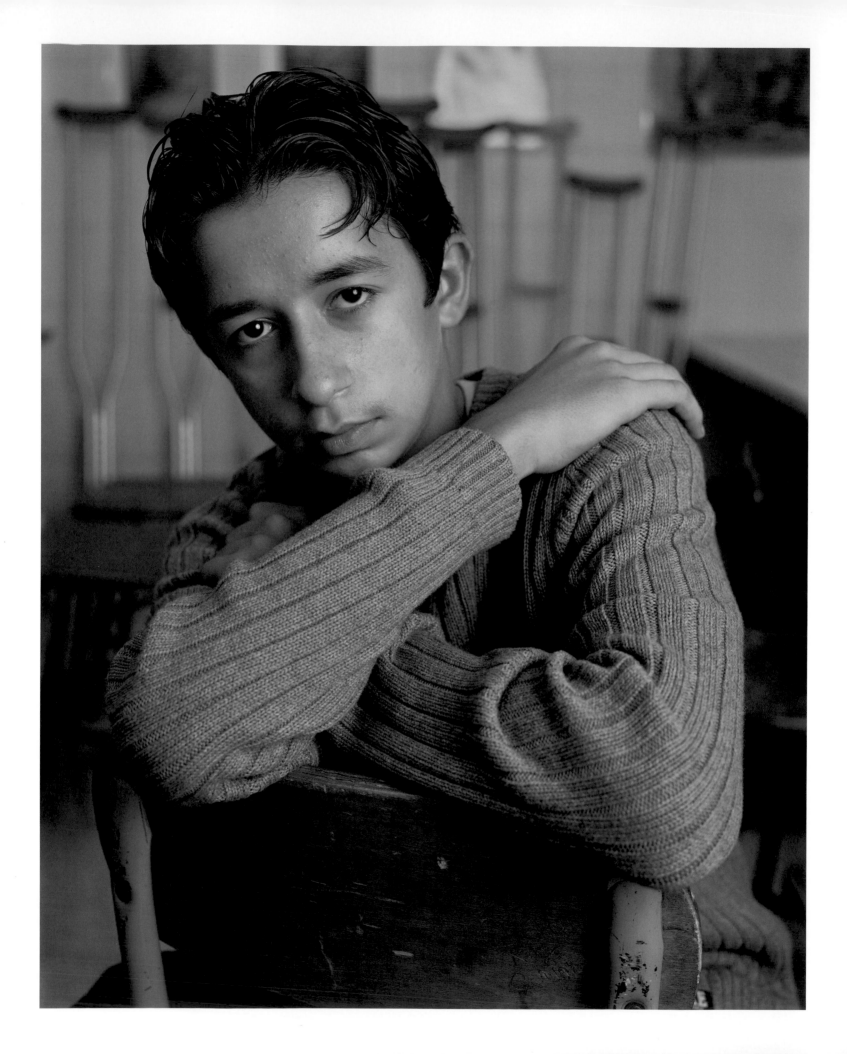

DAVID

I think that when I'm twenty-five years old, I'll be spending time with my wife, tuning cars, messing with electronics because I like electronics, and I'll probably be a designer, engineer, or technician.

The person I most resemble in my family would be my dad because he likes cars. I love cars. He likes airplanes; I'm kind of interested in airplanes. He likes electronics, and so do I.

COURTNEY

What can I say? I am shy. People look at me and think I'm an open book. I'm not. I'm not rude, I'm very nice. I don't want the world to know me. I wanna be unknown to the world, at least till I am twenty-three years old. I have a crazy set of nerves that will soon become my downfall. I am very emotional. Most people don't know that because I hide it very well. Oh, yeah . . . another thing most people don't know is that I used to be an only child for fourteen years. Now I have a baby sister, and we both have unisex names. Oh, yeah . . . I am very fun to be around and have very few friends because I trust very few people.

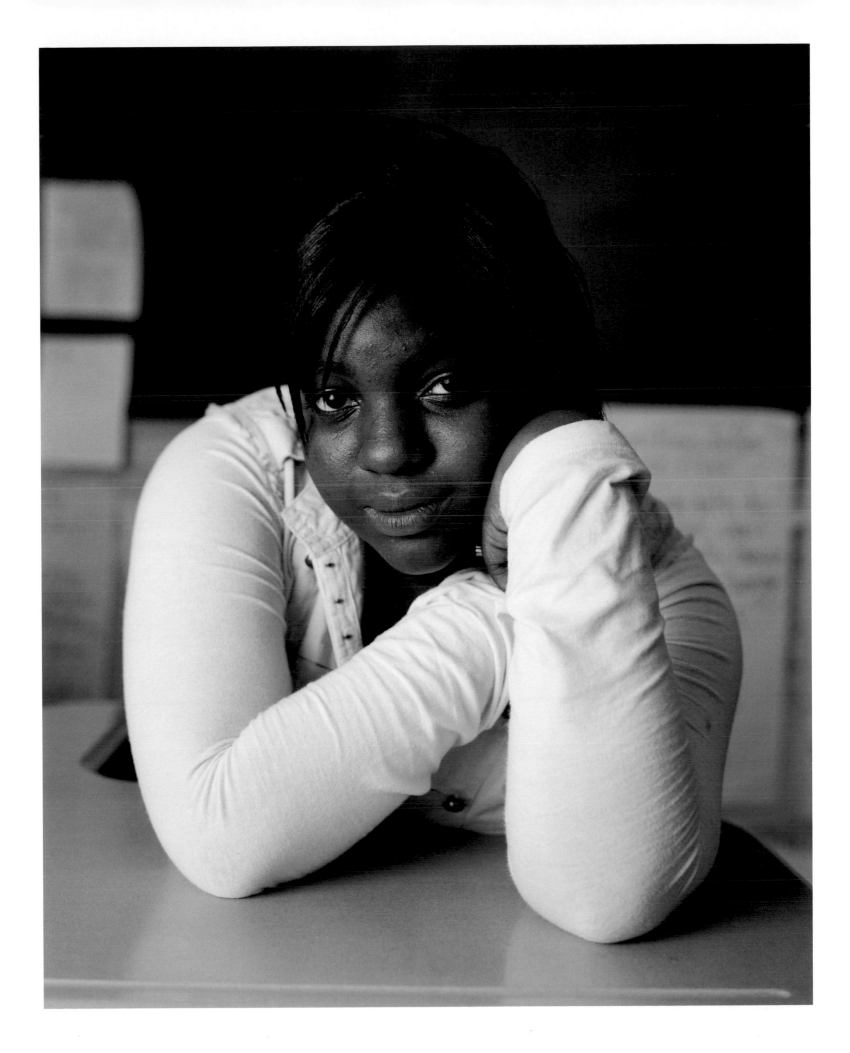

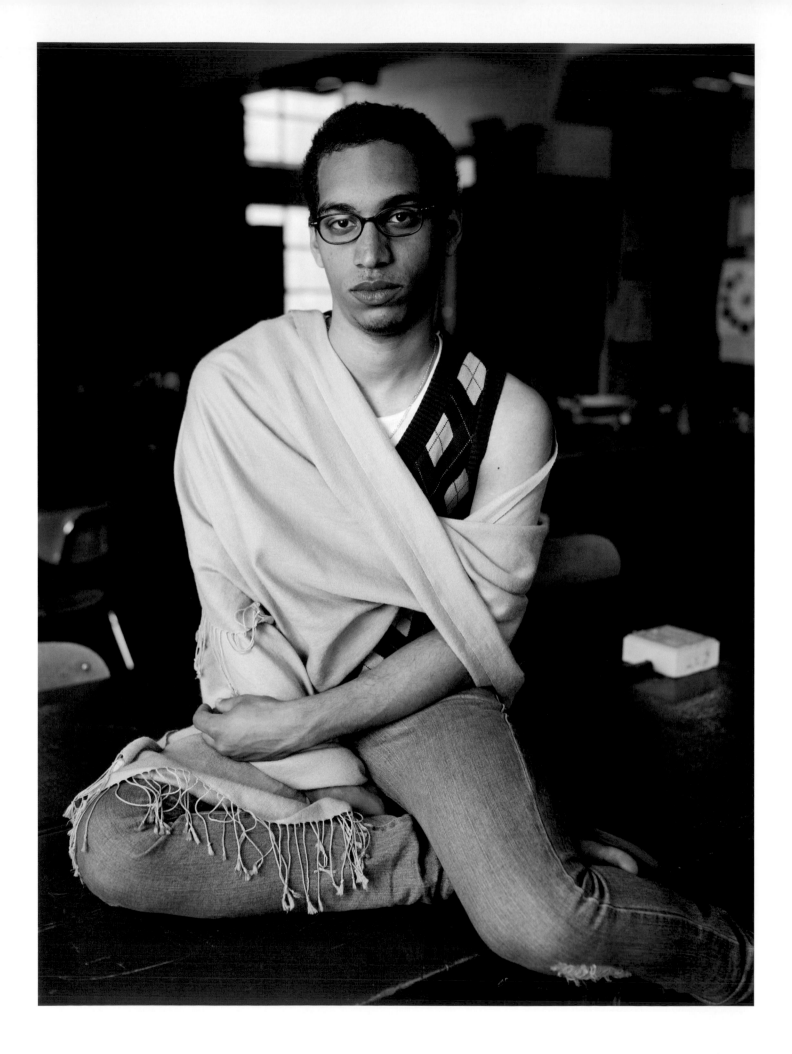

DANNY

Well, I like to think of myself as an outgoing, outspoken person. But in reality I'm really a quiet guy. People see me and they see a crazy party freak that likes to enjoy himself. But I'm really not that person. I'm a homebody type of guy, with a really good heart, that loves life and people with really beautiful personalities.

ODALYS

My name is Odalys, and I'm a good person, and I like to play with my baby. It's real fun to play with her, and I hope this baby comes out, you know, healthy, and I hope that I can get out of school and study. I want to be a professional doctor 'cause that's what I want to do.

I hope everybody remembers me, because I just started in this school and everybody knows me, "The little pregnant girl," so, I hope they remember me.

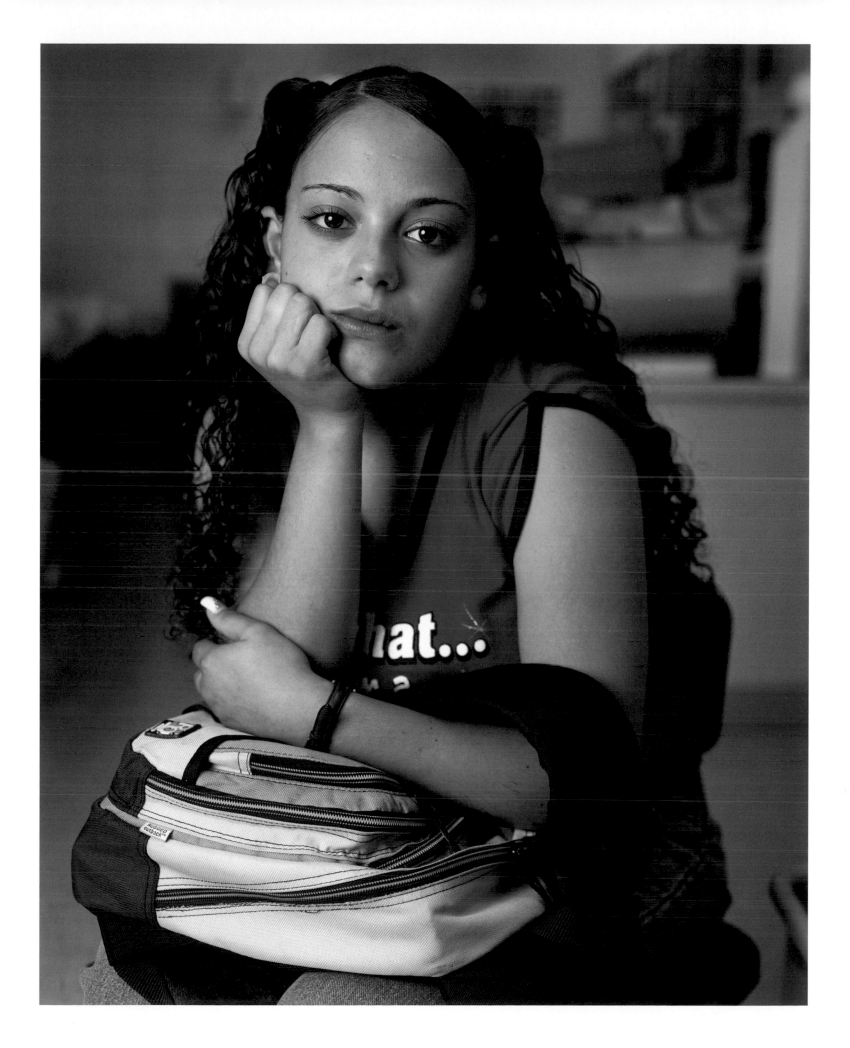

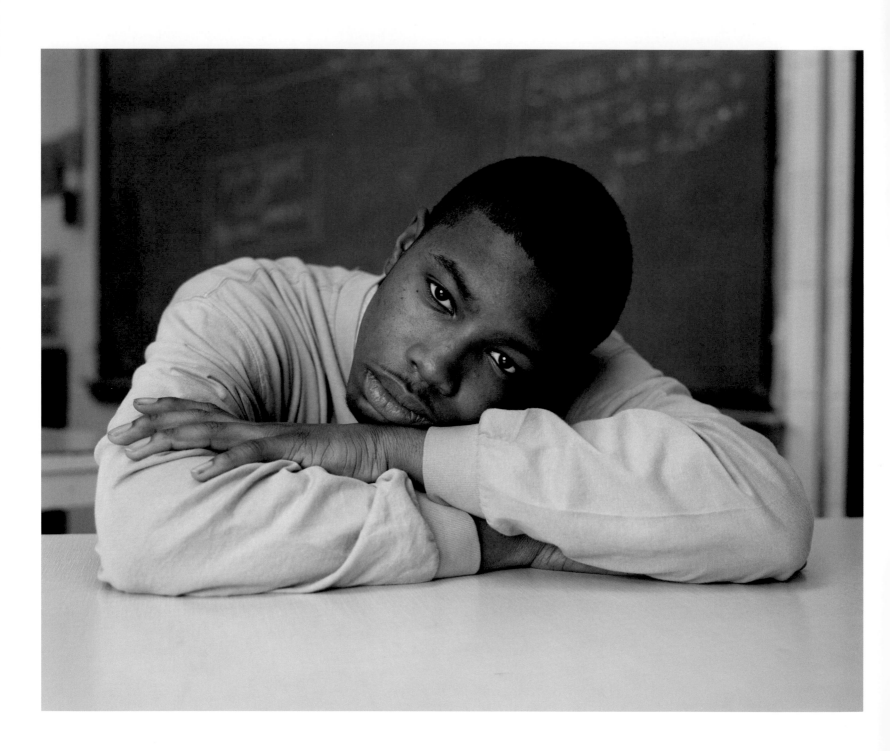

KENNETH

If it wasn't for school, I don't know where I'd be. One of my friends just died recently, shot in the back of the head. He was walking down the street, him and a couple of friends of his. He was going back to meet his father 'cause his father was coming to pick him up. And then everybody started running; he was the only one who got hit by the bullet. At first I really couldn't believe it, 'cause, like, in the neighborhood we stay in his whole family used to live around there, and he was like one of the main people that I actually spent time with. We used to go to the beach together, play basketball. He was a nice kid; all the adults in the neighborhood thought he was nice. It just makes me feel sad, you know, I wish I could have my friend back. That's why I try to keep my mind focused on other, *positive stuff*, such as school, making sure I do all my homework, so I can get the best grades I can get. I want to start my own record label, probably, and like open different types of stores and invest in . . . like, neighborhoods I've lived in and everything, have new buildings built so there'll be less homeless, get people up off the streets.

SARAH

I may be different, but I take a silent comfort in my difference. My looks do not define who I am. I know that I am separate from the rest of my school because I look the way I do, not "normal." What is normal anyways? And who decides what is normal?

My soul is not dark. I have dealt with pain and misfortunes. I have also had wonderful people and experiences in my life. Everything I go through, the good and the bad, makes me a better person, not just a better person but stronger too. My experiences define who I am.

I'll tell you what I see when I look at myself. I see a young woman owning her individuality, being her own leader, not following the crowd, and I see a young woman who learns from everything around her. Now do I seem so strange?

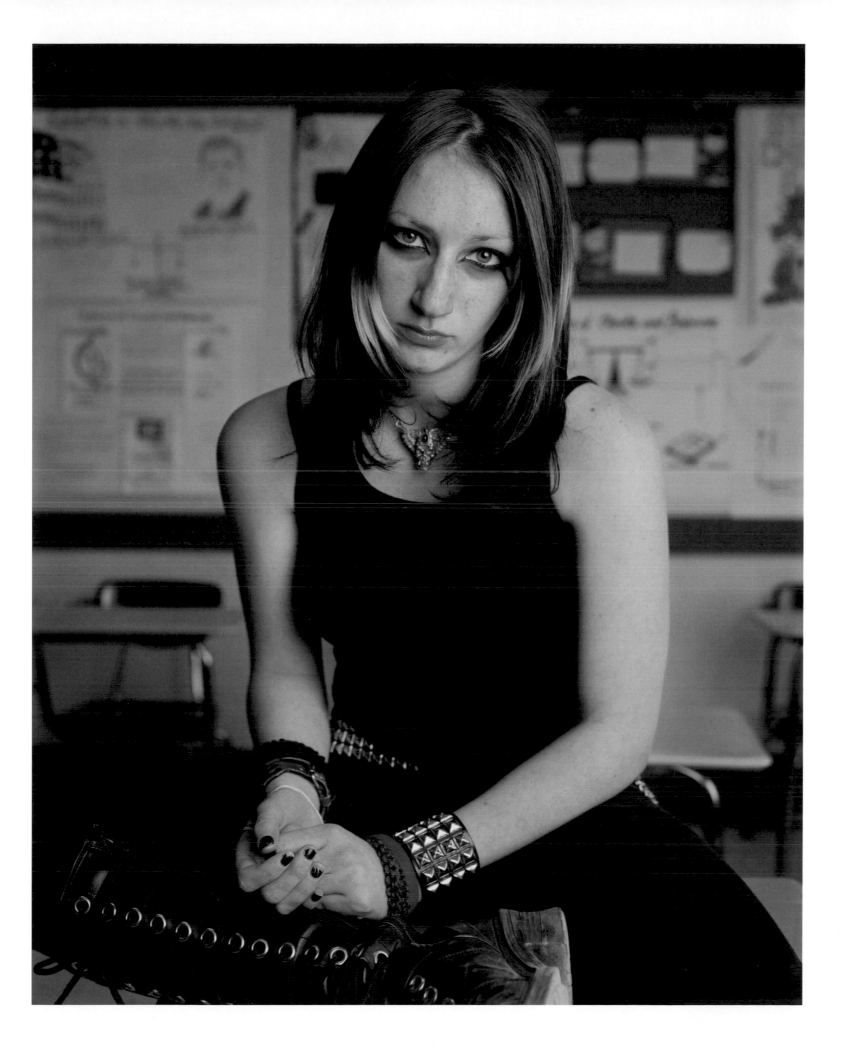

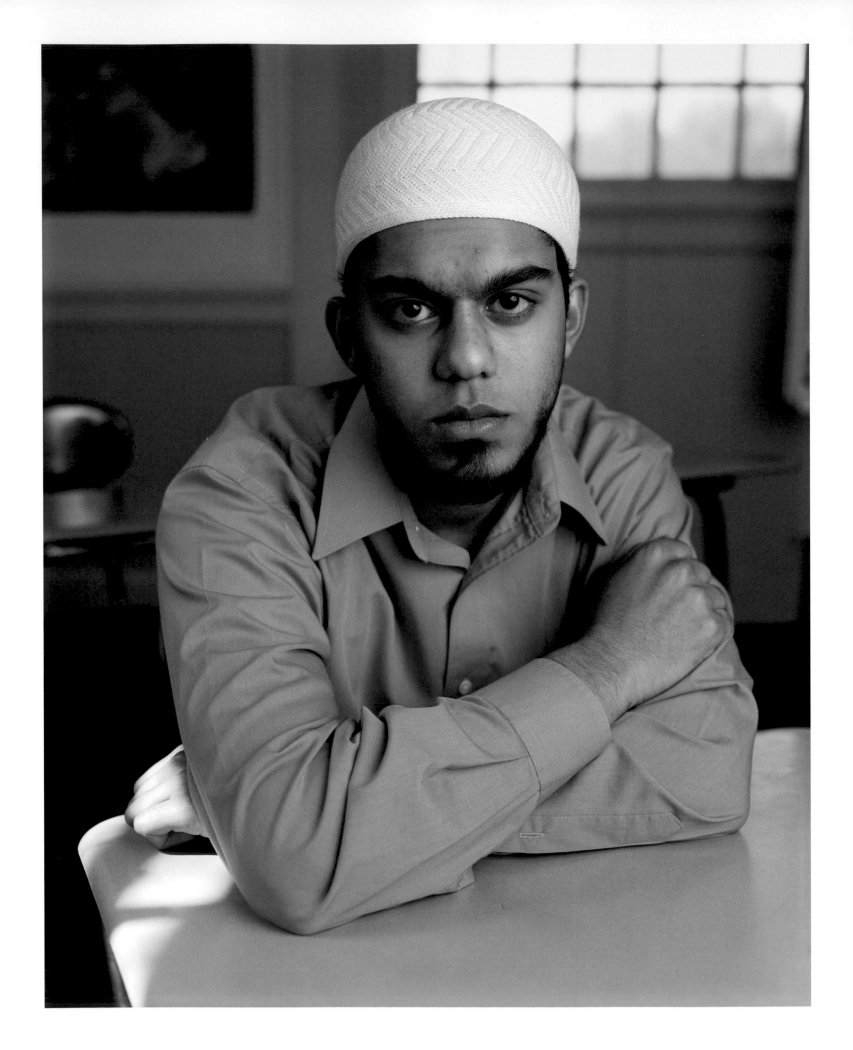

OMAR

I know that I shouldn't but sometimes I wonder how other people look at me. What do they see first? My brown-ness, my beard, my cap, my clothes, the color of my eyes, the design of my T-shirt? I think that people see my skin color first. They probably see me as a brown guy. Then, they might see my black beard and my white kufi (prayer cap) and figure out I am Muslim. They see my most earthly qualities first. Brown, that's the very color of the earth, the mud from which God created us. Sometimes I wonder what color my soul is. I hope that it's the color of heaven.

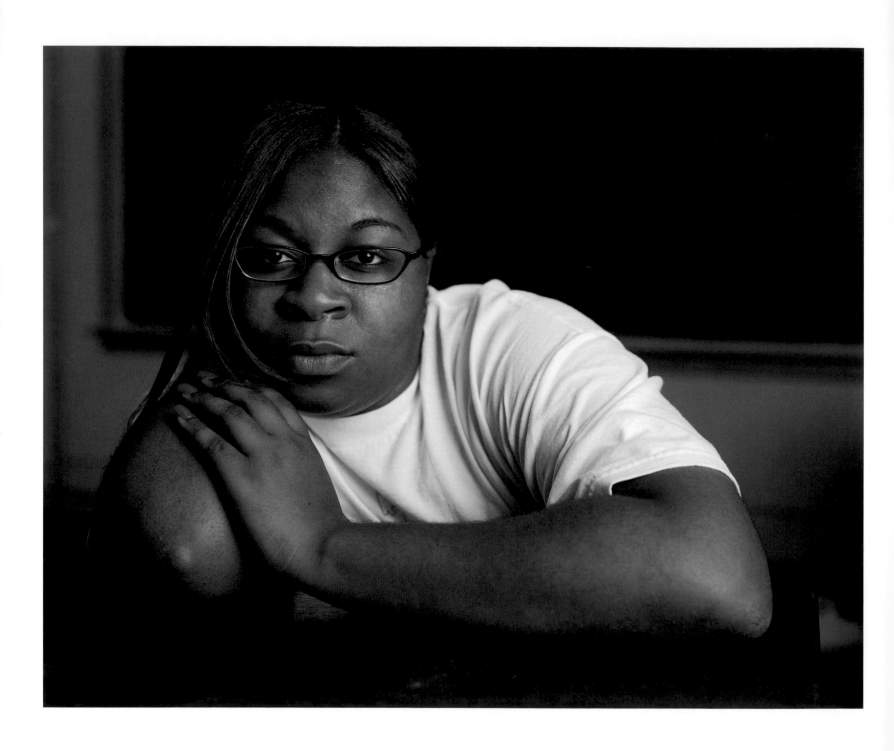

ARTICIA

I want everybody to know me as being strong, 'cause I go through a lot. I am going through things now where I feel as though people feel sorry for me. I don't want anybody to feel sorry for me. A lot of people are offering a lot of handouts, and I don't want to accept it. So I want everybody to remember me as being strong, independent. I'm seventeen years old now, basically taking care of myself. My mom does her thing or whatever, and my father lives in Alabama, so really it's just me. I guess it was my attitude toward my sisters that is the reason that I am not with them now, but hopefully they will be able to look over that, but, yeah, basically just me being strong and keeping it together.

JORDAN

I grew up in a lesbian family, and I met my dad when I was four years old. My mothers taught me to never judge or discriminate against others, and to look at them for who they really are. I think this point of view is something that is lacking in our world today. I feel so fortunate that I live in a place that I feel represents me perfectly. Every new day for me brings new and exciting adventure. I spend most of my time doing the typical things seventeen-year-olds do, but always find myself trying to take it to the next level, advancing my life as much as possible. Most people would say that I am mature for my age, that I don't act like I am seventeen. The only way I can explain this would be to say to them that I am very content with myself, and what I have accomplished thus far in my life, and I treat each day with the hope that it can be better than the previous.

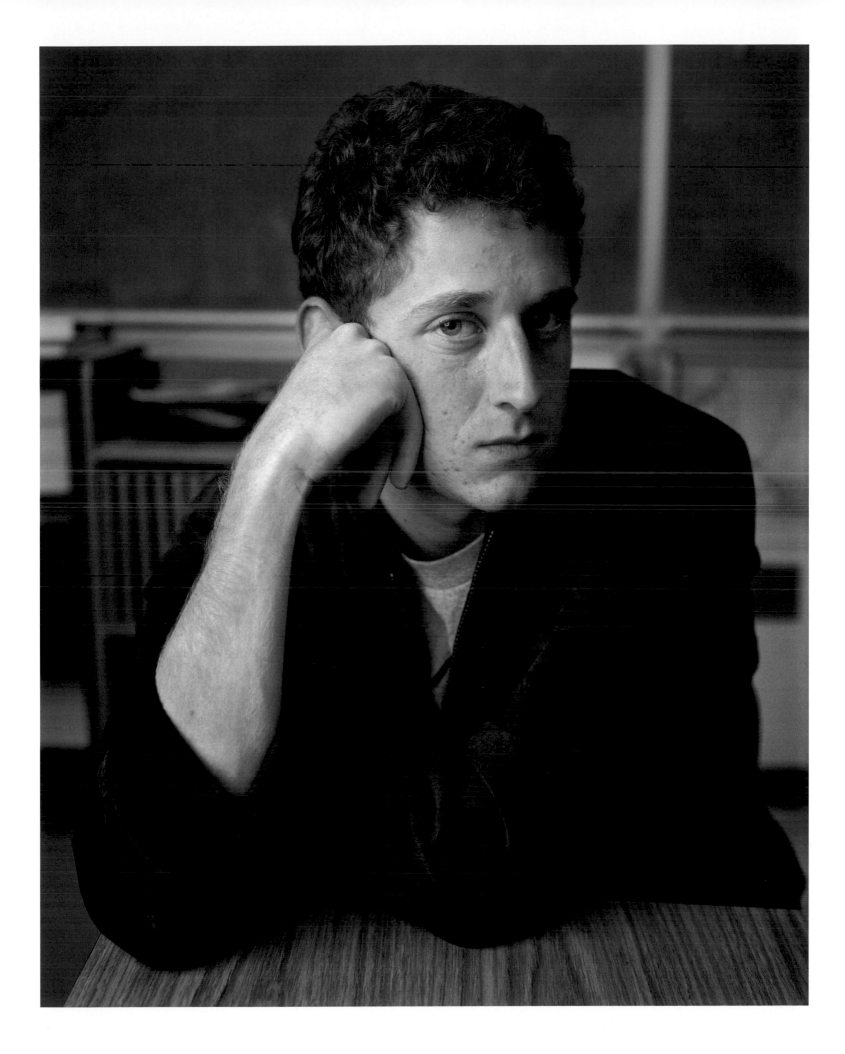

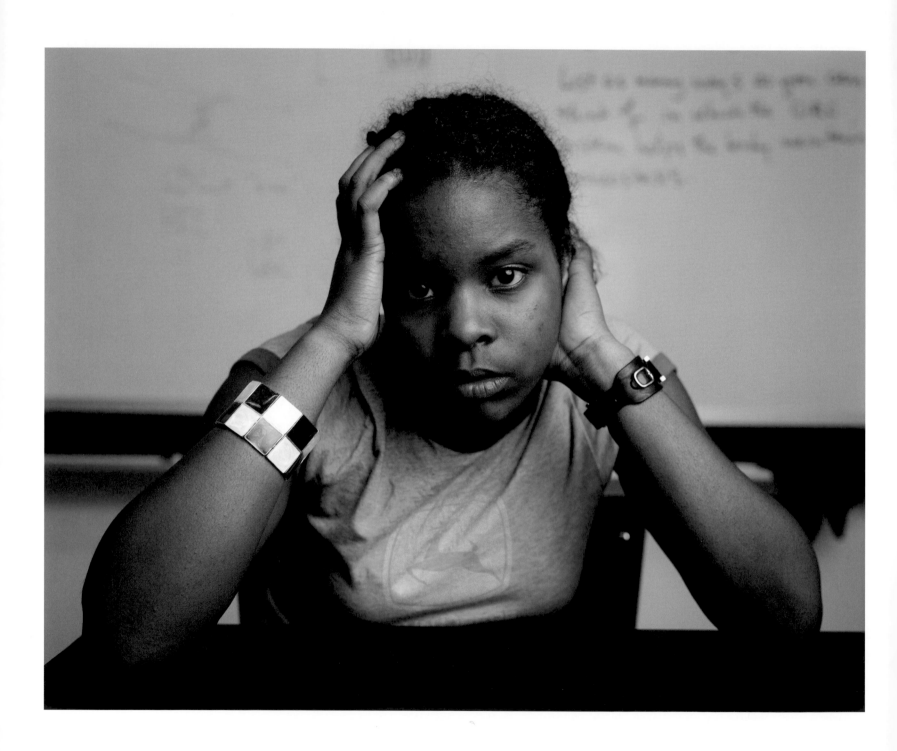

CHELSEA

It's funny, while I was sitting in English class yesterday, my teacher asked the class to find one question, a very specific question, to ask a person who they are. That led me to an answer of my own. I am the sum of my experiences. Everything that I have felt, seen, tasted, thought, dreamed, and so on, has culminated into the person I am today. I don't believe that anyone could truly see every single aspect and value and belief that makes up me, Chelsea, but as Vonnegut says, "We are what we pretend to be, so we must be careful about what we pretend to be," and show the world what is true, beautiful and right to myself, to us all as people. So who am I? No words could comprehend.

KEVIN

When I was about six or seven my father died. This was either the worst or best thing that ever happened to me. In fact, now that I think about it, it was both. That experience was both my blessing and my curse. I don't remember much before the death of my father. For me it feels like that's when life as I know it really began. It's not like I was saddened by the event. I hardly knew my father. His memory only survives in my head because of three scenarios: the way his coarse mustache pricked my cheek when he kissed me, the short collect calls he made from the correctional facility, and the photos that my mother keeps under her bed. After his death my mother became incredibly detached. She became a mere exoskeleton of her former self. With a dead father and a deeply depressed mother who basically stopped living, I had no choice but to take care of myself. I became as self-reliant as possible. There was no more time for childhood. I was all about business. Thanks to the death of my father I learned to value independence, hard work, and maturity. This is my blessing. Thanks to the death of my father I grew up much too fast and never learned how to ask anyone for help. I carry my own burdens . . . alone. This is my curse.

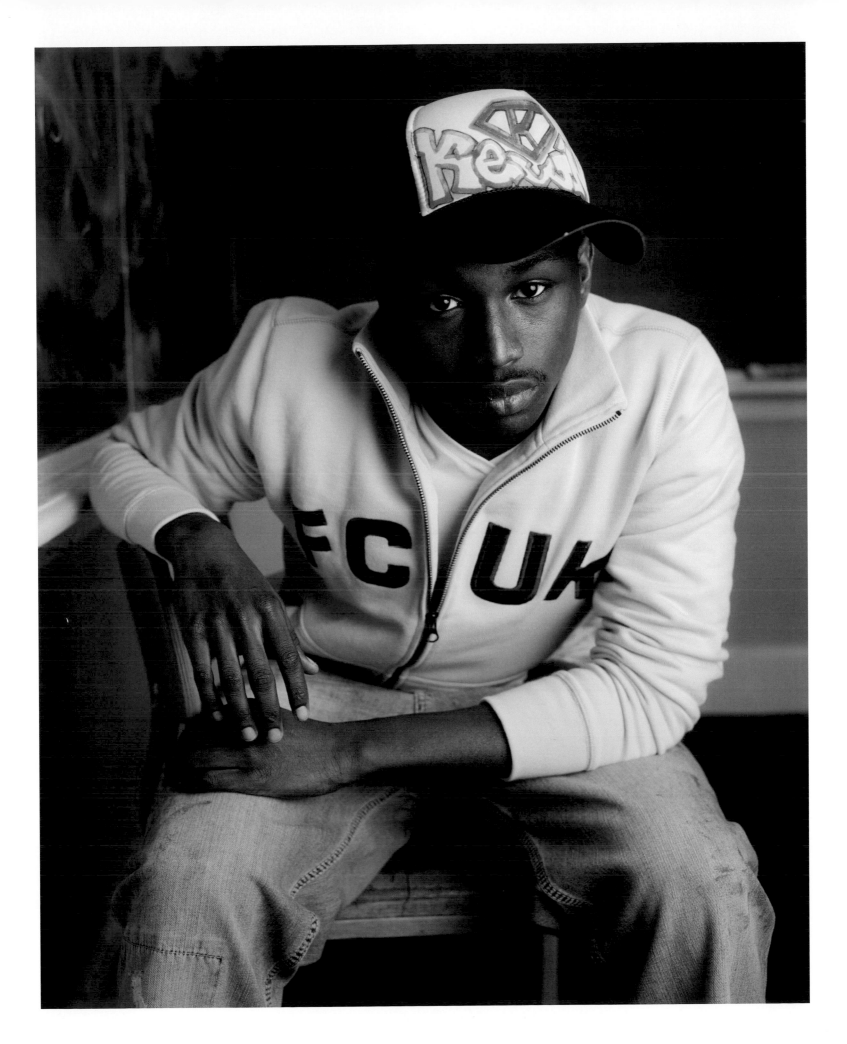

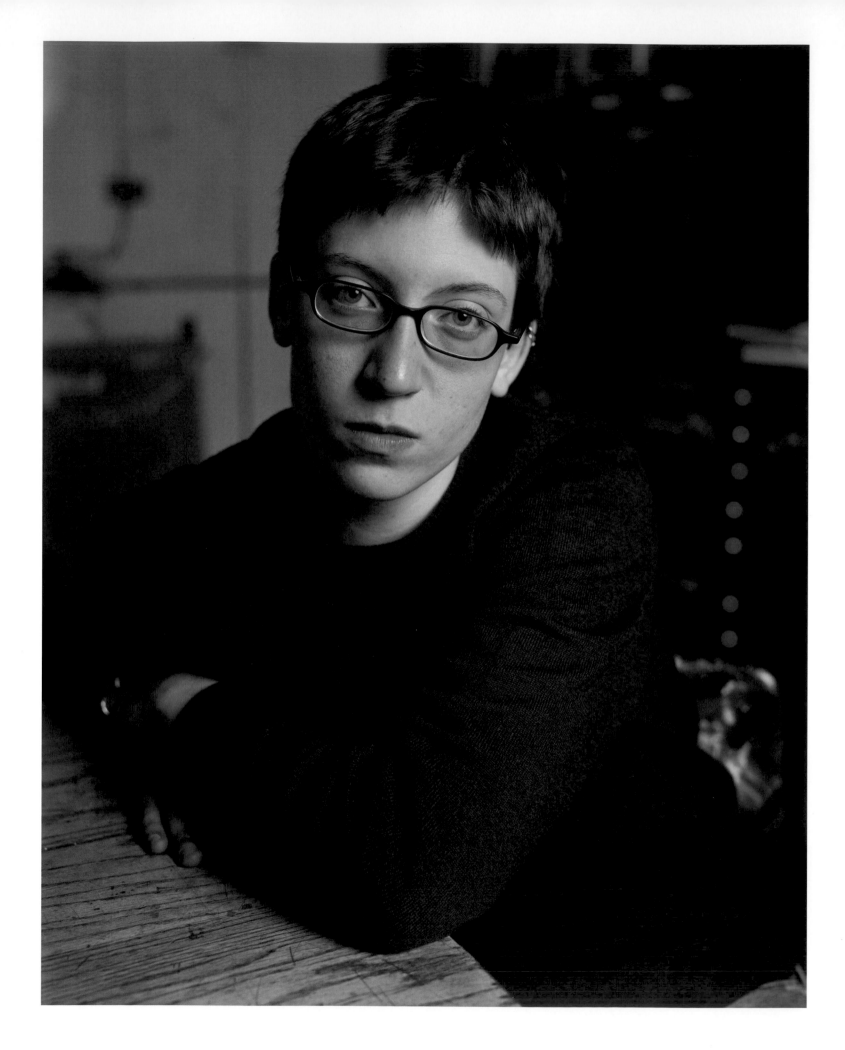

ISABEL

I hate it when I have a fake smile in a picture. So I don't smile. And then people always say that I'm being negative, but I just don't like to look stupid. Sometimes people think it means I'm in a bad mood, but I don't really care because it's not usually true. People think that I'm really blunt, and so, in a way, that can be good, but also it sucks 'cause people think I'm mean when I'm *not* trying to be mean and I don't even notice that I offend people sometimes. And so that can be frustrating 'cause it will come back a week later in my face and they'll be like, "You made me so upset the other day, blah, blah," and then it's like, "I didn't know, sorry, I didn't mean it that way." And so in a way I like that about myself, 'cause I hate it when people are two-faced and lie, but in another sense it alienates me from people sometimes, because I don't know that I'm offending them. And, something most people don't see about me is that I, I think people think . . . like I was saying, people think I'm blunt, they also think that I am *not* sensitive to, like, *them*. So they think that since I often offend people accidentally, that it's hard to, like, hurt *my* feelings, and people don't know that I'm actually kinda shy. I don't spill my emotions . . . like sometimes my friends will say, "You never tell us anything. You listen to us and you're nice but you don't . . . ," and I don't even notice that about myself, 'cause I do feel a lot of things, obviously, but I just don't *express* them to people that I'm not really close to, and I don't trust a lot, you know.

DEMARCO

I like when people look at a picture of me and be like, "Oh, he looks like he'll do something bad like this." Some people might be like, "Oh, he looks like a bad kid," or . . . like, "I can picture him beatin' up somebody or taking something from somebody," whereas that's not me at all. I guess there is a certain look, 'cause I've experienced it before. Like, teachers in school, they're like, "Oh, I thought you was a bad kid, but you're all right," you know. 'Cause I like to prove people wrong so I can make *me* look better in the end. 'Cause as they get to know me, then they'll see—like I said, I'm a funny person—and they'll *see* I'm a funny person.

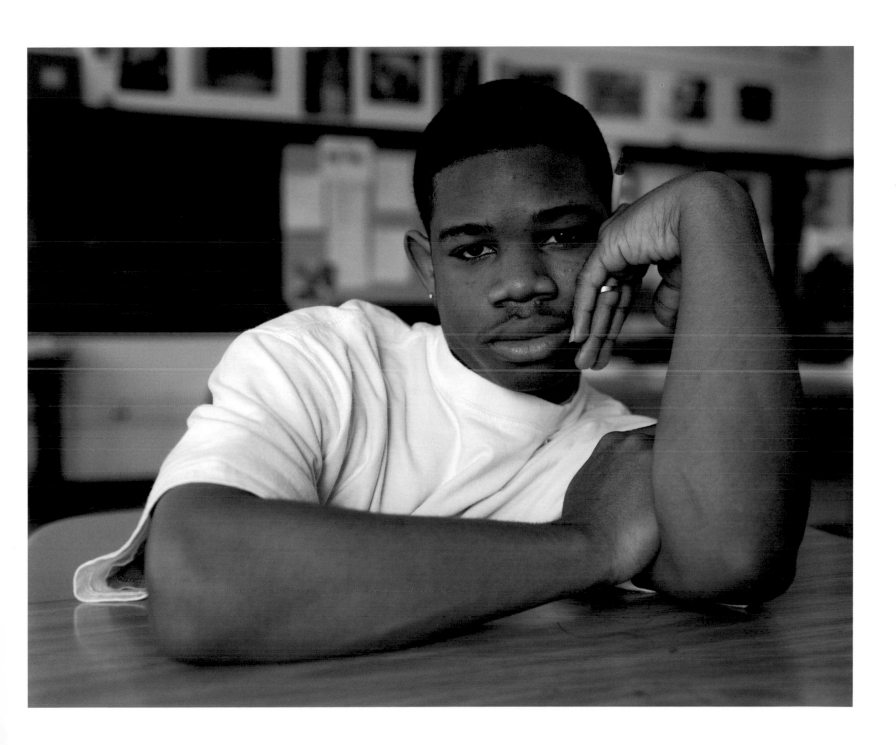

CATHERINE

I would say I am not like most seventeen-year-old girls, or at least most girls from my hometown. I do not have much of a social life that would be very interesting to talk about because my life pretty much revolves around school. I may sound like a nerd, but I am also not particularly smart. I'm not at the top of my class or a teenage prodigy in any way. However, I do go to a very academically demanding school and must prove to myself that I can survive there. As a junior, the burden of college applications is looming, and it's scary. I once heard another student from my school tell me that it didn't matter what college I got into as long as I got accepted somewhere, after all, there is nothing in a name. At the time it seemed like a somewhat positive thing to say, as it was "anti-superficial" or something along those lines. But I later realized that it was against everything my parents had taught me.

Where I am from, there is nothing more to strive for than "something more, something better." I also decided that there is something in a name—there's prestige, honor, pride, etc. That's why I chose to go to a private "rich kid" school in the first place. What I choose to do with that prestigious education is what can make it honorable. That's what school is about anyway; it's about reaching and surpassing a series of levels, ending up somewhere higher and better each time. It's also about enjoying it and being happy while you do it and being proud of where you're going. So, I do want to go to an amazing university. That's where I'm headed right now.

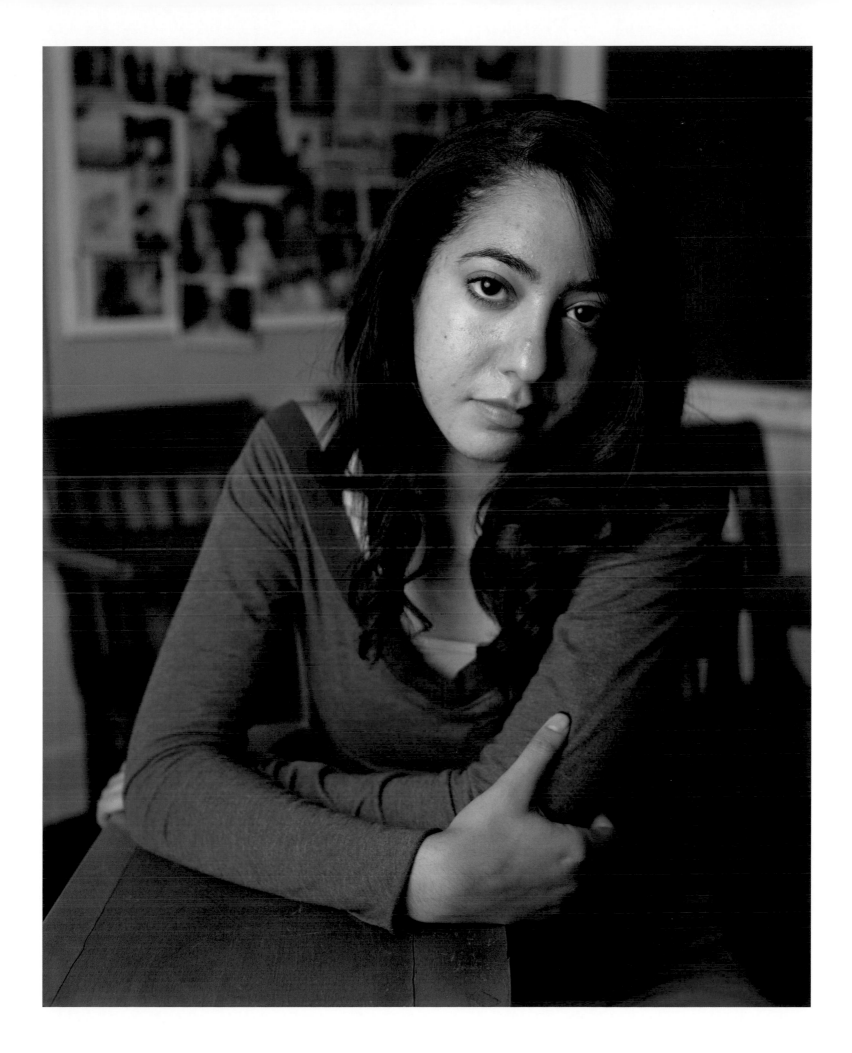

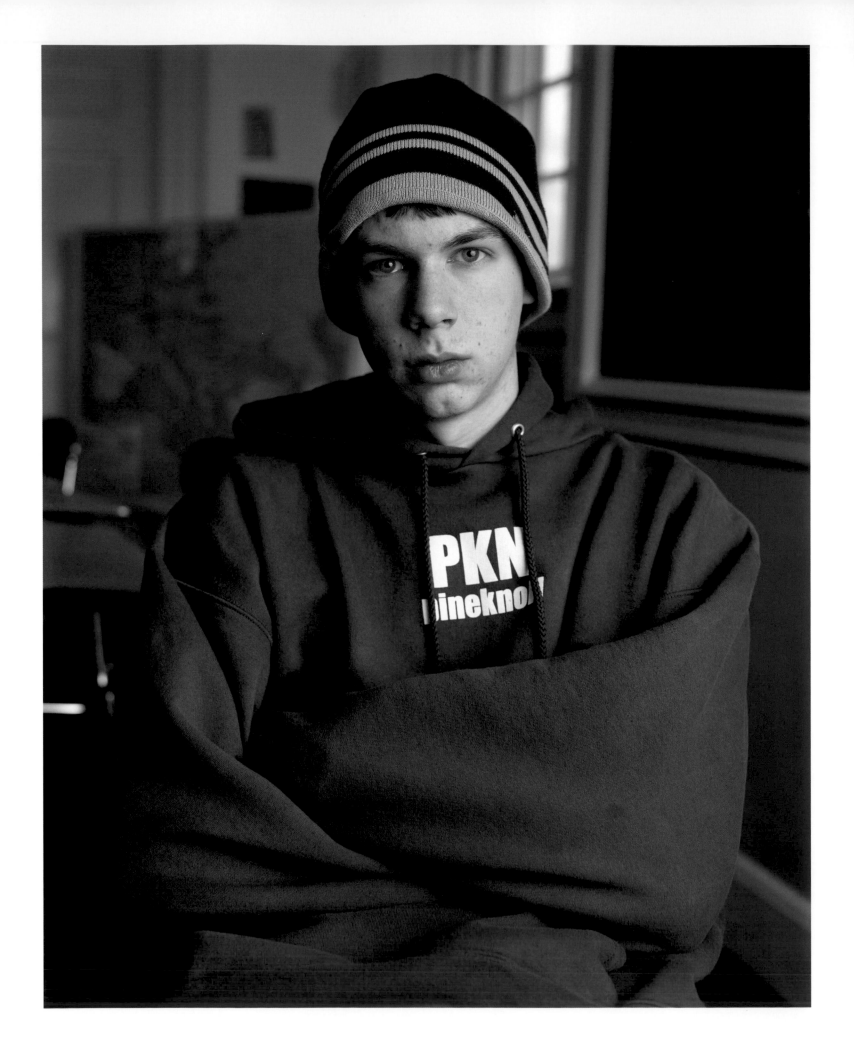

CHRISTOPHER

I suppose something that would not be perceived immediately would be my having cancer. I don't have it anymore, I've been treated for it, but nonetheless, my experience with it has a large say in who I am. I am a humble person who is only trying to get by, by doing the best I can, and I don't feel as if I love to share everything with everyone, just like my experience with cancer, though I suppose now I am telling everyone who reads this about my experience. But the treatment itself has affected me in a way that isn't extremely obvious. I come off frequently as either being very formal and polite or as being coldhearted, though I like to think that the former is more often true. The real me, however, is very emotional and understanding. When I got chemotherapy I saw children not even five years old with more severe cases of cancer or intestinal problems or what have you, and I felt . . . I knew something was wrong with this, with young, innocent children being sick in the way they were, and I wished I could take their pain and suffering from them. From then on, I look at people with a different outlook, and I see how ignorant many people are from events like that, and it lifts me to a new level of understanding. So while I am polite, I understand how life would be different or even how they would act differently if an illness or disease were playing a role in someone else's life.

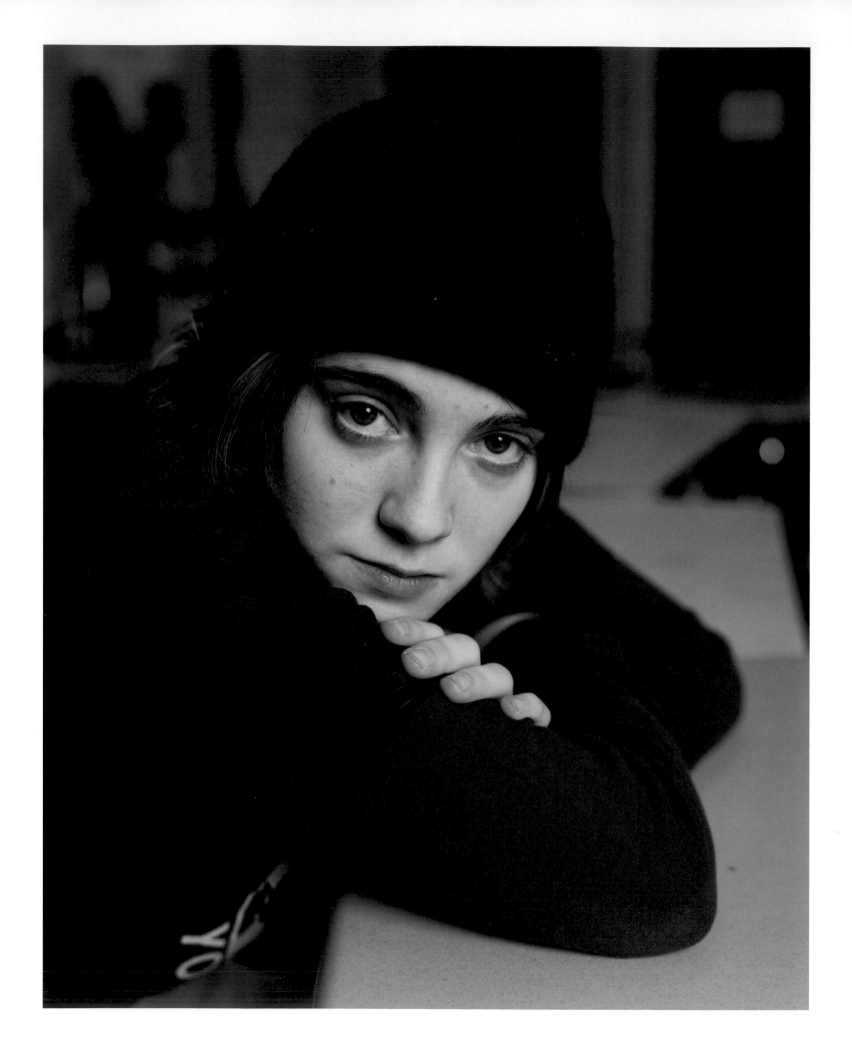

LEAH

I think *all* the time. I mean, no matter where I am I'm thinking, you *cannot* shut
my brain up, you know. I mean, there are times when I'm the person that I fear
the most. You know, I don't wanna deal with my thoughts anymore, I don't
wanna think. So I'm either off *trying* to find somebody to talk to so I don't have
to really think about my own stuff, or that I can talk to about my own stuff so
that it's not confusing anymore. I've always walked around with the assumption
that I can figure things out, I can figure me out and I can figure you out and I can
understand how things work. There are times when I sit back and I'm like, no,
I can't, and I need to stop asking, you know, I need to stop trying because that's
when I don't get confused, you know, when I stop trying to find answers.
And when I realize that maybe there aren't even answers, you know. But when
I forget that, you know, when I forget that I can't know it all and I can't figure it
all out, that's when, you know, I become my own monster.

EBONY

My favorite color is blue. I like everything blue. If you really look at me, everything I wear is blue. Even my room and bedspread are baby blue. My second favorite color is pink. I started liking pink about two years ago when I got some pink and black shoes and had to buy some pink outfits to go with them.

One interesting thing about me, which my mother says, is I always look mean, but when I'm in a nice mood, you always see me smiling. One more interesting thing about me is many people say I don't talk much, but when you get to know me I start to talk a lot.

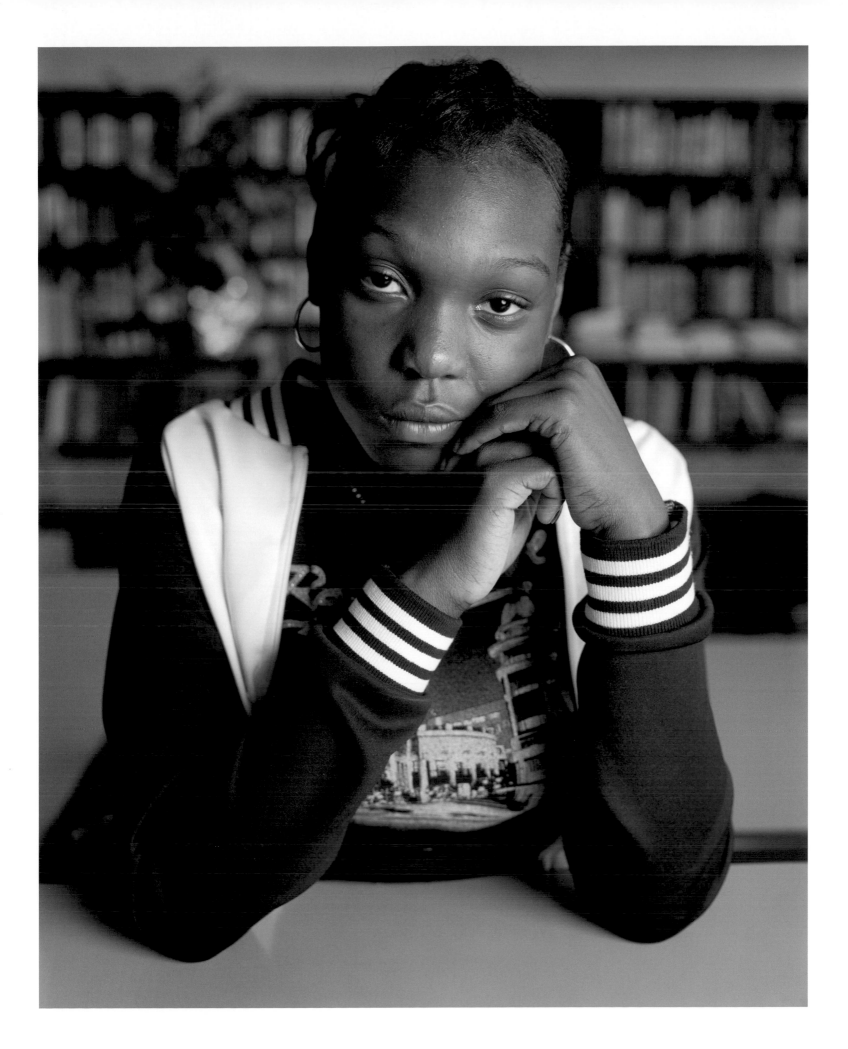

MARK

My first football game I didn't really know what I was doing because I wasn't really into football that much. I didn't know the rules and stuff. I was in the ninth grade, and they asked me if I wanted to play football. I said okay. I showed up for the game. I didn't have one day of practice. I didn't know what was going on. The coach told me I had to play, "We need you," they told me, "you're playing line," and I was like, "What is line?" I didn't even know what it was, so then they just put me in there. They told me who to stand by and stuff. I was running up and hit somebody, and I didn't really know what I was doing. They were calling penalties on me. Our score was zero the whole game until the last two seconds, and we scored two points and won. But I didn't really know what I was doing. They just told me, "Get in there." Now I'm a veteran, and I want people to remember that Mark Ramos is the best lineman at Chadsey.

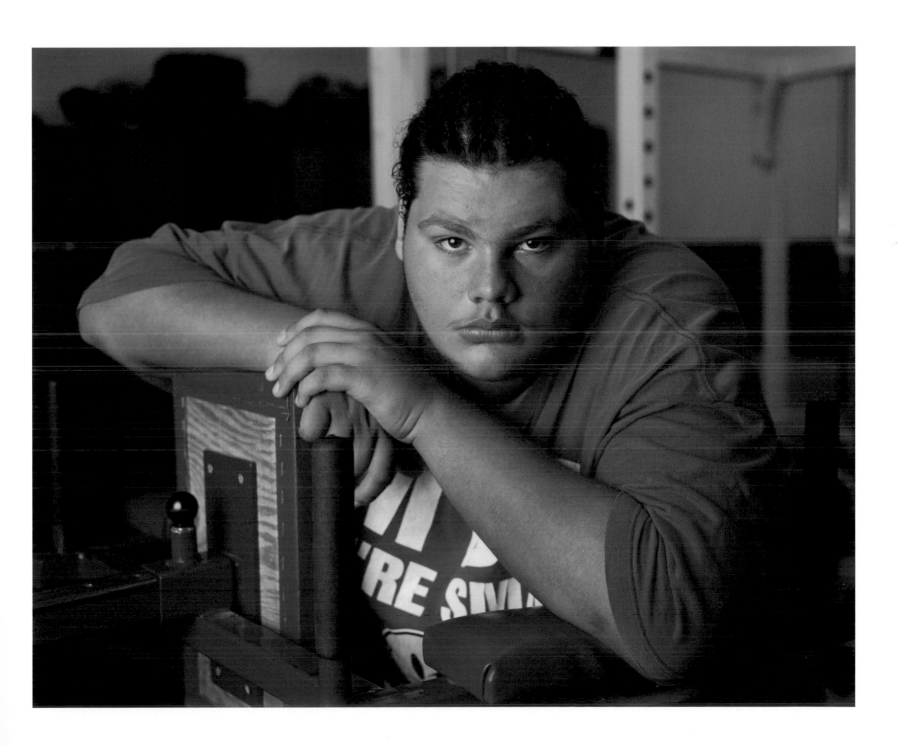

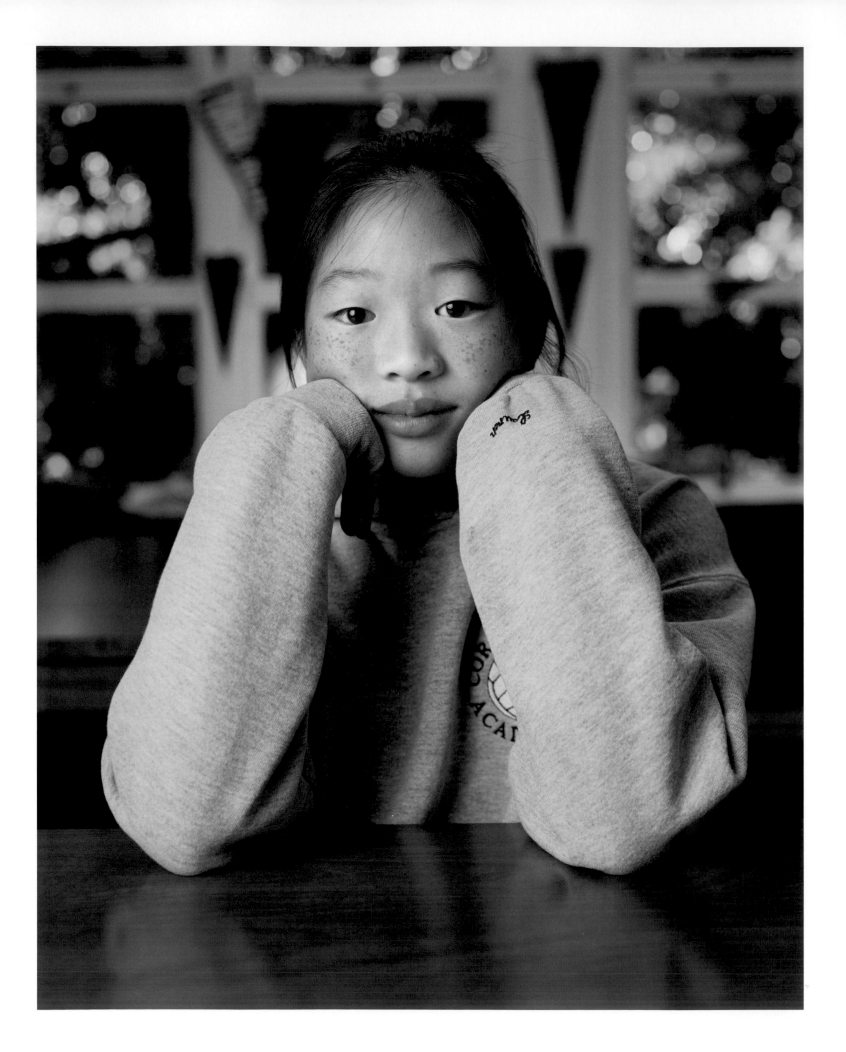

LAUREN

I'm glad my parents were always there to guide me and help me think of the choices I was making. I like to join a lot of activities, but once something goes wrong, my first thought is to quit. When I tell my parents what happened, they always push me to give it another try and not quit. Without that extra push I wouldn't have been able to do many things, like play basketball, volleyball, swim, or even play the piano.

GODWIN

I am a very generous young black man with a lot of talents. I like doing new things. I play the piano, I play basketball, football, and soccer. I also like having fun. I will say I'm addicted to having fun because I over-have fun. I hate being bored because I grew up in a family that's always doing fun stuff. I'm also a very friendly person. I see myself as a very unique man with a lot of potentials.

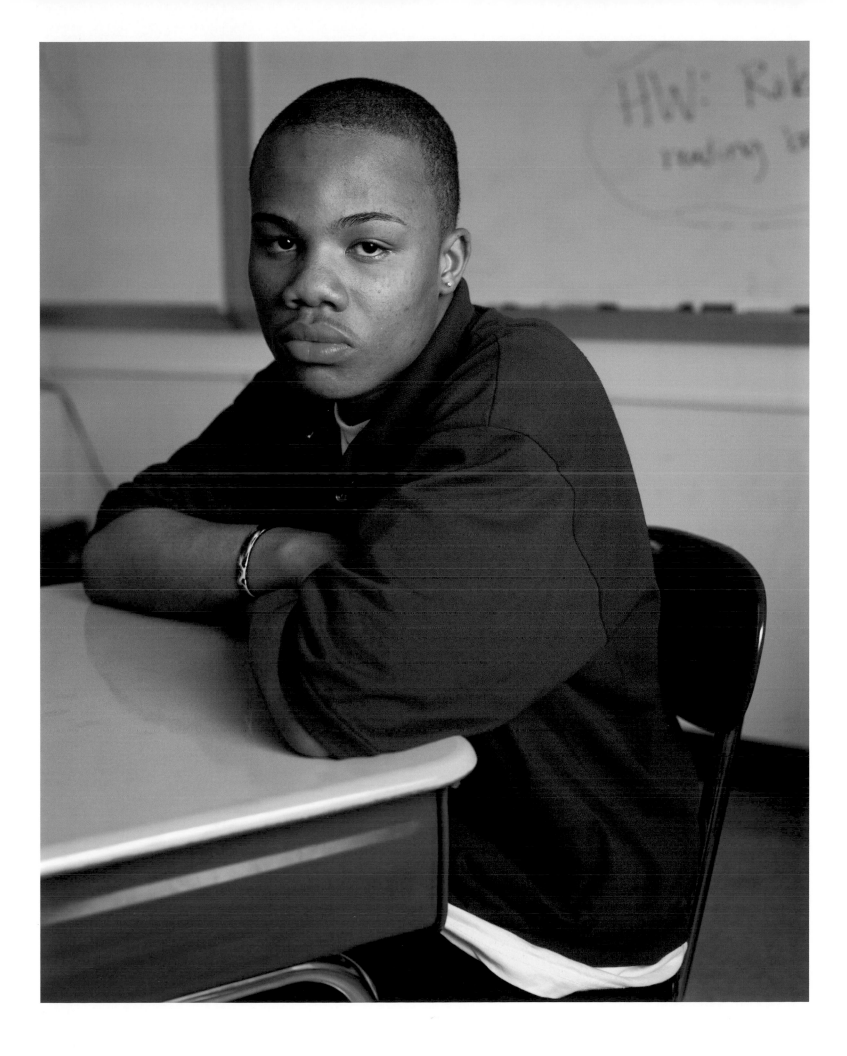

MARIEKE

When I was younger, before I came to Andover, I used to go downtown with my father. We made the rounds: grocery store, shirt store, video store, and finally the library. There I would pick up books off the shelves, accumulating such great stacks that my father made me put some back. "Save them for later," he said. Carrying piles of slippery books in my arms, frequently dropping one or two along the way, I would take them up the stairs, into my house, and often straight to the living room couch. There, my body wedged between cushions and warmed by the afternoon sun, I would read straight through to dinner. If I was still in the middle of a book, I might bring it to the table, placing it next to my plate until my parents made me put it away.

Now I read in between classes, before bell time, and during free periods. Andover's library is the largest secondary-school library in the country, but I am even reluctant to start new books; they keep me awake at night and from my schoolwork. When I do, I try to economize, to choose shorter books. When I was younger my parents worried that I wouldn't look back happily upon my childhood memories.

Now, it's really all I can do. I look back and wait for summer and a sunny afternoon.

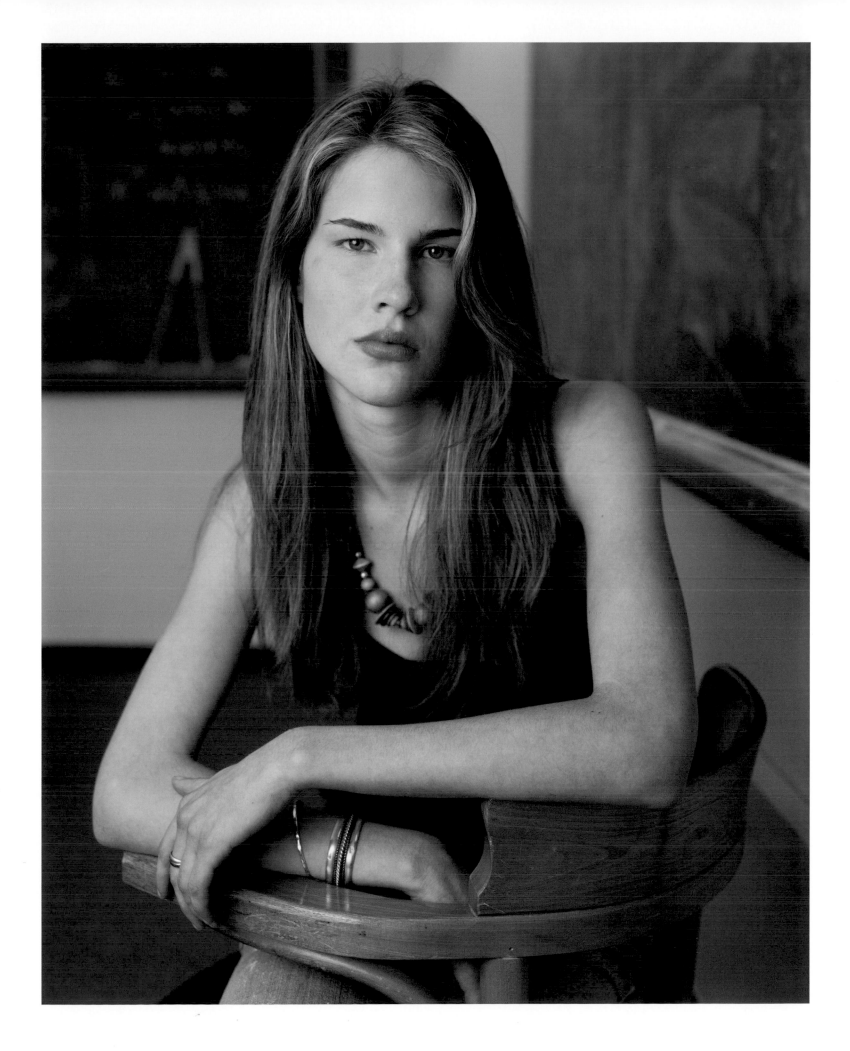

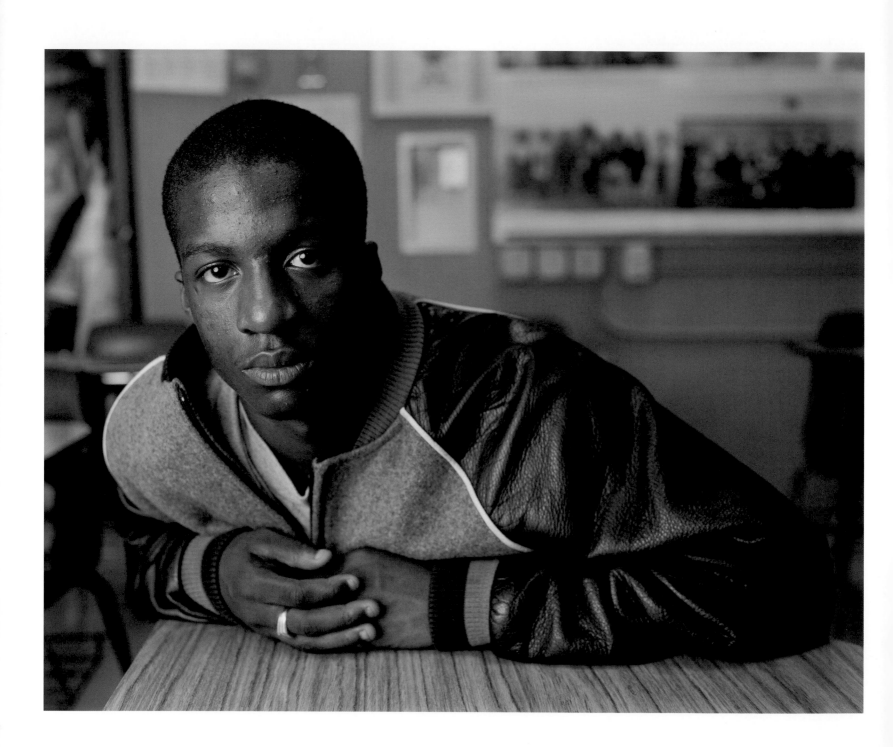

JOSEPH

I love to dance. The reason I love to dance is because I love to show how I feel at certain times. I love to be myself. I want to be an artist that can show other kids that they can do anything they can do or put their minds to. But I want to do more than that. I want to be in the music business. I think that if I work hard I can do what I want. Yes, I want to be a dancer, but I have more dreams. I think I can go anywhere.

MICHELLE

My mom always calls me her perfect child, not in front of my other siblings of course. I am told that I learned to walk at the perfect age, how I get perfect grades, how I have the perfect attitude. No pressure to keep it up, right? My friends caught on, too. They'd laugh at how their parents would compare them to me and all. Being perfect, which then grew to being the best, became contagious. Later, it really hurt when I wasn't anymore. The weird part is I brought this "perfectness" upon myself. My parents didn't believe in pushing, I guess because they knew that I would do it myself. But sometimes I wish they pushed me so I wouldn't have to do it myself because sometimes I feel lost like I don't know what to do next. Then sometimes I don't want to do anything next, but instead just stay in the moment right there and then while I'm as happy as I can be. So now I'm at a new school where I'm not the best. I don't get the perfect grades and, according to my parents, I've developed a teen not-so-perfect behavior. Plus, I don't know what I'm doing next. I used to be a perfect planner but now I'm playing by ear on the spur of the moment. Things have changed and sometimes it's good, other times not so good. But I don't know. I guess whatever comes will come and we'll just see. But my mom still calls me perfect.

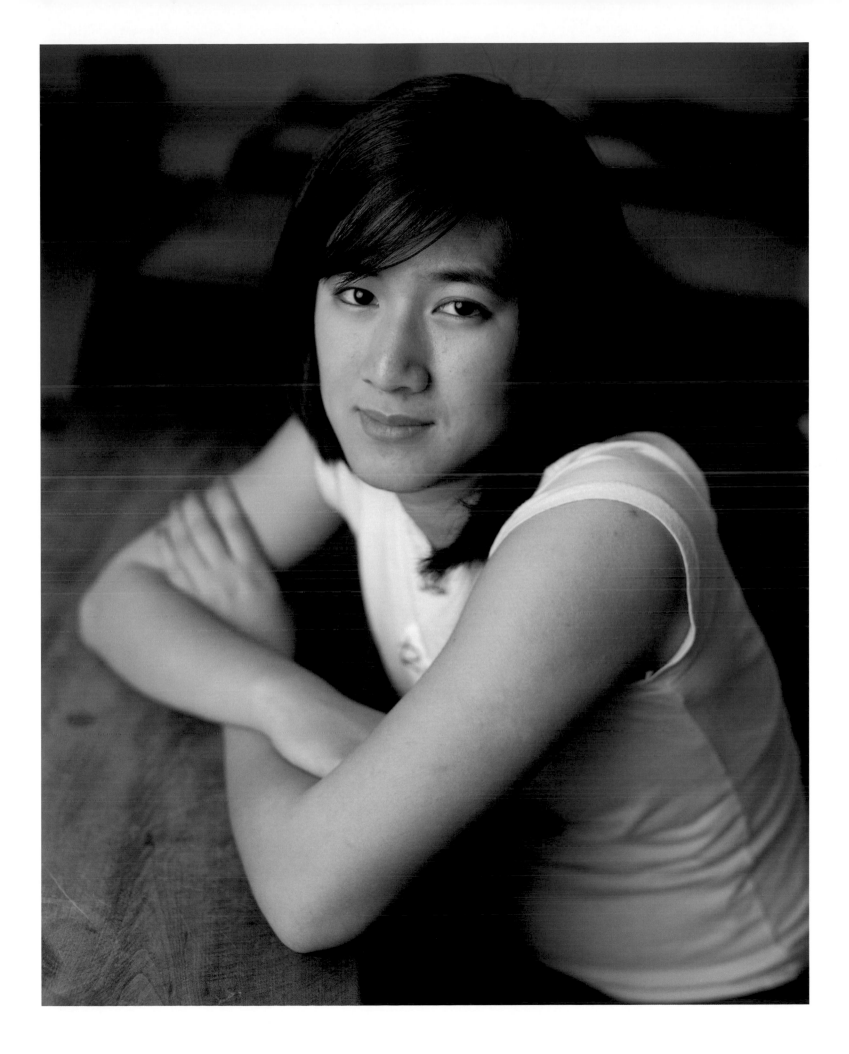

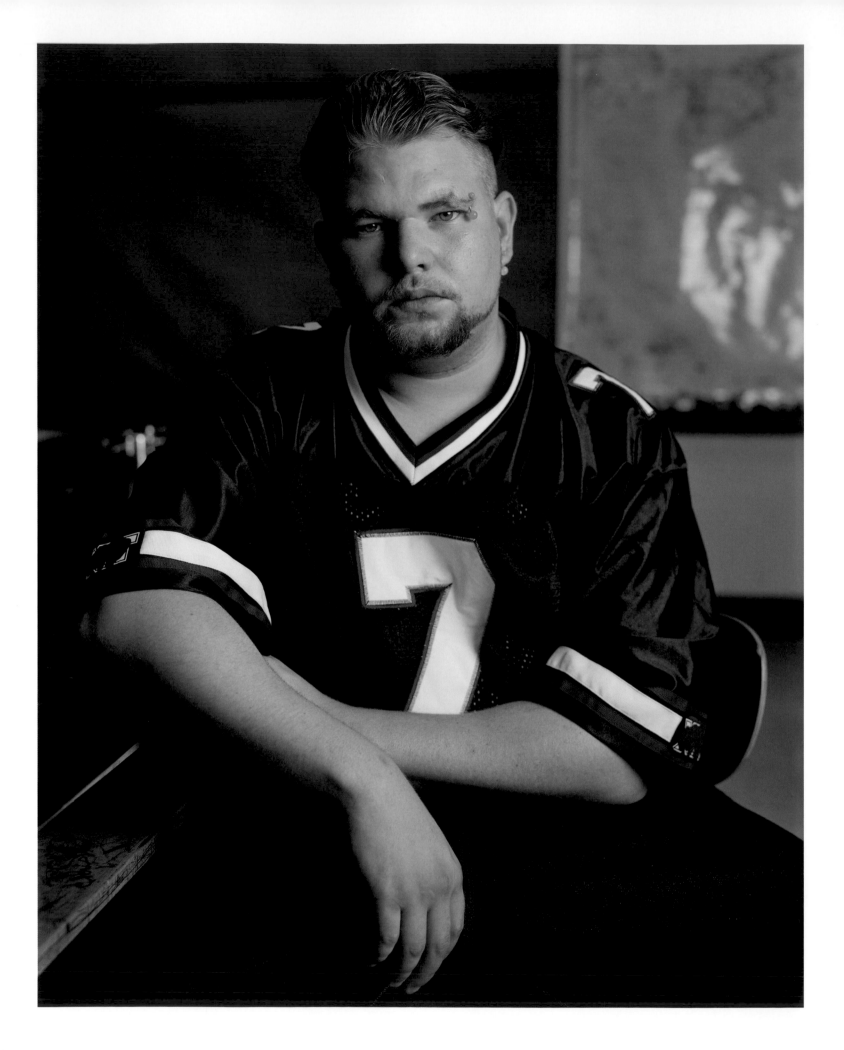

ROBERT

My favorite sports are football, baseball, and wrestling. I like to play video games and watch TV. I like people. I have a girlfriend. I asked her to marry me, and she said yes. We will be getting married on February 18, 2005.

My life is perfect with her. I mean, ever since I got with her I stopped fighting. I quit all the stuff I used to do and just put all my time with her. I mean, if she wants me to I mean . . . sometimes I just put stuff down like if I gotta do something, like go visit somebody, I put that aside just for her 'cause I love her so much. I done told her at the beginning I'd do anything for her. I'd put anything aside for her and that's what basically I've been doing. I treat her like she's my queen. I would rather put her first than I go first. So it's like I told her when every time I get money or something, I give it all to her—"I don't want none of it, it's all for you." And that's what I've been doing lately.

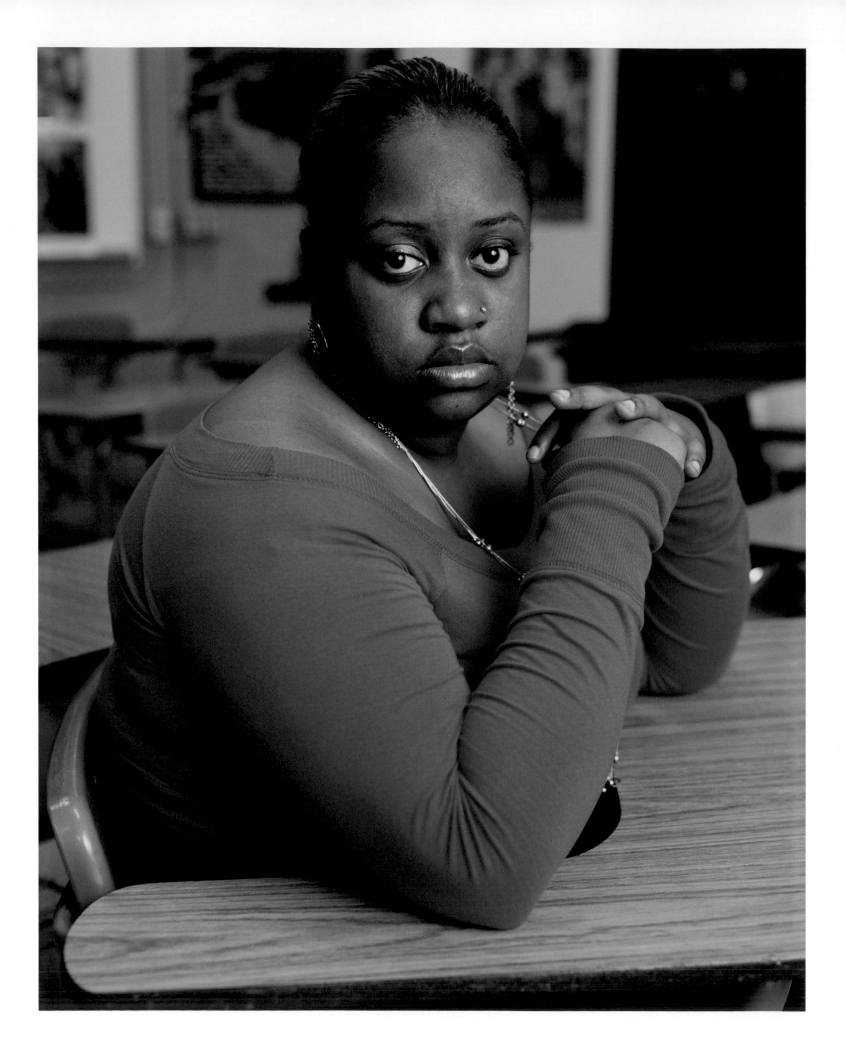

KELECHI

Words can't even express how much I love music. Growing up as a little girl I would sing every song on the radio. I knew then that music would be a big part of my life. I've played flute one year, violin two years, and the trumpet for seven years. I think that music is a way of life, it's a way for you to express how or what you're feeling. When I hear/see all the stuff that's going on in the world, I turn to God. Not only listening to what he says, but his music, "gospel." We can learn a lot from gospel music if we just take the time and listen to the words, 'cause many of us have questions and trust that gospel has the answers.

ERICK

I love it when I work on my trucks. I just bought a '96 GMC Z71 4x4. It's a beautiful truck, and I just love working on it. I took off the old muffler and pipes and put on flow masters so it would make it louder. The engine it had in it had power but not enough, so I put in a new engine, a 350-vortex engine. I also changed the tires and put in a nine-inch lift kit. I just love driving that truck. It makes me feel good.

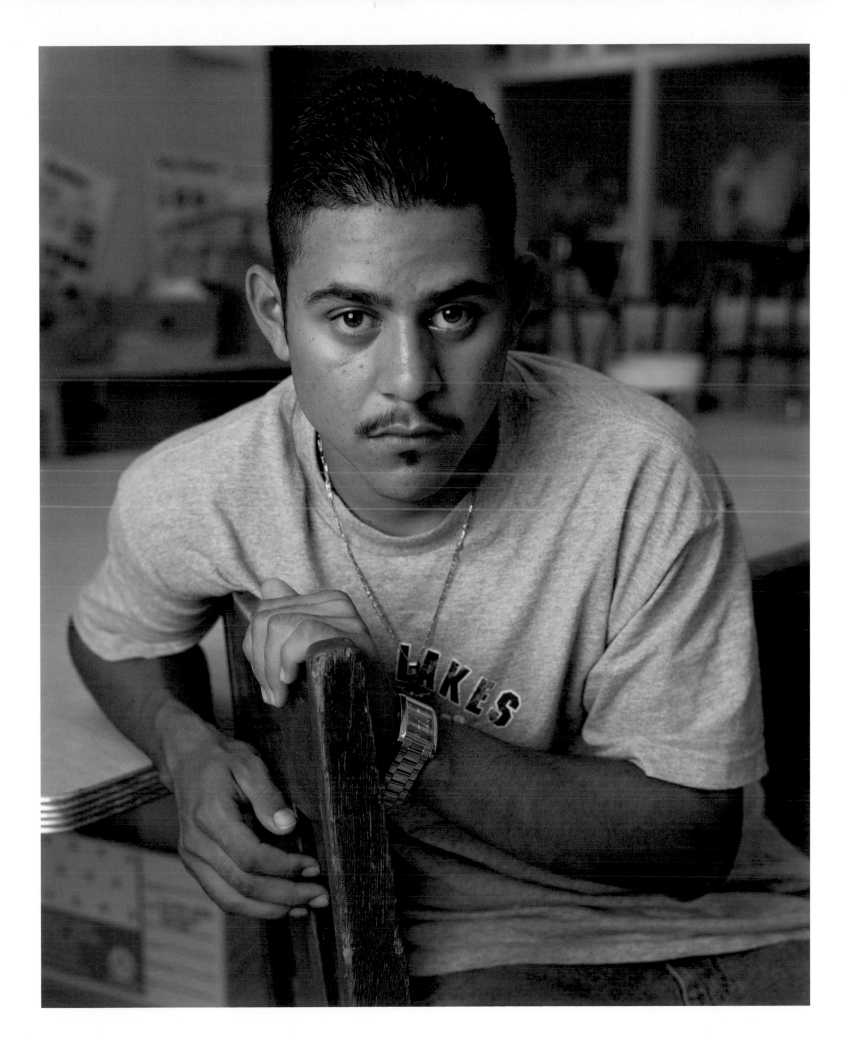

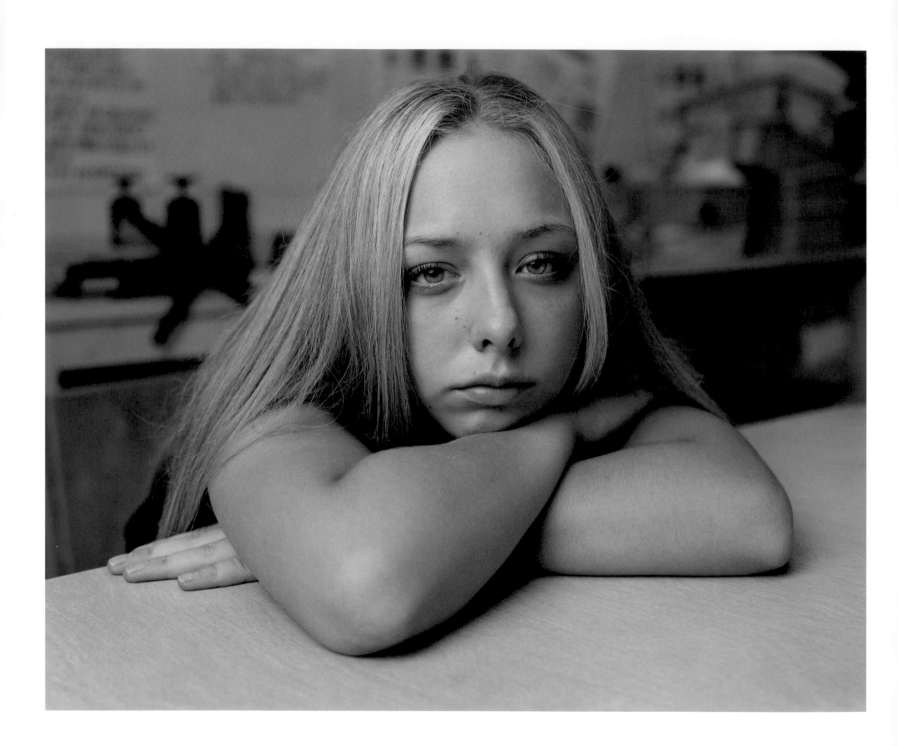

MICHELLE

I'm the kind of girl you would see on a hot sunny day lying on the beach reading a book. I'm the type of person who likes to relax and put my head in a book and take my mind to different places. I love sitting somewhere surrounded by nature just reading away. When you go on a road trip, people usually say to take some games to play on the way, but I would much rather take a book.

GERARD

I am a hardworking man and I am black. I have a nice smile and nice long hair.

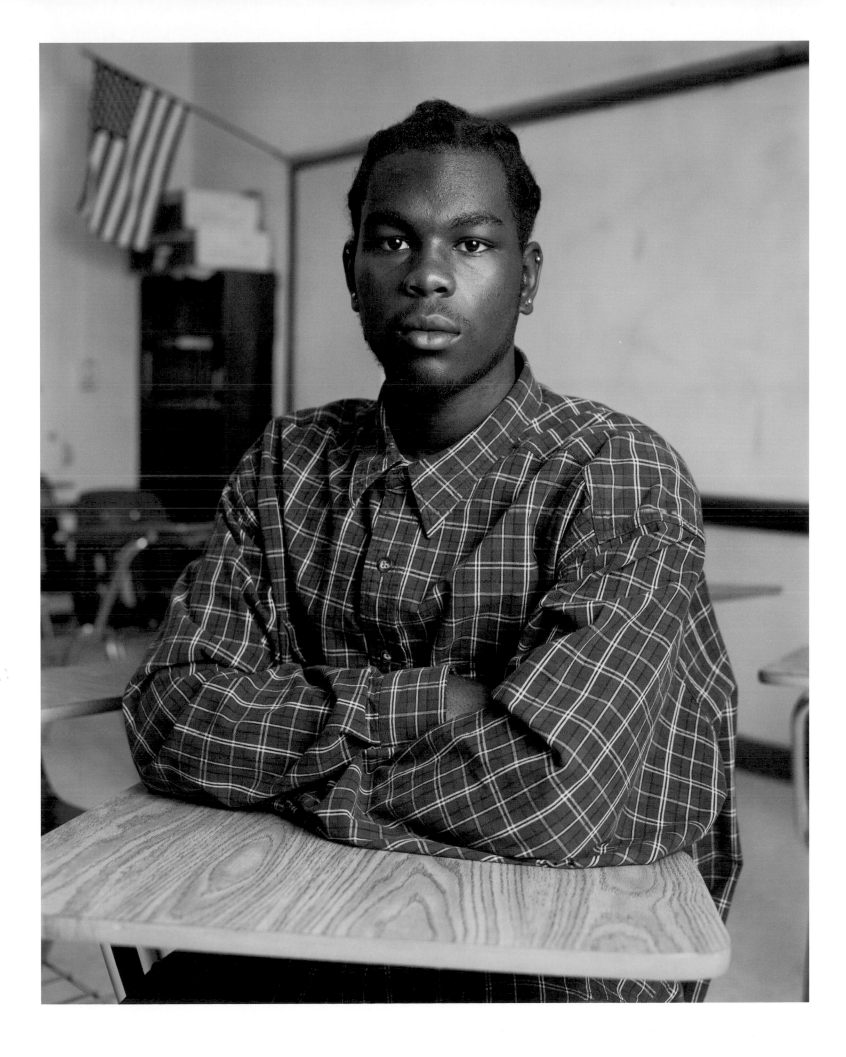

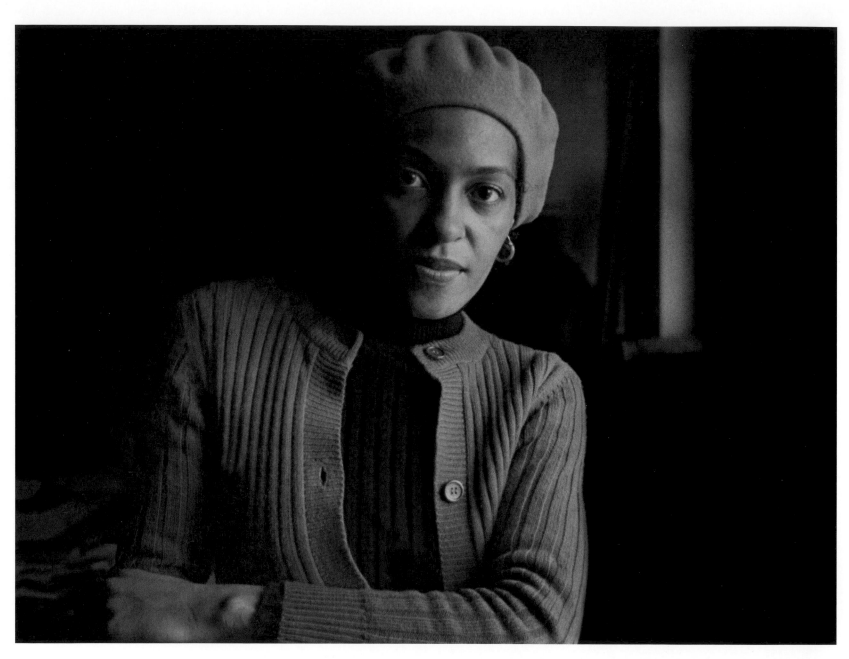

Carrie Mae Weems, 1976. Gelatin-silver print. Courtesy Carrie Mae Weems

INTERVIEW: DAWOUD BEY AND CARRIE MAE WEEMS

WEEMS: I have a great photograph you made of me at the Studio Museum in 1976 (opposite); I'd been one of your students for a couple of weeks by that time. I didn't realize then that you had been photographing "professionally" for only a year. You were so experienced that I just assumed you'd been doing it for years.

BEY: I wasn't even in art school yet. I had gotten my first camera when I was fifteen and had taken a class at the local Y. Maybe two years before I met you, I had worked in a commercial studio and learned a lot of the technical stuff I knew there. I began my academic career at the School of Visual Arts in New York about a year after I began teaching at the Studio Museum, and I continued to teach at the museum even while I was a student at the School of Visual Arts. Most of the artists that I had come in contact with at that early point were not photographers. They were people I came to know initially through what was the beginnings of my relationship with the Studio Museum in Harlem.

WEEMS: The Studio Museum has been a very important part of your life.

BEY: The Studio Museum has certainly been a constant in my life as an artist, going back to the very beginning, because the very first artist that I ever had sustained contact with was LeRoy Clarke at the Studio Museum. I would get on the train, come in from Queens, go up to the museum, and just stay there all day. LeRoy

Clarke would be talking, or maybe preaching would be a better word. . . . He would just preach at me all day while he made his work. That's when I began to get a sense that making art was about more than making interesting pictures, in terms of the role that art could potentially play in the larger cultural world of a particular community.

WEEMS: I know that you were born in Jamaica, Queens, New York, that you lived there in a rather middle-class family, that you went to visit Harlem occasionally because you had relatives who lived there.

BEY: My mother and father had actually lived there; they met in Harlem. My father was an electrical engineer by training, who later got his master's and then his doctorate in education at U-Mass-Amherst. My mother, in the way of many women in the 1950s, stopped working when my brother and I were born, and was a homemaker for pretty much all of her life.

My initial creative outlet was writing, and then music. I played music for quite a number of years. As a young artist, I was encouraged, even when my mother and father didn't quite understand what it was I was trying to do or how in the world I could possibly make a living at this. But there were no models for what I do in my family. I didn't grow up being taken to museums. My first trip to the Metropolitan Museum, to see the *Harlem on My Mind* show (1969), was on my own.

WEEMS: At a certain moment, you decided that Harlem was a place that you absolutely needed to work in—not Queens or Brooklyn or Midtown or the Village—but Harlem.

BEY: Certainly Harlem occupied a very big place in black sociocultural production, going back to Langston Hughes, going back to the Harlem Renaissance, going back to Marcus Garvey, going back to James Baldwin, going back to the collaboration of Roy DeCarava and Langston Hughes on *The Sweet Flypaper of Life* (1955), which I became familiar with very early on. So Harlem was both a place in my imagination and also a very real place in the history of my family. Even though I'd never actually lived there, I wanted to go back and make some photographs of my own that would have something to add to that history through my own observations about Harlem at that particular moment.

WEEMS: I want to think about how that experience shaped you, what you actually did there, and what you think about what you did there now that you have this distance.

BEY: When I began making those photographs on the streets of Harlem in 1974 and 1975, my intentions were rather rhetorical. To make a positive image of the people of Harlem that would stand in direct opposition to the more pathological representations of that community that had been constructed within the media. But once I actually began photographing, the challenge quickly changed from that to, How do I use the camera as a tool? How do I use that to talk about the experience of these people I was meeting?

WEEMS: At a certain moment, you had to shift from this idea of constructing the positive image to having a deeper experience, and it's in having that deeper experience that you construct a positive image.

BEY: One of the things that I've come to believe and one of the things that I began to find out in making that work

in Harlem all those years ago is that the best work tends to result not from a kind of imposition of an idea on the situation, but from being more truly responsive to what is going on once you get there. The idea is still meaningful, because it is the impetus that gets you out the door to go to this particular place. But once you get there, the work is driven not just by this idea but by the experiences that you're actually having, by the people that you're actually meeting, and by trying to find some way to honestly and clearly describe that experience. That's what began to happen for me once I was actually in the situation of Harlem, not the hypothetical situation of Harlem that I envisioned from Queens.

WEEMS: There is a philosophy governing the way that you've approached your search to construct an image, to construct a notion of something that is fundamentally more human. Could you talk about that idea of "fundamentally more human"?

BEY: I think what has been driving and directing my work for a long time is this idea that through making pictures I can affect viewers in such a way that they too will become invested in these subjects. Because I've chosen the camera as the means to do that, that compels me to find some interesting way to use it. Otherwise, why the camera? I could write, which I also do. But if you're going to use the camera, it requires that you be equally as invested in the means of production as you are in the subject. And that's been the thing that's really motivated my work over the years.

But it's driven, too, by a fundamental curiosity about the human subject. A curiosity about those people who have been marginalized.

WEEMS: There has been a history in your work of dealing with the black subject—not just with marginalized people, but often with the African-American subject first and foremost.

BEY: It has to do with my belief that, for artists, the deepest and most meaningful work can likely come from what you're most familiar with. Being that I am African-American, the black subject had been, certainly in my earlier work, the thing that I had the most ready access to, the thing that I have the most sustained knowledge of and the most sustained experience with. I mean, it's who I am. And also, from early on I have been aware of how the black subject has been represented, misrepresented, used, misused, abused, and deformed and degraded throughout the history of social and visual culture. That called for a response. And for me, the Harlem work was certainly about that, about finding a way to let the experience of those people in the photographs speak through my work.

WEEMS: I would say that the black subject can stand for much more than itself.

BEY: The thing that I have always hoped is that potentially any person standing in front of my photographs is able to see some aspect of himself or herself staring back. I really believe that if I could make photographs with that kind of subjectively transparent intent, then anyone could potentially identify some aspect of themselves in the work and, through that, forge a connection with it that hopefully would extend out into the world, too.

WEEMS: Let's start with the early Harlem work, so we have a context.

BEY: When I began the Harlem work, which was made with a 35 mm camera, I'm not sure I was even aware that there were other kinds of cameras. Even as I became interested in photographs by Walker Evans, I was not acutely aware of how those pictures were made, what tools were used to make them. So even though my early Harlem works are handheld 35 mm pictures, they are made almost as precisely and premeditatively as view-camera pictures. There's a kind of stillness to them. Because those are the kinds of pictures that I was looking

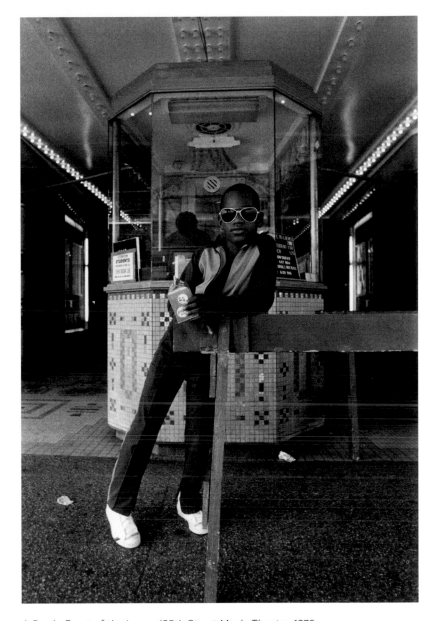

A Boy in Front of the Loews 125th Street Movie Theater, 1976. Gelatin-silver print

at, that I wanted to emulate, and it didn't occur to me at that point that they had been made with radically different cameras.

This idea about the relationship between the camera and the kinds of pictures I wanted to make became more evident to me as I continued working. Certainly, the material quality of the photographic object was very important to me. So I was able to use the 35 mm camera up to a point to make a kind of lush material description

of the subject matter that ultimately, about eight or nine years after I began the Harlem work, led me to use the 4-by-5-inch camera on a tripod. At that point, I more fully understood the relationship between the kinds of pictures I was trying to make and the kind of camera required to make those kinds of pictures, as well as the changing nature of the relationship when one uses a small camera held in the hand as opposed to a view camera on a tripod in the street, which lends a degree of almost ceremonial atmosphere to the proceedings. It's very deliberate, it's very slow, it requires a different level of participation.

WEEMS: So you went from the 35 mm to the 4-by-5-inch and then finally to the 20-by-24-inch Polaroids. What were the first major photographic projects that you produced, using a 35 mm, using a 4-by-5 inch, using a 20-by-24 inch?

BEY: As far as the 35 mm work, the Harlem pictures were the first major work that I made with some clear degree of intention. Then, beginning in 1988, still using black and white, I began what became the Brooklyn Street Portraits, the first sustained group of pictures that I made using the 4-by-5 camera and Polaroid Type 55 film. Then I continued the Street Portraits in different parts of the country.

WEEMS: So now we're really outside of Harlem. By 1988 you're starting to move around not just in terms of the technology but also your own advancing career as an artist.

BEY: By then my work was starting to be shown in galleries and museums. When I presented my show *Harlem, USA* at the Studio Museum (1979), that was the first time I seriously began to consider the museum as a site, not just the incidental place where works are shown. What kind of relationships to create between the institution as space, the hypothetical audience that moves through that space, and the objects on the wall were also

becoming part of how I was thinking about making the work, even as I was trying to reinvent the idea of picture making as a process.

WEEMS: What do you mean by "reinvent"?

BEY: To reinvent the process by asking myself a different set of questions about how the tool can be used to describe the human subject.

WEEMS: You can't photograph someone with a 4-by-5-inch camera the same as you can photograph with a 35 mm. It just won't happen. You can't photograph someone with a 20-by-24-inch Polaroid in the same way that you would photograph them with a 4-by-5. They require different kinds of consensus with the subject. This idea about reciprocity, this idea about consensus, this idea about a certain kind of collaboration, seems to me to be the thing that's also changing in the work.

BEY: I think that from the 35 mm work, to the 4-by-5 work, to the 20-by-24 work, and now the work that I'm doing again with the 4-by-5s plus text, there has certainly been a heightening of the process of engagement.

WEEMS: So this has been a very interesting route, hasn't it, from really working the streets and hanging out on that one street corner for hours at a time. The world is no longer the studio; the studio in fact is the world, and you're invited into this highly constructed, contained space where now something is going to be made, isolated from the environment, isolated from the larger sphere.

BEY: I've been bouncing back and forth between those different poles—being out in the world and then retreating from the world, but finding a way to bring the world into the studio. And now, with the recent work, where I'm going into the schools making pictures, I'm back out in the world, but I'm using the world to construct a kind of momentary studio situation in the classroom.

WEEMS: I want to address the predatory nature of the photographer . . .

BEY: Well, I have tried to banish this notion of the predatory act of making a picture. I'm not trying to capture anything. I'm not trying to bag something. I'm not trying to do any of those things that this predatory language describes. I know that predatory language is largely a habit, but it sets up a very problematic kind of relationship. I am very conscious of how I want to work in opposition to that tradition, to make it ever more consensual.

WEEMS: Is there a space where you feel more comfortable working at this point?

BEY: I feel most comfortable working in a space where I am, in some very real way, alone with the person and trying to use that very heightened situation to make a photograph. Because in the work that I'm doing now, the Class Pictures project, whenever I photograph the students in the classroom, it's just me, the student, the camera, and a light. I like the heightened sense of attention that we bring to each other under those circumstances. There are no distractions.

WEEMS: In the last few years, you've been doing a great deal of work with adolescents, with teenagers, photographing them, often using a 20-by-24-inch camera. When and how did you become interested in photographing children?

BEY: Teenagers.

WEEMS: Teenagers.

BEY: In 1992 I was invited by Jock Reynolds to be in residence for eight weeks at the Addison Gallery of American Art at Phillips Academy, which is a boarding school in Andover, Massachusetts. When I was photographing with the 4-by-5 in the street, I had made a number of photographs of young people. But when I

went to Phillips-Andover, that was the first time that I had sustained contact with a group of teenage subjects. Certainly the world of New England prep schools is very different from the world I grew up in. So I had my own preconceptions about what I would find when I got there. When I actually got there, those preconceived ideas, which turned out to be largely stereotypical, were pretty much blown out of the water. Among other things, there was, and there is, a very diverse population of young people, in terms of race, class, gender.

Spending eight weeks photographing them really began to make me think about how young people have traditionally been described within our visual culture. I think, for the most part, young people tend to come onto the social radar in terms of various kinds of problems—when they come on the radar at all. Because I was having such a rich experience photographing in Andover, I realized that I could probably make photographs of young people in a way that was quite different from the photographs of young people I had seen in the culture at that point.

WEEMS: Through your images, we have a kind of collective memory of young people who are between being children and adults, trying to figure out who they are in a shifting terrain.

BEY: My choice of the teenage subject stems, first of all, from a real belief that this society, in spite of all the rhetoric, really does not care as much about young people as it purports to. For all of this rhetoric about "leave no child behind," I don't think this society, quite frankly, really gives a shit about young people other than as a kind of periodic political football.

I'm trying to construct a kind of representation of the teenage subject that functions in opposition to those representations of teenagers as socially problematic or as engines for a certain consumerism. I think people tend to come to young people with a very specific sense of how they might be useful to some strategy, rather than

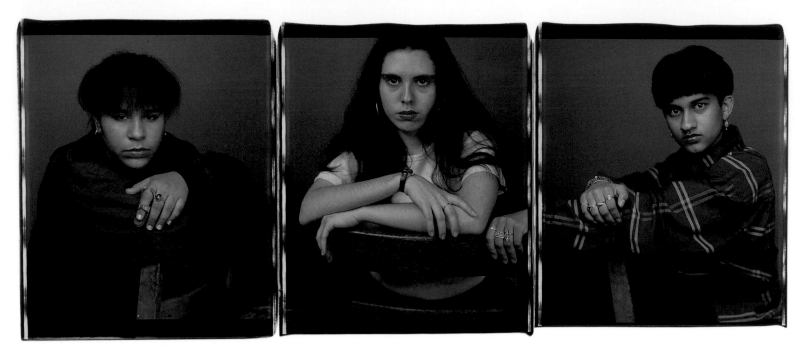

Nisha, Adalisse, and Taina, 1992. Three Polaroid prints, 30 x 66 in. (76.2 x 167.6 cm), overall.
Courtesy Rhona Hoffman Gallery, Chicago

just coming to them as a way of finding out what they're thinking about. Who are they, besides just someone to pile on some more CDs, to pile on more video games or more clothes or more things that they don't need, that advertising teaches them that they *do* need. Who are they beyond that?

WEEMS: Can you talk a little bit about the subjects in your pictures?

BEY: The teenage subject has been a kind of anchor for my work over the past fourteen years. The pictures have been made in radically different ways—single images, diptychs, triptychs, multiple images. So the teenage subjects are simultaneously speaking about the subject and speaking about how pictures can be made.

One of the things that I was very much aware of in all of the years before the Class Pictures project was how much information lies outside the photograph. Over the years, I began to want to bring more of that information into the construct of the work. And that's where the text comes in. I began working that way for the first

time in 2002. I had always had conversations with the students. Not while we were making the pictures, but before and after. And there were all kinds of things that they were telling me, none of which were apparent in the photograph.

WEEMS: Out of the mouths of babes . . .

BEY: Come the most profound things. The most profound things!

The first photographs that I made for the Class Pictures project were in three different high schools in Chicago. Originally, the photographs were shown in conjunction with an audio component in which the students were talking about their lives. Parabolic sound domes hung over the photographs, so that as you stood there looking at the pictures you also heard the voice of the subject (see page 14).

After that, I started asking students before I photographed them to just write something about themselves. I gave them a lined piece of paper with maybe two questions on the top, like "Tell me something about

yourself that you think no one knows," or "Tell me something about yourself that you'd like someone to know who couldn't possibly know this if they didn't know you." I wasn't sure if their written texts could have the same degree of immediacy as their spoken voices. But they did, and in some cases, even more so. So that became the basic framework for making the work.

They would come and meet me in the classroom at whichever school, and while I set up they would just sit quietly and write something about themselves. I wouldn't read it before making the picture, because I didn't want to read the text and then try to make a picture in response to that. Because I don't think that the text really tells you how to make a picture. Once they have left, I read the text, and the stories that they have told and what they have chosen to reveal about themselves have been quite extraordinary.

WEEMS: One of the things that I thought about looking at the photographs is that there's a very deep level of intimacy that's been established and that the student is highly aware of the seriousness in this endeavor. So what they are revealing in some cases are very deep, intimate, vulnerable places that maybe nobody else knows about. In some cases there is a vast distance between what is written and what the subject looks like.

BEY: When these photographs and texts have been shown, I've had any number of people, from the students' parents to teachers who know them well, come up and tell me: "I never had a clue; she's been in my class for four years, and I didn't know; now I understand what's going on."

WEEMS: Looking at the photographs in *Class Pictures*, I notice that they are formally changing. Do you see that change?

BEY: Certainly the thing that I am aware of and have been aware of is the challenge that is presented in photographing the human subject. Because, after all, how many things can the human body do gesturally?

Answering that question is part of what continues to motivate the work, to try to locate some individually idiosyncratic gesture or response that speaks perhaps to the nature of who this person is in front of the camera. There is a challenge of having to reinvent the idea almost each time, so that I don't make the same picture again and again and again.

I try to take my gestural cues, my behavioral cues, from the person, and then work with the person to shape that to the rectangular form. If it is a burden, that's the burden that the photographer has to deal with, this immovable rectangular form into which everything has to fit and flow.

WEEMS: But the only thing that really changes in a fundamental way is what your relationship is with the subject at any given moment.

BEY: With these pictures, what's interesting is that the transaction and relationship that I have with each student tends to be very brief but intense. Because most of these students have been released from one class period for forty-five minutes, in order to work with me to make a picture. So, interestingly enough, a lot of the improvisational things about picture-making that I learned from working with the small camera early on have served me well in being able to think quickly in making the work.

WEEMS: I'm wondering to what extent your experience as a musician helps you immediately engage intimately with a subject, where you have to work very quickly, think very, very fast about how you're going to ask that person to reveal something that he or she might not share with anybody else.

BEY: There's a confidence that comes with musical improvisation. You understand what the form is, you understand what the parameters are, and then you jump in with the experience that once you start, you can't stop until the process is finished.

WEEMS: One of the things that I find so astonishing about the single portraits is that in the end you're really just left with an intimacy between you and that other person.

BEY: I agree. The technology is the other thing that continues to make it interesting for me. But it is ultimately about that relationship with the person. Over the years, I've devised various ways of getting at that, through different processes, through different materials, through different formal strategies, even through different ways of conceiving projects, moving from the public street to the public institution. But none of those things can substitute, in the end, for the need to make a compelling description of the subject that will lead to some kind of response by the viewer.

WEEMS: I was thinking, as you spoke, about the early work of Larry Clark. Can you talk about the difference between Larry's approach and the kinds of photographs you're making?

BEY: Well, interestingly enough, Larry Clark, certainly at the time of the Tulsa photographs, was making those pictures from the vantage point of an insider. The experiences of the people in the photographs were simultaneously his own experiences. He was a momentary outsider at the point at which he introduced the camera into the situation. But all of the things that they were doing in the pictures, we can presume he was doing as well. He was the same age. Those were his friends. Those were the people he was hanging out with.

In the case of my own work, there is certainly the issue of presumed difference, the most immediate one being difference in age, and then, of course, there's the difference in race and gender. I have very consciously taken this on as one of the inherent challenges of the work, in response to the question: Is it possible to transcend the boundaries of difference and still make a credible and meaningful representation of the subject?

Does one have to be twenty-five years old and black to speak credibly for the experience of someone who is twenty-five years old and black? Does one have to be gay and white in order to be able to speak legitimately and credibly about that experience? Is it possible to transcend lines of difference and find a way to make work with some meaningful common denominator that transcends all of those things? I'm very much aware of that challenge, and I set out to take it on in a very direct kind of way.

WEEMS: It seems as though your project conceptually has really opened up the issue of African-American subjects. But it's not a specific goal in and of itself any longer.

BEY: Earlier on, I saw African-Americans as being a seriously beleaguered and essentialized subject. That became the immediate point of departure for my earlier work—to make a set of images that would lead to something rather unspectacular, which was the representation of black normalcy.

WEEMS: I can think of few representations made by artists, in a consistent and sustained way, of African-Americans who come from the upper echelons of society or even of the middle class. For the most part, the vast majority of the imagery that exists seems to be of the working classes or the urban poor. I'm wondering why you think that continues to be the case, and if in your work you think about redressing that structure.

BEY: The whole idea of *Class Pictures*, and the title for it, is very much about that. Because within this work, a photograph can come from very privileged prep schools or very troubled urban schools. So I'm aware of that, and I wanted to use it in this work, even though it's not always readily apparent which are which.

WEEMS: This brings up another question. I know that you've taken hundreds of photographs. How do you edit and select? What are the qualifications for those that will remain, for those that will be put back in the box, maybe not to see the light of day for a while?

BEY: The selection of photographs for this project has been somewhat difficult, because I am dealing with both the quality and weight of the text, and the quality and weight of the photograph. Sometimes the photograph carries a little bit more weight than the text. Sometimes the visual representation is stronger and has more nuance and drama than the text. Occasionally, I've had situations in which the weight of the story is not quite matched by the photograph, which I still believe has to have its own intrinsic level of interest as a visual object. The text does not make the photograph more interesting. It's either an interesting photograph or it's not. So for me, the initial editing process begins with the photograph.

WEEMS: Finally, you say that you've answered the questions that you needed to answer with the Class Pictures series. Can you tell me what some of those questions were, and then maybe what some of the answers were?

BEY: One of the questions was how to make work that continues to be both socially and aesthetically engaging. The work is an articulation of a certain set of values, and I teach out of that set of values. That's what makes the work meaningful to me. You know how, in the late 1960s and early '70s, they used to say, "You're either part of the solution or you're part of the problem." I kind of bought into that. I don't believe that the world is so absolutely black and white at this point, but I do know that I would rather my work be a part of the solution. I do believe that, in some real way, we all have the potential to be part of the solution, and that's also what motivates my work.

WEEMS: I know that, in a lot of ways, I've sacrificed my personal comfort, and at times I think I've even sacrificed my personal happiness, in order to follow through on a deeper social commitment. I wonder to what extent your notion of commitment and responsibility and principle and practice has impacted on your life.

BEY: In addition to the sacrificing, I think there is also what you might call the joy in struggle. There is tremendous joy to what I do. It's a real privilege to determine how you're going to live your life and to do the things that you believe matter, even if there is a price to be paid. Because quite frankly, there's a price to be paid either way. I'd rather pay the price knowing that I'm doing something that has the potential to meaningfully impact on the human community in a good way. If the ideas that I'm proposing through my work are able to seep into the culture of this time, then I think there is something very meaningful to that. I think there's a real joy in being able to pay the price in making the choices that you want to make as opposed to having those choices imposed on you. Don't you think so?

This interview took place in San Francisco, September 29–30, 2006.

LIST OF PLACES

Chicago, 2002–3
ARTIST IN RESIDENCE, DAVID AND ALFRED SMART MUSEUM OF ART
Kenwood Academy
South Shore High School
University of Chicago Laboratory School

Detroit, 2003
ARTIST IN RESIDENCE, DETROIT INSTITUTE OF ARTS
Chadsey High School

Eatonville and Orlando, Florida, 2003
ARTIST IN RESIDENCE, ZORA NEALE HURSTON NATIONAL MUSEUM OF FINE ARTS, EATONVILLE
Edgewater High School, Orlando

Andover and Lawrence, Massachusetts, 2005
ARTIST IN RESIDENCE, ADDISON GALLERY OF AMERICAN ART
Phillips Academy, Andover
Lawrence High School

New York, 2006
ARTIST IN RESIDENCE, STUDIO MUSEUM IN HARLEM
Young Women's Leadership School, Manhattan
Mother Cabrini High School, Manhattan
Bronx Academy of Letters
Millennium High School, Manhattan
Fashion Industries High School, Manhattan
Fiorello H. La Guardia High School, Manhattan
Christopher Columbus High School, the Bronx
High School for History and Communication, Manhattan

San Francisco, 2006
ARTIST IN RESIDENCE, SAN FRANCISCO ARTS EDUCATION PROJECT
School of the Arts
Gateway High School

LIST OF PLATES

All photographs are chromogenic prints, either 30 x 40 in. (76.2 x 101.6 cm) or the reverse.
They are printed in an edition of four, with two artist's proofs, and are accompanied by text.

PAGE 25
RASEC, 2005. Lawrence High School,
Lawrence, Massachusetts

PAGE 26
USHA, 2006. Gateway High School,
San Francisco

PAGE 29
THERESA, 2003. South Shore High
School, Chicago

PAGE 31
JAMES, 2005. Lawrence High School,
Lawrence, Massachusetts

PAGE 32
CHRIS, 2003. South Shore High School,
Chicago

PAGE 35
AMY, 2005. Phillips Academy,
Andover, Massachusetts

PAGE 37
DIMITRIUS, 2003. Chadsey High School,
Detroit

PAGE 38
GERALDO, 2005. Lawrence High School,
Lawrence, Massachusetts

PAGE 40
MGBECHI, 2005. Phillips Academy,
Andover, Massachusetts

PAGE 42
CHARLES, 2005. Phillips Academy,
Andover, Massachusetts

PAGE 45
SAHENDY, 2005. Lawrence High School,
Lawrence, Massachusetts

PAGE 46
ANTOINE, 2006. School of the Arts,
San Francisco

PAGE 49
SIMONE, 2003. Kenwood Academy,
Chicago

PAGE 51
CATHERINE, 2006. Fashion Industries
High School, New York

PAGE 52
AURELIANO, 2003. Chadsey High
School, Detroit

PAGE 55
SHALANTA, 2003. Edgewater High
School, Orlando, Florida

PAGE 56
SARAH, 2003. University of Chicago
Laboratory School

PAGE 59
ZIARRA, 2006. Young Women's
Leadership School, New York

PAGE 60
ALEJANDRO, 2005. Phillips Academy,
Andover, Massachusetts

PAGE 63
NOHELY, 2005. Lawrence High School,
Lawrence, Massachusetts

PAGE 65
TERRANCE, 2005. Phillips Academy,
Andover, Massachusetts

PAGE 66
KENDRA, 2005. Lawrence High School,
Lawrence, Massachusetts

PAGE 68
JULIA, 2003. University of Chicago
Laboratory School

PAGE 71
BARRET, 2005. Lawrence High School,
Lawrence, Massachusetts

PAGE 72
MARIA, 2005. Lawrence High School,
Lawrence, Massachusetts

PAGE 74
YAHMÁNEY, 2003. Chadsey High School,
Detroit

PAGE 76
AUSTIN, 2003. Edgewater High School,
Orlando, Florida

PAGE 79
CAROLYN, 2003. University of Chicago
Laboratory School

PAGE 81
QUENTIN, 2003. Edgewater High
School, Orlando, Florida

PAGE 82
MARCO, 2006. Gateway High School,
San Francisco

CHRONOLOGY

NOVEMBER 25, 1953
Born David Edward Smikle in Jamaica, Queens, New York, to Kenneth and Mary Smikle.

1968
Receives first camera (an Argus C3 rangefinder that had belonged to his late godfather) as a gift from his godmother, Alethea Miller. Receives first set of drums.

1969
Makes first visit to a museum, to see the exhibition *Harlem on My Mind*, Metropolitan Museum of Art, New York.

EARLY 1970S
Changes his name to Dawoud Bey.

1973–74
Apprentices to Levey J. Smith at MOT Photography Studio, Hollis, New York.

1974
Begins spending time at the Studio Museum in Harlem.

1975
Begins black-and-white portrait series, Harlem, USA.

1976
Begins teaching photography at the Studio Museum in Harlem; also teaches at Jamaica Arts Center, in Queens. Begins spending time at Wesusi Nyumba Ya Sana Gallery, Harlem. Meets photographers Frank Stewart and Jeanne Moutoussamy, and mounts a three-person exhibition with them at Benin Gallery in Harlem.

1977
Begins frequenting the 4th Street Photo Gallery, New York; meets its director, Alex Harsley.

1977–78
Studies at School of Visual Arts, New York. His teachers include William Broecker, Sid Kaplan, Larry Siegel, and Shelley Rice. Meets fellow students Albert Chong and Lorna Simpson.

1978–81
Leaves School of Visual Arts to accept an artist's position with the Cultural Council Foundation CETA Artists Project, New York.

Completes the Harlem, USA photographs while in the CETA Artists Project, with sponsorship by the Studio Museum in Harlem. Teaches at the New Muse Community Museum, Brooklyn.

1979
Has first one-person exhibition, *Harlem, USA*, at the Studio Museum in Harlem.

Included in *Harlem: The Last Ten Years*, International Center of Photography, New York.

1982
Marries Candida Alvarez (divorced 2006).

1983
Receives artist fellowship, Creative Artists Public Service (CAPS), New York.

1985
Receives residency fellowship at Light Work, Syracuse, New York.

1986
Receives artist fellowship, New York Foundation for the Arts.

1987
Included in *New American Photographs*, Fogg Art Museum, Cambridge, Massachusetts; and *Out of the Studio: Photography and Community*, P.S.1 Museum, New York.

1988
Begins Brooklyn Street Portraits series, his first body of work using a 4-by-5-inch camera. Attends Empire State College, State University of New York, Saratoga Springs.

1989
Artist in residence, Visual Studies Workshop, Rochester, New York.

Included in *The Blues Aesthetic: Black Culture and Modernism*, Washington Project for the Arts, Washington, D.C., and tour; and *US/UK Photography Exchange: Transatlantic Dialogues*, Camerawork Gallery, London, and tour.

1990
Graduates from Empire State College with a BA in photography. Receives artist fellowship, New York Foundation for the Arts. Included in *Home: Contemporary Urban Images by Black*

Photographers, Studio Museum in Harlem; and *Un Couteau dans la photo,* Galerie du Jour, Paris.

1991
Son, Ramon Alvarez-Smikle, is born.

Begins MFA program at Yale University School of Art, New Haven, Connecticut.

Receives regional fellowship from the National Endowment for the Arts.

Receives award from Polaroid Artist Support Program, which facilitates working in Polaroid's 20 x 24 Studio in New York (also in 1992 and 1993).

Included in *New York Time,* de Meervart Cultural Centre, Amsterdam.

1992
Invited by Jock Reynolds to be Edward E. Elson Artist in Residence for eight weeks at the Addison Gallery of American Art, Phillips Academy, Andover, Massachusetts (also in 1997 and 2005).

1993
Graduates from Yale University School of Art, with an MFA.

Artist in residence, Museum of Contemporary Photography, Columbia College, Chicago; and Providence St. Mel High School, Chicago.

Commissioned by the Museum of Modern Art, New York, to make a portrait of each of the museum's life trustees.

1994–95
Visiting assistant professor of art at Kenyon College, Gambier, Ohio.

1995
Artist in residence, Walker Art Center, Minneapolis; and Wexner Center for the Arts, Columbus, Ohio.

1995–98
Assistant professor of art, Mason Gross School of the Arts, Rutgers University, New Brunswick, New Jersey.

1996
Artist in residence, *Picturing the South: The Commission Project,* High Museum of Art, Atlanta; and Wadsworth Atheneum, Hartford, Connecticut.

1997
Artist in residence, Cleveland Center for Contemporary Art; and Queens Museum of Art, New York.

1998–PRESENT
Professor of photography, Columbia College Chicago.

1998
Included in *Transatlantic Connections,* Royal Scottish Academy, Edinburgh, and tour.

Artist in residence, National Portrait Gallery, London.

1999
Included in *Ghost in the Shell: Photography and the Human Soul, 1850–2000,* Los Angeles County Museum of Art; and *Beyond the Photographic Frame,* Art Institute of Chicago.

Artist in residence, International Artist's Studio Program in Sweden (IASPIS), Stockholm; Parrish Art Museum, Southampton, New York; and Yale University Art Gallery, New Haven, Connecticut.

Commissioned by the Center for Documentary Studies at Duke University, Durham, North Carolina, to make new photographs for *Indivisible,* a national documentary project.

2000
Multiple-image Polaroid portraits of teenagers from the Parrish Art Museum, Southampton, New York, and Queens Museum, New York, residency projects are included in the Whitney Biennial.

Included in *Indivisible: Stories of American Community,* Terra Museum of American Art, Chicago, and tour; *Surface and Depth: Trends in Contemporary Portrait Photography,* Hood Museum of Art, Hanover, New Hampshire; *The Persistence of Photography in American Portraiture,* Yale University Art Gallery, New Haven, Connecticut; and *Representing: A Show of Identities,* Parrish Art Museum, Southampton, New York.

2001
Included in *Interpreting Experience: Bey, DeCarava, Van Der Zee,* Sheldon Memorial Art Gallery, Lincoln, Nebraska; and *The Poetics of Portraiture: From the Sixteenth to the Twenty-first Century,* William Benton Museum of Art, Storrs, Connecticut.

2002
Receives John Simon Guggenheim Memorial Foundation Fellowship.

Included in *Visions from America: Photographs from the Whitney Museum of American Art, 1940–2000,* Whitney Museum of American Art, New York; *Designing the Future: The Queens Museum,* Queens Museum of Art, New York; and *Cut, Pulled, Colored and Burnt,* Hyde Park Art Center, Chicago.

Artist in residence, David and Alfred Smart Museum of Art, Chicago. Starts the Class Pictures series at the Smart Museum, using a 4-by-5-inch camera; incorporates audio elements in the resulting exhibition.

Joins with Carrie Mae Weems in the artist group A Social Studies Project to pursue socially engaged collaborative art projects.

2003
Included in *Embracing Eatonville,* with Carrie Mae Weems, Lonnie Graham, and Deborah Willis (a collaboration between A Social Studies Project and Light Work, Syracuse, New York); *Only Skin Deep,* International Center of Photography, New York; *Hair Stories,* Scottsdale Museum of Contemporary Art, Scottsdale, Arizona, and tour; and *Growing Up: Childhood in America,* Montclair Art Museum, Montclair, New Jersey.

Artist in residence, Detroit Institute of Arts; Zora Neale Hurston National Museum of Fine Arts, Eatonville, Florida; and the Reclamation Project, California State University, Monterey Bay. In the Detroit residency, first incorporates written statements in the Class Pictures series and completes his first video project, *Four Stories.*

2004
Included in *The Amazing and the Immutable,* Contemporary Art Museum, University of South Florida, Tampa, and tour; *Innocence Exposed: The Child in Modern Photography,* Frist Center for the Visual Arts, Nashville; *Inside Out: Portrait Photographs from the Permanent Collection,* Whitney Museum of American Art, New York; *Social Studies: Eight Artists Address Brown v. Board of Education,* Krannert Art Museum, Champaign, Illinois, and tour; and *Fresh: Youth Culture in Contemporary Photographs,* Center for Photography at Woodstock, Woodstock, New York.

2005
Included in *The Jewish Identity Project: New American Photography,* Jewish Museum, New York, and tour; *Back to Black: Art, Cinema, and the Racial Imagination,* Whitechapel Gallery, London; *Nine Portraits,* Stephen Wirtz Gallery, San Francisco; *Beyond Big: Oversized Prints, Drawings, and Photographs,* Detroit Institute of Arts; *HRLM: Pictures,* Studio Museum in

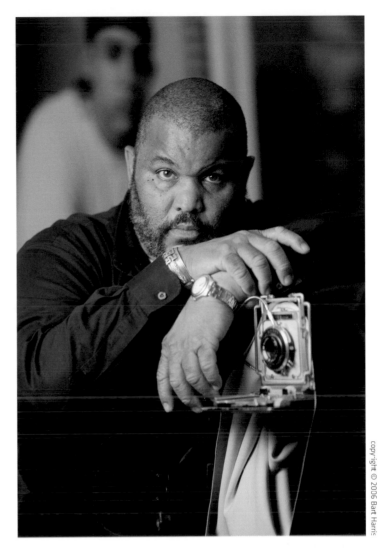

Dawoud Bey, 2006

Harlem; *Likeness: Portraits of Artists by Other Artists,* Institute of Contemporary Art, Boston; and *African Queen,* Studio Museum in Harlem.

2006
Included in *Portraiture Now,* National Portrait Gallery, Washington, D.C.; *Photographs by the Score: Personal Visions Twenty-some Years Apart,* Art Institute of Chicago; *Aura of the Photograph: Image as Object,* Harn Museum of Art, Gainesville, Florida; *Double Exposure: African Americans Before and Behind the Camera,* Wadsworth Atheneum, Hartford, Connecticut; and *Beyond Sight,* Studio Museum in Harlem.

Artist in residence, San Francisco Arts Education Project; Studio Museum in Harlem.

SOLO EXHIBITIONS

1979
Harlem, USA, Studio Museum in Harlem, New York

1983
Dawoud Bey: Recent Photographs, Cinque Gallery, New York

1984
Puerto Rico: A Chronicle, Center for Puerto Rican Studies, Hunter College, New York

1986
Dawoud Bey, Light Work, Syracuse, New York

Photographs by Dawoud Bey, Midtown Y Photography Gallery, New York

Dawoud Bey, Blue Sky Gallery, Portland, Oregon

1988
Brooklyn Street Portraits, BACA Downtown Center for the Arts, Brooklyn

1990
Recent Photographs, Ledel Gallery, New York

1991
Dawoud Bey, Fogg Art Museum, Harvard University, Cambridge, Massachusetts

1992
Dawoud Bey: Photographic Portraits, Addison Gallery of American Art, Phillips Academy, Andover, Massachusetts

Dawoud Bey: Photographs, Rotunda Gallery, Brooklyn

1993
Polaroid Portraits, Museum of Contemporary Photography, Chicago

Dawoud Bey: Photographs, Stockton State College, Pomona, New Jersey

Photographs from the Streets, Drew University, Madison, New Jersey

1994
Dawoud Bey Photographs: Portraits, Cleveland Museum of Art

Dawoud Bey, Olin Art Gallery, Kenyon College, Gambier, Ohio

1995
Dawoud Bey: Portraits, 1975–1995, Walker Art Center, Minneapolis, and tour

Dawoud Bey, Photographers' Gallery, London

1996
Dawoud Bey, David Beitzel Gallery, New York

Dawoud Bey, Fine Arts Center, University of Massachusetts, Amherst

Picturing the South: The Commission Project, High Museum of Art, Atlanta

Dawoud Bey: Residency Exhibition, Wexner Center for the Arts, Columbus, Ohio

Dawoud Bey, Rena Bransten Gallery, San Francisco

1997
Dawoud Bey: Recent Work, Rhona Hoffman Gallery, Chicago

Dawoud Bey: Portraits, Light Factory, Charlotte, North Carolina

Dawoud Bey: Recent Photographic Portraits, Addison Gallery of American Art, Phillips Academy, Andover, Massachusetts

Dawoud Bey/Matrix 132 and *Dawoud Bey Selects from the Amistad Collection,* Wadsworth Atheneum, Hartford, Connecticut

1998
Dawoud Bey, Galerie Nordenhake, Stockholm

Dawoud Bey, Queens Museum of Art, New York

1999
Dawoud Bey: Recent Work, Rhona Hoffman Gallery at Gallery 312, Chicago

Dawoud Bey: The Southampton Project, Parrish Art Museum, Southampton, New York

Portraits of New Haven Teenagers, Yale University Art Gallery, New Haven, Connecticut

2001
Dawoud Bey, Rena Bransten Gallery, San Francisco

2002
Dawoud Bey, Gorney Bravin + Lee, New York

Dawoud Bey: New Photographic Work, Rhona Hoffman Gallery, Chicago

2003

Dawoud Bey: The Chicago Project, David and Alfred Smart Museum of Art, Chicago

2004

Dawoud Bey: Detroit Portraits, Detroit Institute of Arts

Class Pictures, Gorney Bravin + Lee, New York

Dawoud Bey: The Watsonville Series, Revolution, Ferndale, Michigan

2007

Dawoud Bey: New Works, Rhona Hoffman Gallery, Chicago

Dawoud Bey, Howard Yezerski Gallery, Boston

Class Pictures, Addison Gallery of American Art, Phillips Academy, Andover, Massachusetts

SELECTED BIBLIOGRAPHY

BOOKS AND CATALOGS

Anderson, Maxwell, Michael Auping, Valerie Cassel, Hugh M. Davies, Jane Farver, Andrea Miller-Keller, and Lawrence R. Rinder. *2000 Biennial Exhibition,* pp. 62–63. New York: Whitney Museum of American Art, 2000.

Bey, Dawoud. *Dawoud Bey: Portraits, 1975–1995.* With contributions by Kellie Jones, A. D. Coleman, Jessica Hagedorn, and Jock Reynolds. Minneapolis: Walker Art Center; New York: Distributed Art Publishers, 1995.

Billops, Camille. "Three Photographers." In *Artist and Influence,* edited by James V. Hatch, vol. 9, pp. 129–41. New York: Hatch-Billops Collection, 1991.

Blessing, Jennifer. *Photographs from the Buhl Collection,* pp. 86–87. New York: Guggenheim Museum; Distributed Art Publishers, 2004.

Chevlowe, Susan, Joanna Lindenbaum, and Ilan Stavans. *The Jewish Identity Project: New American Photography,* pp. 48–55, 187–88. New Haven, Conn.: Yale University Press; New York: Jewish Museum, 2005.

Ehlers, Carol. *Chicago Photographs,* pp. 28, 108. Chicago: LaSalle Bank; New York: Distributed Art Publishers, 2004.

———. *One of a Kind: Portraits from the LaSalle Bank Photography Collection,* pp. 68–69. Chicago: LaSalle Bank; New York: Distributed Art Publishers, 2006.

Fusco, Coco, and Brian Wallis. *Only Skin Deep,* p. 374. New York: International Center of Photography, 2004.

Galassi, Peter. *Walker Evans and Company,* p. 133. New York: Museum of Modern Art; Harry N. Abrams, 2000.

Hall, Stuart, and Mark Sealy. *Different,* pp. 58–60, 65, 135–37. London: Phaidon Press, 2001.

Heckert, Virginia, and Robert Kingston. *The Amazing and the Immutable,* pp. 35–36. Tampa, Fla.: Contemporary Art Museum, 2004.

Hitchcock, Barbara. *Innovation/Imagination: Fifty Years of Polaroid Photography,* pp. 112, 116. New York: Harry N. Abrams, 1999.

Kozloff, Max, and Greg Tate. *Dawoud Bey: Recent Photographs.* New York: Ledel Gallery, 1990.

Lawrence-Lightfoot, Sarah. "Dialogue." In *Respect: An Exploration,* pp. 119–52. New York: Perseus Books, 1999.

Letinsky, Laura, and Elizabeth Bloom. *Space/Site/Self,* pp. 12, 51–52, 73. Chicago: David and Alfred Smart Museum of Art, 1998.

Miller, Denise. *Photography's Multiple Roles: Art, Document, Market, Science,* pp. 37, 38, 230. Chicago: Museum of Contemporary Photography; New York: Distributed Art Publishers, 1998.

Patton, Sharon F. *African American Art,* pp. 267, 270–71. New York: Oxford University Press, 1998.

Powell, Richard J. *Black Art and Culture in the 20th Century,* pp. 184, 187. London: Thames and Hudson, 1997.

Rothfuss, Joan, and Elizabeth Carpenter. *Bits and Pieces Put Together to Present a Semblance of a Whole: Walker Art Center Collections,* pp. 131, 132. Minneapolis: Walker Art Center; New York: Distributed Art Publishers, 2005.

Sancho, Victoria A. T. "Respect and Representation: Dawoud Bey's Portraits of Individual Identity." In *Third Text: Third World Perspectives on Contemporary Art and Culture,* no. 44, pp. 55–66. London: Kala Press, 1998.

Smith, Stephanie, ed. *Dawoud Bey: The Chicago Project.* With contributions by Don Collison, Elizabeth Meister, and Jacqueline Terrassa. Chicago: David and Alfred Smart Museum of Art; University of Chicago Press, 2004.

Sobieszek, Robert A. *Ghost in the Shell: Photography and the Human Soul, 1850–2000,* pp. 158, 162. Los Angeles: Los Angeles County Museum of Art; Cambridge, Mass.: MIT Press, 1999.

Tokyo Metropolitan Museum of Photography. *American Perspectives: Photographs from the Polaroid Collection,* pls. 65, 66. Tokyo: Tokyo Metropolitan Museum of Photography, 2000.

Willis-Thomas, Deborah. *Black Photographers: An Illustrated Bio-Bibliography, 1940–1987,* pp. 16–17, 187–89. New York: Garland, 1985.

Willis, Deborah, ed., and Michael Cottman. *The Family of Black America,* pp. 84–89. New York: Crown, 1996.

Willis, Deborah. *Reflections in Black: A History of Black Photographers, 1840 to the Present,* pp. x, 190–91, 265, 280. New York: W. W. Norton, 2000.

Wolf, Sylvia, Sondra Gonzalez-Falla, and Andy Grundberg. *Visions from America: Photographs from the Whitney Museum of American Art.* New York: Whitney Museum of American Art; Munich: Prestel, 2002.

ARTICLES

Aletti, Vince. "Choices: An Opinionated Survey of the Week's Events–Photo." *Village Voice,* February 24, 1987.

———. "Portrait in Black." *Village Voice,* April 17, 1990.

Cotter, Holland. "Art in Review: Dawoud Bey." *New York Times,* October 25, 1996.

Curtia, James. "Thinking Man's Photos." *Portfolio Magazine,* October 1996, p. 18.

Curtis, Cathy. "Something to Smile About." *Los Angeles Times,* April 22, 1997.

Foerstner, Abigail. "Photography: Dawoud Bey Specializes in Capturing the Big Picture." *Chicago Tribune,* November 5, 1993.

Glueck, Grace. "Art Review: A Century's Worth of Efforts to Capture a City's Essence." *New York Times,* October 30, 1998.

———. "Photography Review: American Jewishness in All Its Infinite Variety." *New York Times,* October 10, 2005.

Hamlin, Jesse. "Traveling to High Schools Nationwide, Dawoud Bey Puts a Face on Teen Life." *San Francisco Chronicle,* December 13, 2005.

Iverem, Esther. "Portraits across the Seas." *New York Newsday,* August 23, 1989.

Johnson, Ken. "Art Review: Seen and Heard: Under the Spell of Childhood and Its Trappings." *New York Times,* August 20, 1999.

———. "Photography Review: Enigmatic Portraits of Teens Free of All Context." *New York Times,* August 21, 1998.

Kimmelman, Michael. "A New Whitney Team Makes Its Biennial Pitch." *New York Times,* March 24, 2000.

Lifson, Ben. "Reviews: Dawoud Bey." *Artforum* 36 (February 1997): 87–88.

Lippard, Lucy. "Commentary." *Nueva Luz 1,* no. 2 (1986): 32–33.

Nance, Kevin. "The Power of Eye Contact: Dawoud Bey's Teens Connect with Viewers." *Chicago Sun-Times,* October 4, 2006.

Reid, Calvin. "Review of Exhibitions: Dawoud Bey at David Beitze." *Art in America* 85 (April 1997): 113.

Schwabsky, Barry. "Photography: Redeeming the Humanism in Portraiture." *New York Times,* April 20, 1997.

Sengupta, Somini. "Portrait of Young People as Artists." *New York Times,* January 18, 1998.

Stein, Lisa. "Face to Face with Teens through Bey's Lens." *Chicago Tribune,* May 30, 2003.

Vogel, Carol. "Surprises in Whitney's Biennial Selections." *New York Times,* December 8, 1999.

Williams, John A. "Dawoud Bey." *Black Photographers' Annual* 4 (1980): 76–81.

Wilson-Goldie, Kaelen. "Street Life." *Art and Auction,* May 2002, p. 117.

SELECTED WRITINGS BY DAWOUD BEY

"In Search of a Vision: Edward Clarke and Candida Alvarez." *Uptown* 2, no. 1 (1981).

"Ana Mendieta: A Woman, an Artist." *East New Yorker* 1, no. 2 (1982).

"David Hammons: Purely an Artist." *Uptown* 2, no. 3 (1982).

"Images: Six Black Photographers in Focus." *American Arts,* September 1982.

"Portfolio." *Obscura* 2, no. 4 (1982): 28–29.

"A Light from the Darkroom—Anthony Barboza." *City Sun,* August 1, 1983.

"Berenice Abbott. Images and Essence." *American Arts,* March 1983.

"Photography: Image Problems." *American Arts,* July 1984.

"My Harlem Homecoming." *City Sun,* May 1–7, 1985.

Contact Sheet 51 and 53 (1986).

"Corrective Vision." *Afterimage* 16, no. 2 (1988).

"Commentary." *Nueva Luz: A Photographic Journal* 3, no. 3 (1991).

"Behind the Scenes—On Location." *PhotoEducation* 8, no. l (1992).

"Introduction." In *Graduate Photography at Yale.* New Haven, Conn.: Yale University School of Art, 1993.

"In the Spirit of Minkisi: The Art of David Hammons." *Third Text: Third World Perspectives on Art and Culture* 27 (1994).

"Chicago Story: Polaroid Images by Dawoud Bey." *Creative Camera* 332 (February 1995): 20–21.

"Summer Reading 96." *C: International Contemporary Art* 50 (1996).

"Basketballs, Tree Trunks, Melancholia, and Hope." In *ARS 01,* pp. 78–80. Helsinki: Museum of Contemporary Art, 2001.

"Documentary Photography and Artistic Practice." *Document* 2, no. 1 (2001): 23–26.

The Human Presence. Chicago: Hyde Park Art Center, 2002.

Patchworks: Photographs by Alex Harsley. New York: June Kelly Gallery, 2002.

"Authoring the Black Image: The Photographs of James Van Der Zee." In *The James Van Der Zee Studio,* by Colin Westerbeck, pp. 27–34. Chicago: Art Institute of Chicago, 2004.

"Into the Light: Dawoud Bey Looks at the Photographs of Alex Harsley." *Art on Paper,* May 2004.

"The Ironies of Diversity; or, The Disappearing Black Artist." *ArtNet,* April 2004, www.artnet.com.

"The Black Artist as Invisible (Wo)Man." In *High Times Hard Times: New York Painting, 1967–1975,* edited by Katy Siegel, pp. 97–109. New York: Independent Curators International and Distributed Art Publishers, 2006.

"Correspondence, An Installation by Ceci Mendez." In *Big Red and Shiny,* December 2006, www.bigredandshiny.com.

CLASS PICTURES

PHOTOGRAPHS BY **DAWOUD BEY**
ESSAYS BY **JOCK REYNOLDS** AND **TARO NETTLETON**
INTERVIEW BY **CARRIE MAE WEEMS**

For the past fifteen years, Dawoud Bey has been making striking, large-scale color portraits of students at high schools across the United States. Depicting teenagers from a wide economic, social, and ethnic spectrum—and intensely attentive to their poses and gestures—he has created a highly diverse group portrait of a generation that intentionally challenges teenage stereotypes. Bey spends two to three weeks in each school, taking formal portraits of individual students, each made in a classroom during one forty-five-minute period. At the start of the sitting, each subject writes a brief autobiographical statement. By turns poignant, funny, or harrowing, these revealing words are an integral part of the project, and the subject's statement accompanies each photograph in the book. Together, the words and images in *Class Pictures* offer unusually respectful and perceptive portraits that establish Dawoud Bey as one of the best portraitists at work today.

DAWOUD BEY (born New York, 1953) earned his MFA from Yale University School of Art and is professor of photography at Columbia College Chicago. He has been featured in numerous exhibitions—including a mid-career survey at Walker Art Center, Minneapolis, in 1995—and received several awards, including grants from the National Endowment for the Arts and a Guggenheim Fellowship. He is represented by Howard Yezerski Gallery, Boston, and Rhona Hoffman Gallery, Chicago.

JOCK REYNOLDS is The Henry J. Heinz II Director of Yale University Art Gallery, New Haven, Connecticut.

TARO NETTLETON is a doctoral candidate in the Graduate Program in Visual and Cultural Studies, University of Rochester, Rochester, New York.

Photographer **CARRIE MAE WEEMS** lives in Syracuse, New York, and has known Dawoud Bey for thirty-some years; her books include *The Hampton Project* (Aperture, 2000).

aperturefoundation
547 West 27th Street
New York, N.Y. 10001
www.aperture.org